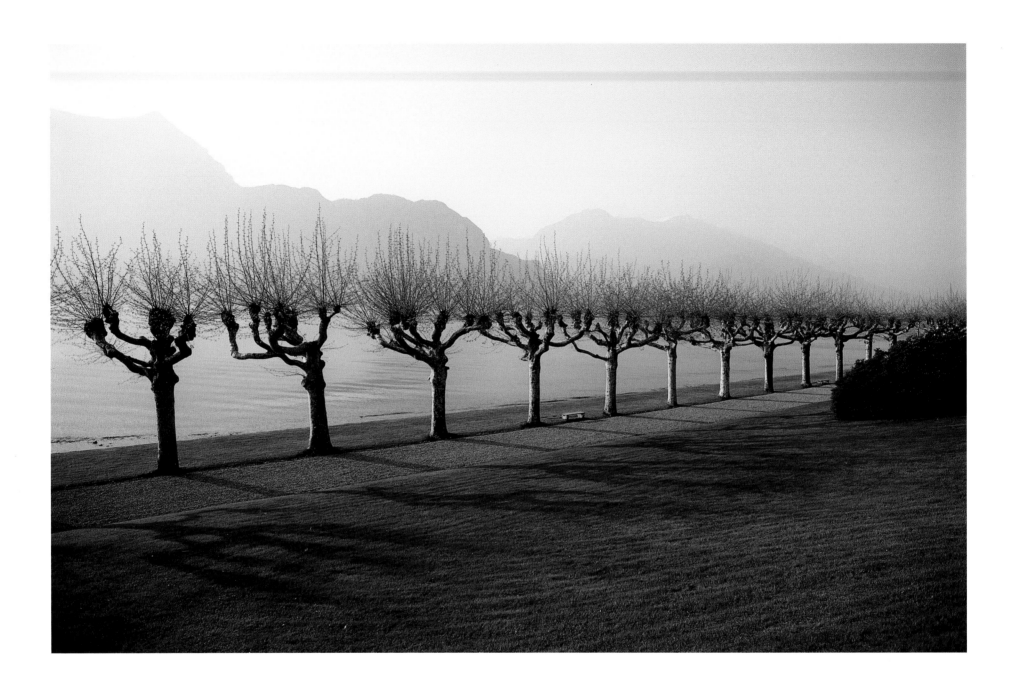

SEEING GARDENS

#23065416

SAM ABELL

NATIONAL GEOGRAPHIC
WASHINGTON, D.C.

CONTENTS

6 ~ INTRODUCTION

24 ~ PART ONE

THE GARDEN

Autumn in Kyoto ~ The English Spring ~ The Italian Lakes ~ A Moroccan Oasis
In American Gardens ~ Greenhouse Gardens

84 ~ PART TWO

WILD GARDENS

Appalachian Trail ~ Water Gardens of the Okeefenokee ~ Rainforest Gardens of the Northwest
Arctic Gardens ~ Sandstone Gardens of the Southwest ~ Landscpae Gardens of the Australian Outback

142 ~ PART THREE

CULTURAL GARDENS

Tolstoy's Garden ~ Lewis Carroll in the Garden of Wonderland
Britain's Hedgerows ~ The Shakers' Brief Eternity ~ Sculpture Gardens of the Civil War

192 ~ EPILOGUE

SEEING GARDENS

208 ~ AUTHOR'S NOTE

(HALF TITLE PAGE) ROCKERFELLER CENTER, NEW YORK
(TITLE PAGE) PLANE TREES, VILLA MELZI, LAKE COMO, ITALY
(OPPOSITE) SHALIMAR GARDEN, KASHMIR, INDIA

THE GARDEN IN LIFE

PERHAPS NO PLACE ON EARTH IS RICHER IN GARDENS THAN LAKE DAL. Shalimar and other grand Moghul pleasure gardens are situated on its shores. In summer the lake itself blooms with lotus. Aquatic produce gardens are tended and harvested throughout the year. But on this early spring day there were no gardens to be seen. A long, slow trip across the lake in a barren boat was ahead of us. Then we chanced upon a floating flower vendor we knew who went by the name of Mr. Wonderful. He insisted on filling the prow of our boat with flowers. We haggled a little, paid him, and discussed his life on the lake. As our boats separated I warned him that I had seen another flower vendor on the far side of the lake the day before. He said, "That's my son." "Really," I said. "What's his name?" Over his shoulder he answered, "Little Mr. Wonderful."

I turned and saw we had been given the gift of a garden. Moments before, the boat had been cold and blank. Now flowers gave our journey the warmth of home. They did something to the view as well. They centered and deepened the scene and gave an intimate human scale to the lake and the mighty landscape of the Himalaya.

Seeing gardens—in expected and especially in unexpected places—has given meaning to my life as a photographer and traveler. Throughout the world flowers are arranged, fabrics designed, homes situated, and views framed because people place the poetry of the garden at the center of their lives. In my work I seek to show the nature of this beauty and the connection between cultivated gardens, incidental arrangements, and the undesigned wilderness.

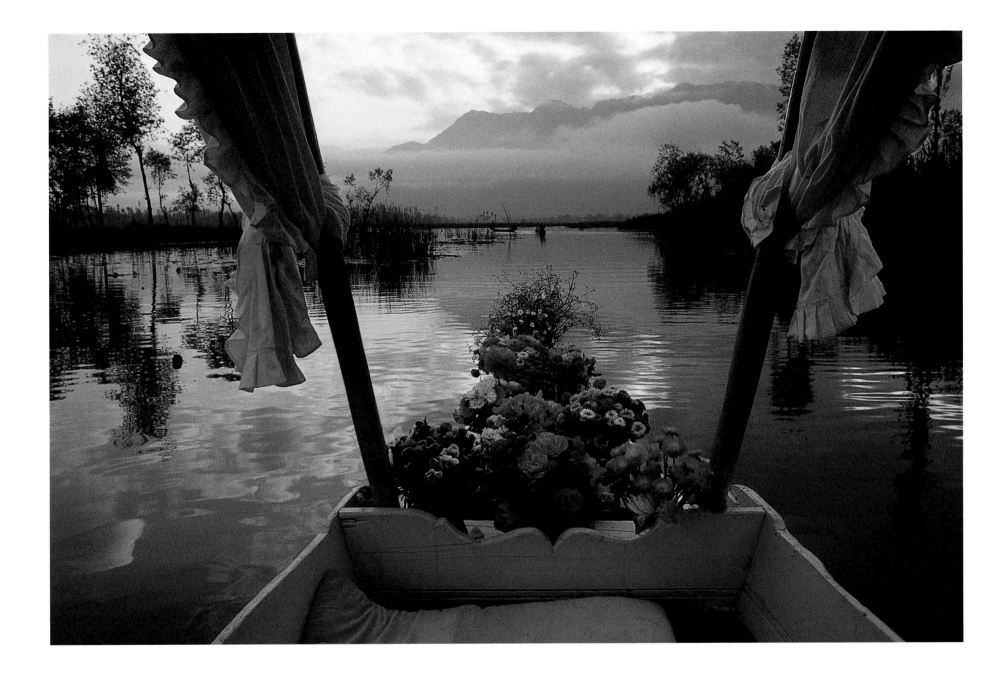

LAKE DAL, KASHMIR, INDIA

As boys my brother and I had to spend part of our summer vacations visiting cultural shrines with our parents. We found these trips tiresome, except for the grounds and gardens of the great estates.

One of the memorable estates was Monticello. Jefferson's symmetrical house looked familiar. It was almost identical to the back of the nickel I took from my pocket for comparison. But the garden and view were new to me. The garden wasn't just big; it had flowers, seeds, and leaves we didn't have in Ohio.

Now I live ten miles from Monticello. I've seen Jefferson's garden many times, but never as strikingly as when a spring storm rained apple blossoms down onto the grass, rock walls, and wooden handrail overlooking the garden and vineyard.

Jefferson was a naturalist as well as a statesman, and his terraced garden was—and is—alive with his discoveries, experiments, and curiosity. Monticello in Jefferson's time was a center of horticulture, with ideas and plants pouring in from the Old and New Worlds—from Peale and Bartram and from Lewis and Clark.

The garden was also something else. It was the foreground and the foundation of Jefferson's deeply layered view of Virginia's graceful landscape. Standing above the garden, it is easy to understand Jefferson's statement: "I am happy nowhere else, and in no other society, and all my wishes end, where I hope my days will end, at Monticello."

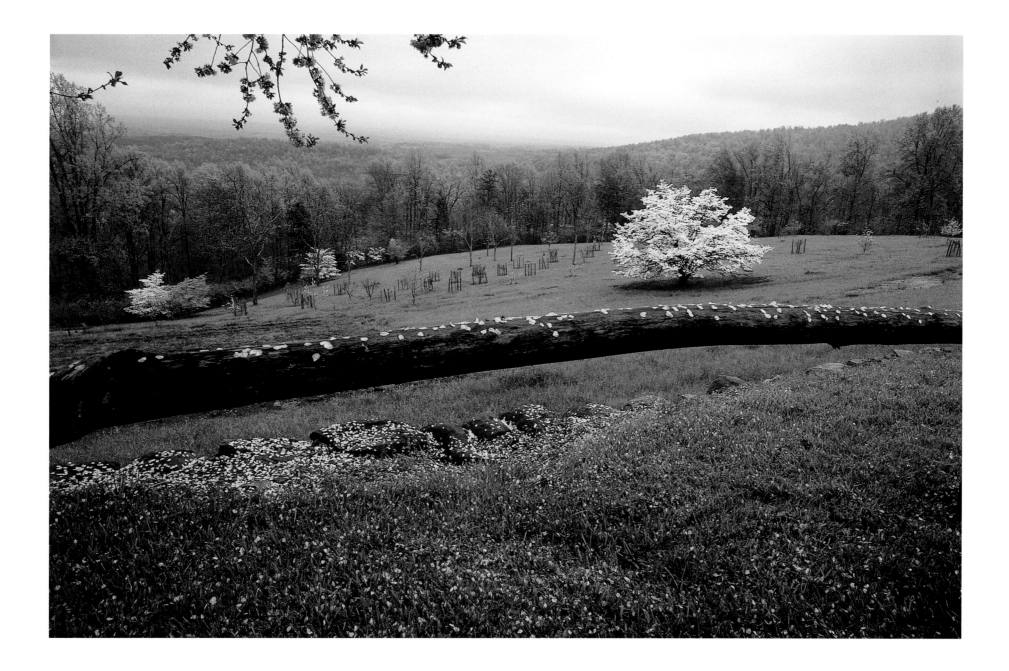

MONTICELLO, CHARLOTTESVILLE, VIRGINIA

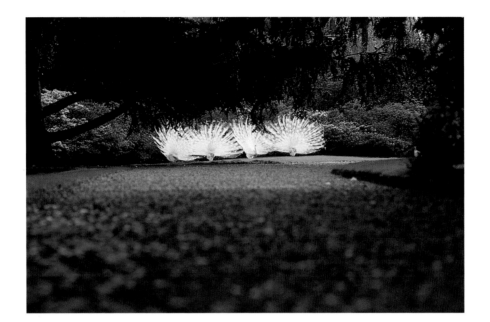

WE ARRIVED LATE IN THE DAY at Isola Madre, an eerily empty garden island. The villa was silent and the garden still. Deep within the garden, at a junction of paths, there appeared to be a shimmering mirage. It was a cluster of white peacocks in full display, their feathers silently swaying.

The vision seemed too fragile to last. But the peacocks stood still, then began to preen, then to parade for one another. We felt as if we were seeing marble statues come to life.

Their silent dance lasted many minutes, ending only when a gust of wind suddenly blew their feathers backward, affirming for a moment the wildness that underlies even the most ornamental of gardens.

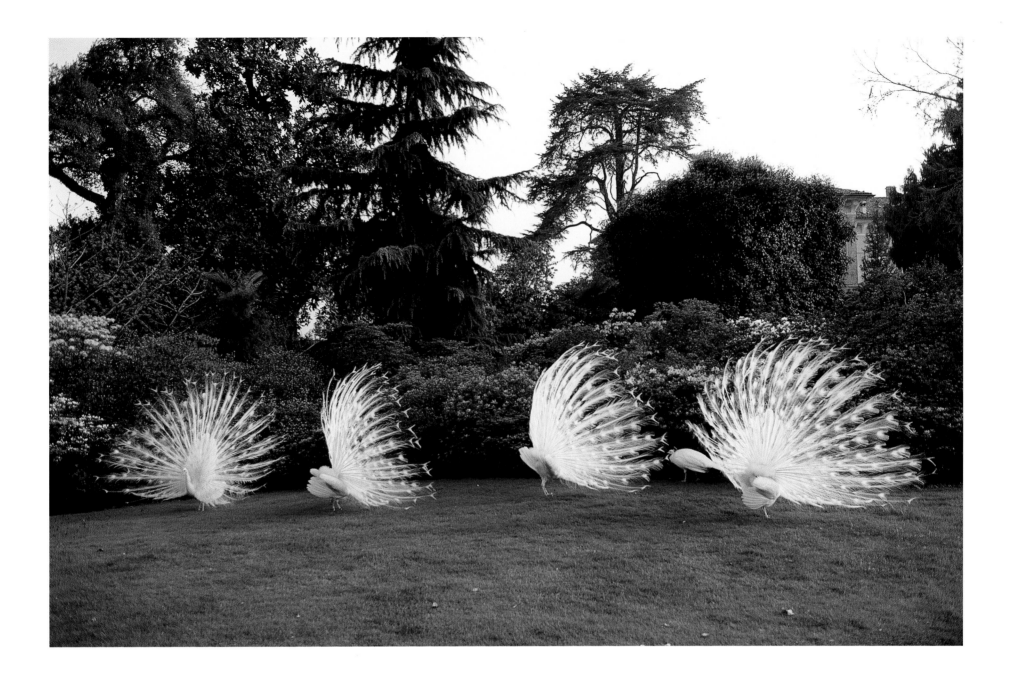

ISOLA MADRE, LAKE MAGGIORE, ITALY

IN JAPANESE DRY-LANDSCAPE GARDENS nature is symbolized. Stones stand for mountains, sand for the sea, and moss for the forest floor. Space itself is implied. Only the illusion of it exists.

Within the small dry garden at Korin-in Temple, designed by the contemporary master Kinsaku Nakone, are continuous, evolving views of one complex composition. But only one view is stilled by a frame—the first one, at the entrance to the garden. With its dappled darkness, bell-shaped arch, subtle shoreline, and dry sea, the design is meant to slow and even stop visitors.

But its power goes beyond this. By making an art of the garden entrance, Nakone endows the view with promise. Expectations are raised. One is drawn deeper into the garden.

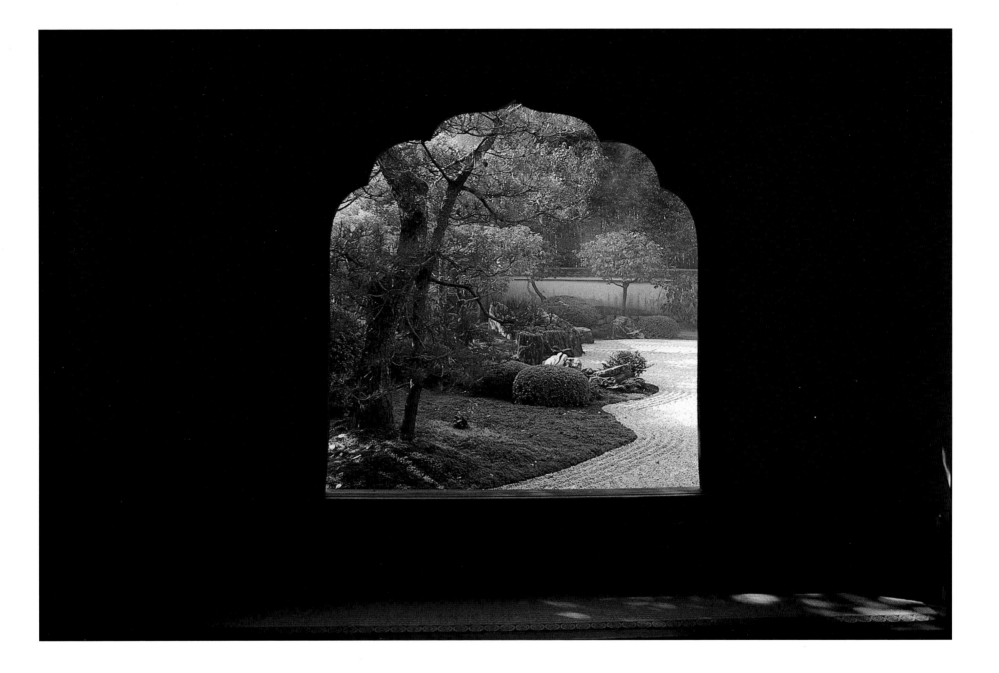

KORIN-IN TEMPLE, KYOTO, JAPAN

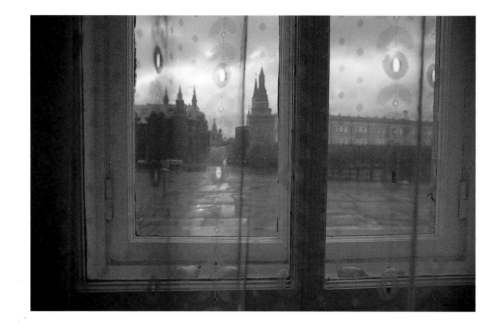

SOME OF THE GARDENS THAT MEAN THE MOST are impromptu arrangements, like this still life of pears on a windowsill in Moscow. This garden came into being casually, existed for a day or two, and vanished—in this case it was eaten. But while it lasted it was consoling. After a month in Russia I was feeling far from home. My work had me on the street for days at a time. Finally my interpreters and I called a day off. I spent it in my room.

I photographed the pears throughout the day, beginning in the drizzly dawn. Late in the afternoon when the sun came out, I waited for it to simultaneously light the pears, the Kremlin, and the distant cupola of St. Basil's Cathedral. As that happened, a breeze lifted the curtain into the room and held it there.

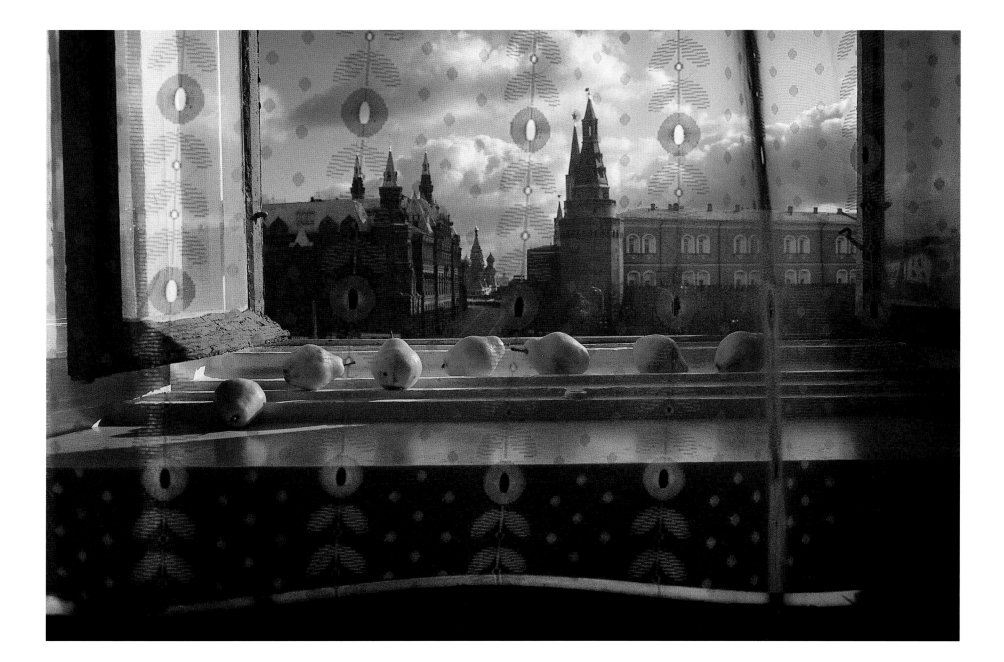

NATIONAL HOTEL, MOSCOW, RUSSIA

MY AUSTRALIAN FRIEND Kerry Trapnell and I called this secluded, silent place on Fraser Island the "Zen garden" because of its almost empty, austere beauty.

We camped here several days trying to render, photographically, the power of the place. That power was in the skeletal trees, remnants of an ancient rain forest that had been buried centuries ago by shifting sand dunes. Over time the sands shifted again, revealing this scene. But just behind the trees an almost vertical dune was advancing to rebury them. The trees seemed to be elemental calligraphy spelling out that story.

Conveying the character of this natural sculpture garden occupied us for three days. We contemplated and recontemplated the composition, and we photographed the scene in every available light, even moonlight. But the quality of the place eluded us.

On the last day the setting sun cast long shadows over the trees, ending—I supposed—our effort. Instead, the shadows inked the trees, snapping them sharply against the sunlit sand, giving to the scene a dark dimension.

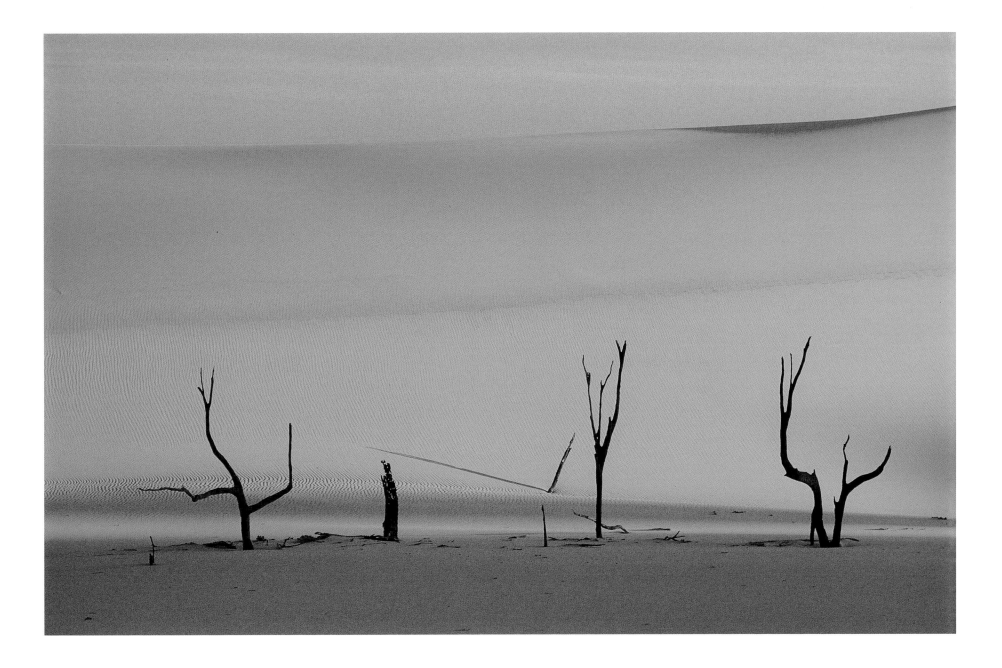

FRASER ISLAND, QUEENSLAND, AUSTRALIA

GARDENS WERE FAR FROM MY MIND in the High Sierra. I was on a months-long backpacking hike on the Pacific Crest Trail, which was buried beneath the vast snowfields we were struggling through.

At this elevation, 11,500 feet, the dazzling summer sun melts snow into patterns of soft "cups," which greatly inhibit hiking. There is beauty in infinite fields of snow cups. They are graceful. But it's hard to focus on their beauty after days of plunging through them.

One day, around noon, my hiking partner Will Gray stopped and pointed straight down. A swallowtail butterfly was resting in a snow cup. The scene held us for some time. When we plunged on, the butterfly was still there, an improbable jewel in a garden of snow.

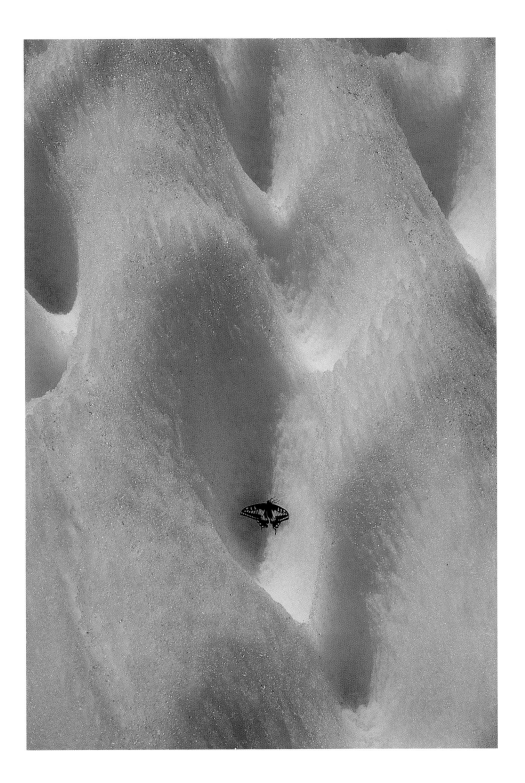

PINCHOT PASS, SIERRA NEVADA, CALIFORNIA

PEOPLE ARE RELUCTANT TO LEAVE THE GARDEN. They want to bring it with them into the center of their lives because the garden is an enduring image of life itself.

Artists elevate this ideal. And this child, the daughter of one artist, is asleep on the couch of another while elsewhere in the house a party is about to begin.

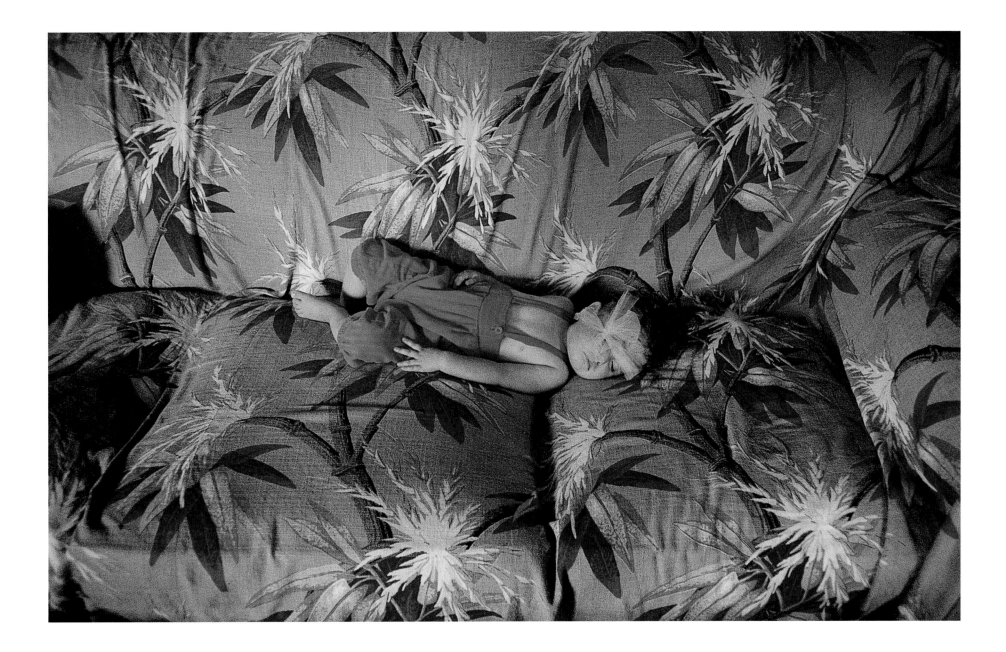

SEATTLE, WASHINGTON

ONE AUTUMN I SPENT A MONTH AT AN OLD INN in western Japan and twice a day passed by this window. I often stopped, studying the contrast between the calm gray glass and the complex scene it framed.

I began photographing it in even light, but the results were flat. Late in the month I photographed the window in direct sunlight, which splintered the tree and tiles into a shimmering pattern of highlight and shadow, giving to the scene the contrast and movement I was after.

But framing is the foundation of this photograph. It is also, for me, the essence of seeing photographically.

When I look at this picture I think of Japan, the old inn, and its window. And I think, too, of the close connection between the framing of photographs and the seeing of gardens.

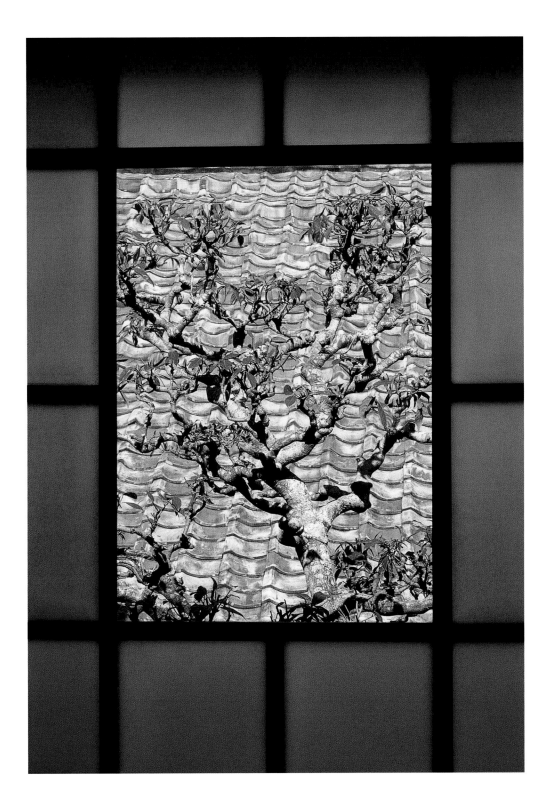

TOMOE RYOKAN, HAGI, JAPAN

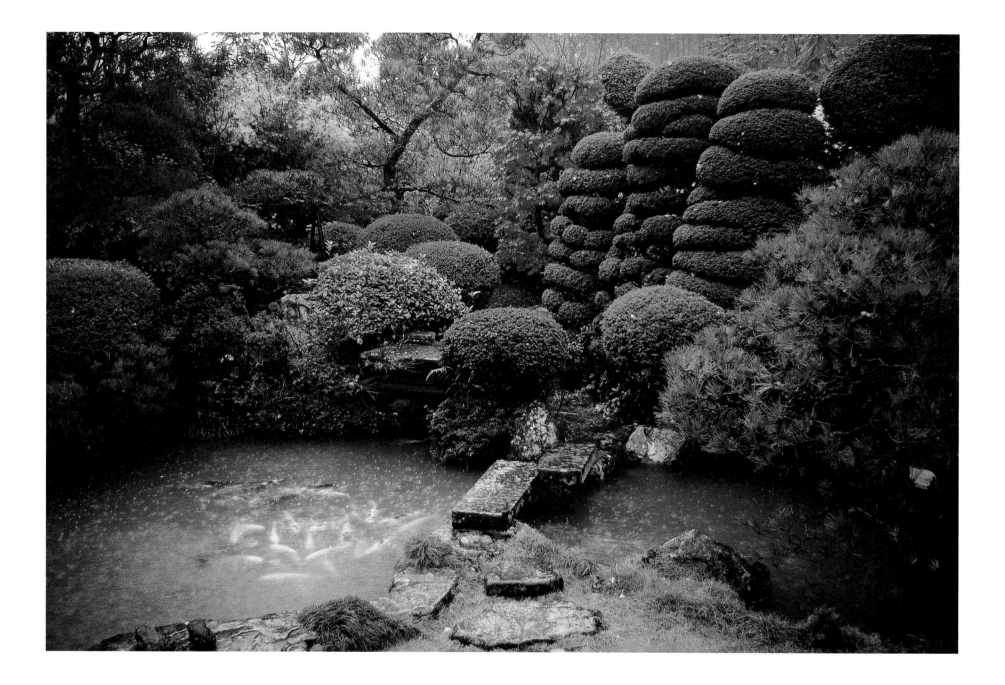

POTTER'S GARDEN, HAGI, JAPAN

THE GARDEN

AT OUR HOUSE ON GARDEN PARK DRIVE what mattered most were the gardens. There were two of them: My mother grew flowers and my father raised vegetables. When visitors arrived, the first things they were shown were the gardens. This little tour allowed everyone to visit in a good way. People didn't talk about themselves; they talked about the weather, the growing season, nature in general.

The gardens gave guests a chance to be complimentary. They gave my parents a chance to modestly lament that the plantings were not as perfect as they could be. Seeing the gardens was a ritual that was repeated when we visited our grandmothers in Kentucky and elsewhere in Ohio. But slowly all of it—the visits, the gardens, and our grandparents—faded from my life.

I was to discover the social ritual of seeing gardens again as a traveler.

One autumn afternoon I visited the home of a renowned Japanese potter. I was there to photograph his studio and work. But first we looked at the garden. Then tea was served in the subtly elevated garden viewing room—the refined equivalent of my grandmother's back porch in Louisville. It began to rain, darkening the garden's beauty. As soon as it was polite to do so, I asked if I could photograph the scene. Except for the milling fish the garden was deeply composed. I waited some time for the fish to arrange themselves and complete the composition. When I was finished, I asked the potter why the garden had such an effect on me. He answered, "It's six hundred years old."

Autumn in Kyoto

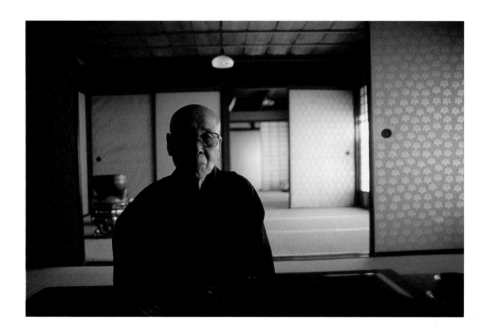

ANJUSAN, HEAD NUN, SAIRAI-JI TEMPLE

"I'M SORRY, NO," the monk said, "you can't visit the garden today. It's not raining." I appreciated his reasoning. The aesthetic difference between dry and damp gardens is only one of the refined nuances of gardening in Japan. On the other hand, we wanted to see the tea garden, one of the oldest, smallest gardens in Kyoto. We couldn't wait for the rain. The monk relented. "Come this afternoon, but not before two o'clock."

When we arrived the garden was wet and shining. It had been watered by hand.

Garden consciousness like this is at the center of spiritual life in Kyoto. For a thousand years the Imperial Palace was situated here. Around it grew an array of temples, subtemples, shrines, schools, and detached palaces, each with its own gardens and often, it seemed, its own garden philosophy.

These gardens, still tended by monks and nuns, are intimate but don't feel small. They are thoroughly thought out, yet seem inevitable. They are sensual but speak to the spirit.

In autumn, storms bring down leaves, and for a few days the glow of the trees is also on the ground. Sunlight reenters the garden. It is warm, but briefly; winter is in the air.

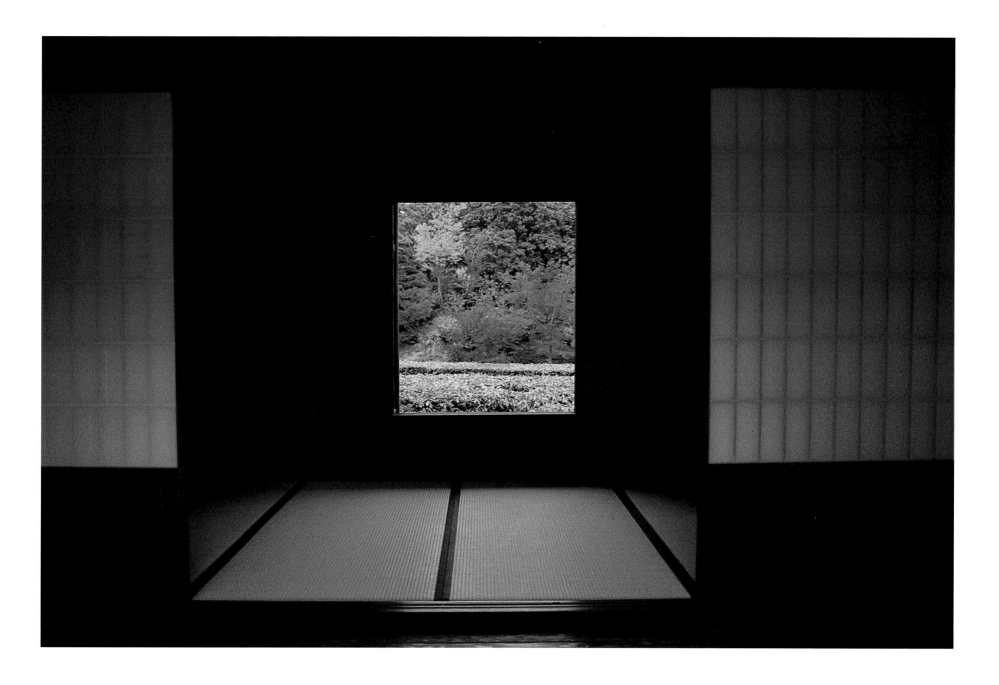

GEPPARO TEA PAVILION, KATSURA RIKYŪ IMPERIAL VILLA

Saihō-ji Temple is famous for its extensive garden of meticulously maintained moss. It's impossible not to be impressed by the rich moss—there are even islands of it in a small lake—but after a while it feels a bit overadmired. I wandered away and spent time elsewhere in the garden.

My favorite place became the quiet mōsō bamboo grove at the back of the garden. The vertical cylinders of bamboo rose from the forest floor in a clean, strong way. But the foreground was a dry blanket of dull bamboo leaves.

A few days later rain fell, and I returned to the grove. Gardeners had swept maple leaves from the moss carpet of the main garden and spread them here, over the bamboo leaves. The starry, wet leaves were radiant and gave to the foreground a strength to match the bamboo. This wasn't an accident; it was an incidental act of inspired gardening.

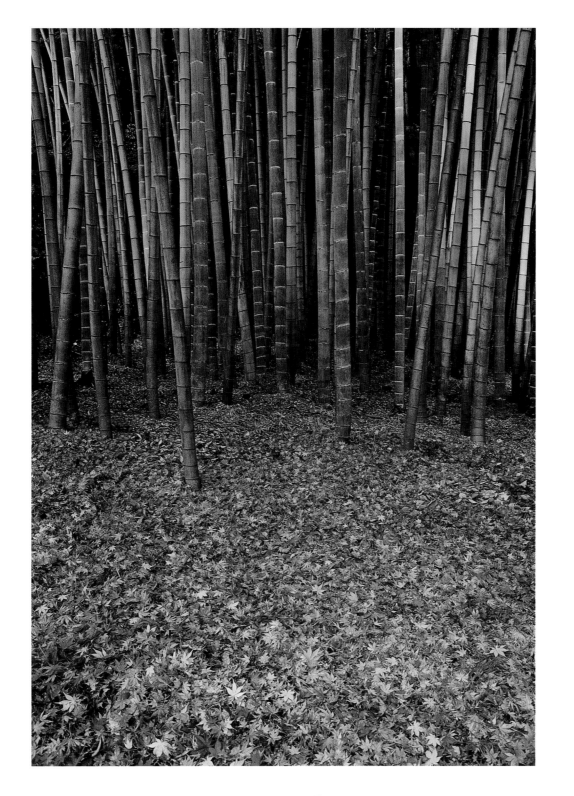

MŌSŌ BAMBOO, SAIHŌ-JI TEMPLE

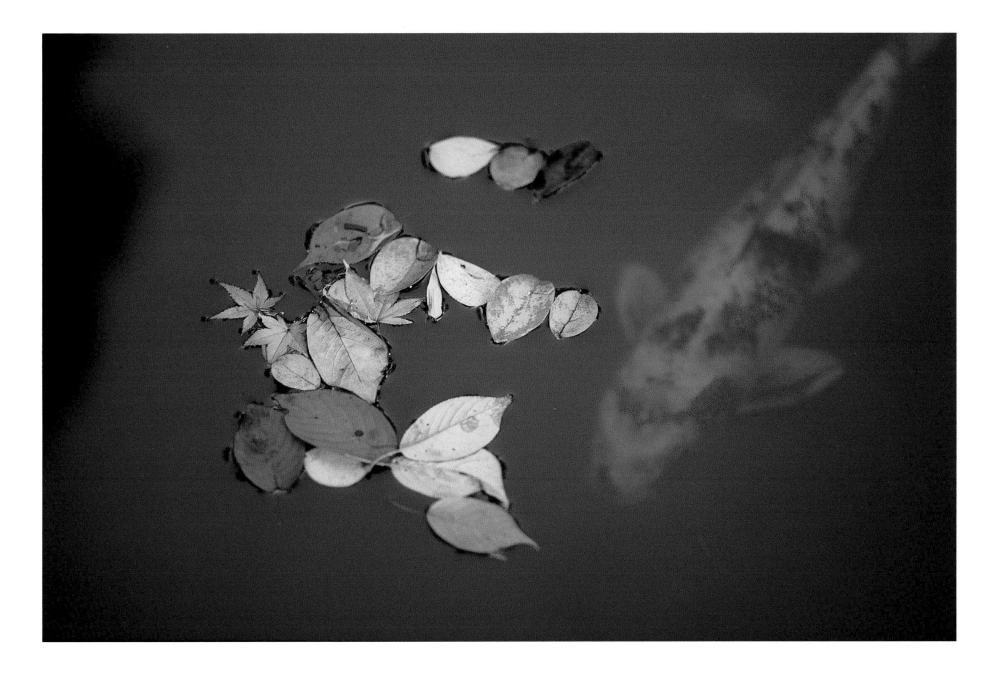

TENJŪ-AN TEMPLE

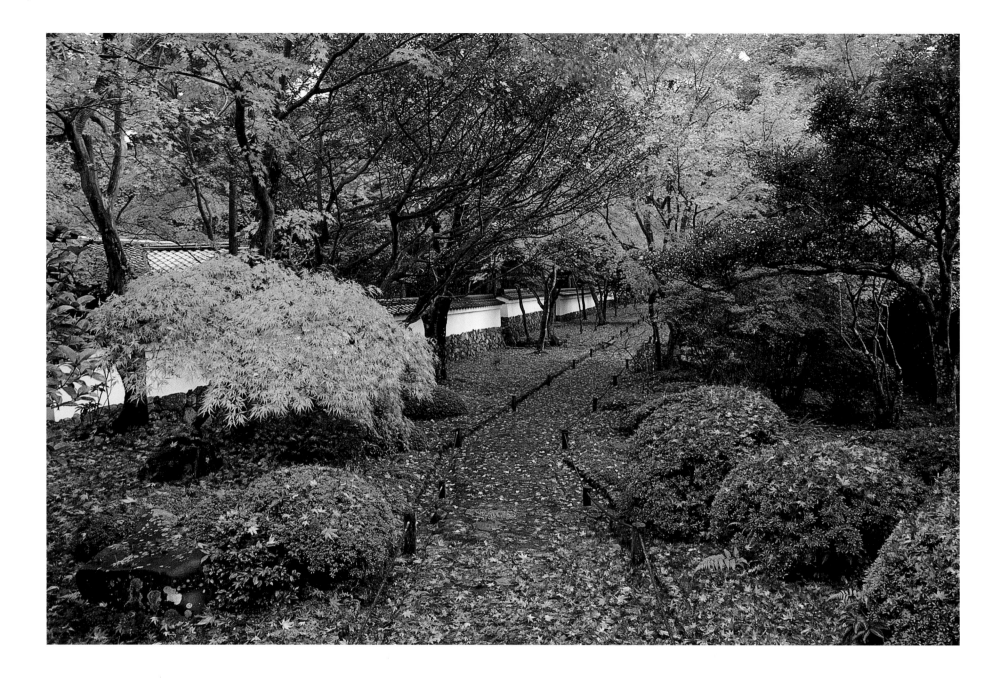

SAIHŌ-JI TEMPLE

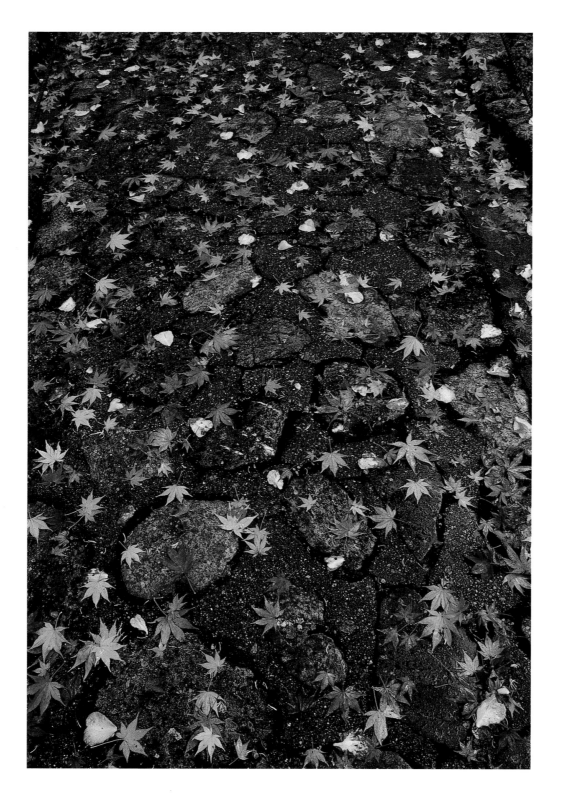

SAIHŌ-JI TEMPLE (DETAIL)

Autumn in Kyoto ends with the wrapping of tender plants for winter. Without the insulation of rice straw these tropical cycads would perish in the cold months ahead.

But even this routine and annual task is done with considerable care, a sense of traditional design, and an eye for how this small corner of the Imperial Garden will look in winter when the colorful, eccentric shapes of the warmly clothed cycads will sway in the snow.

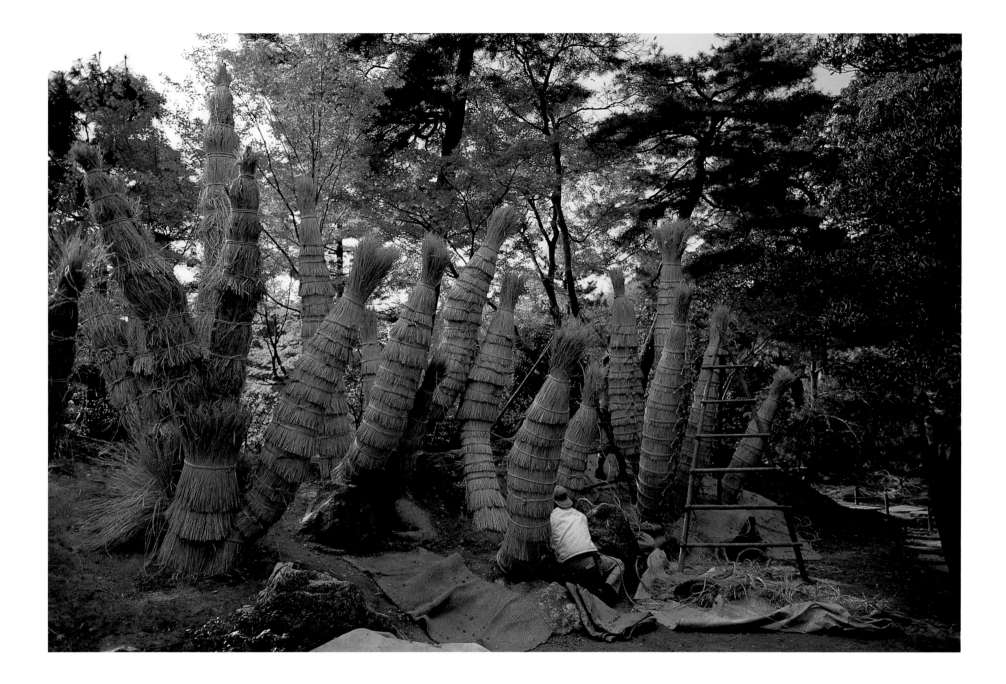

KATSURA RIKYŪ IMPERIAL GARDEN

THE ENGLISH SPRING

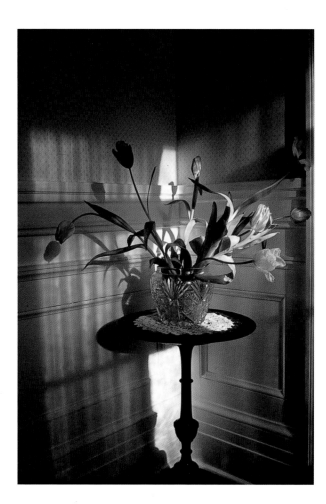

DEVON

"ROB IS IN THE GARDEN waiting for you. Do go out," said an Englishwoman to me several years ago. I could see Rob through the kitchen window, reading. His chair was on an impeccable lawn. There wasn't a garden in sight. But to the English a flawless grass lawn *is* a garden.

That is because they have mastered the art of growing, maintaining, and designing grass. Grass is the flooring of almost all the English "garden rooms." It is also the refined surface of every cricket pitch, bowling green, golf course, and lawn tennis court in the land. The grandest plant at the Royal Garden Party is the lush grass underfoot. Against this background people, as well as plants, are at their most appealing.

All it takes to create this green realm of grass are perfect English conditions: a drizzly, cool climate; highly evolved grass seed; and generations of knowledgeable and devoted gardeners willing to work hard.

Standing back to see the greening of grass after one of England's long, low winters is a sustained garden experience. During springtime it's not so much that the sun is out again; it's as though the land is lit from within.

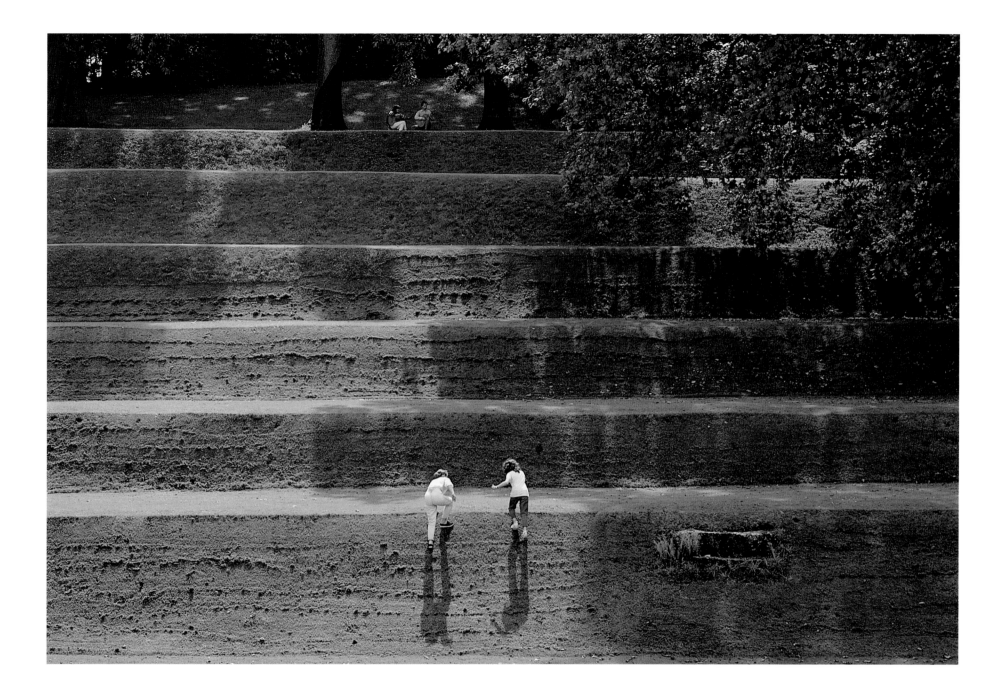

DARTINGTON HALL, TOTNES, DEVON

People come to the town of Wells to see the imposing and harmonious architecture of the Cathedral and adjoining Bishop's Palace. But the grounds are also appealing with gardens, expansive lawns, and tree-lined lanes.

One of the lanes is along a walled moat on the quiet back side of the palace. Old fruit trees, each in its own space, grow side by side on the stone wall. Despite being trained to grow flat, this tree retained its essential shape. Its fullness was undiminished.

I first saw the tree in summer when its leafy branches were heavy with apples. In winter the tree was just a skeletal shape on the cold wall.

But on this foggy morning the boundary between the living tissue of the tree and the inert texture of the wall began to blur. The old tree seemed like stone, and the stone seemed to bloom.

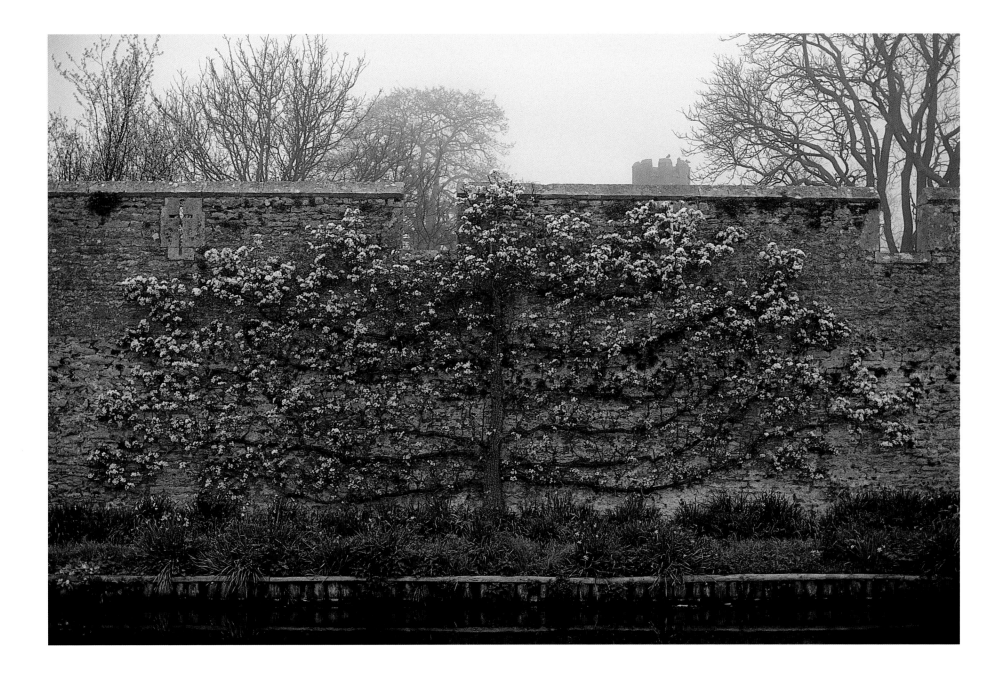

WELLS CATHEDRAL, SOMERSET

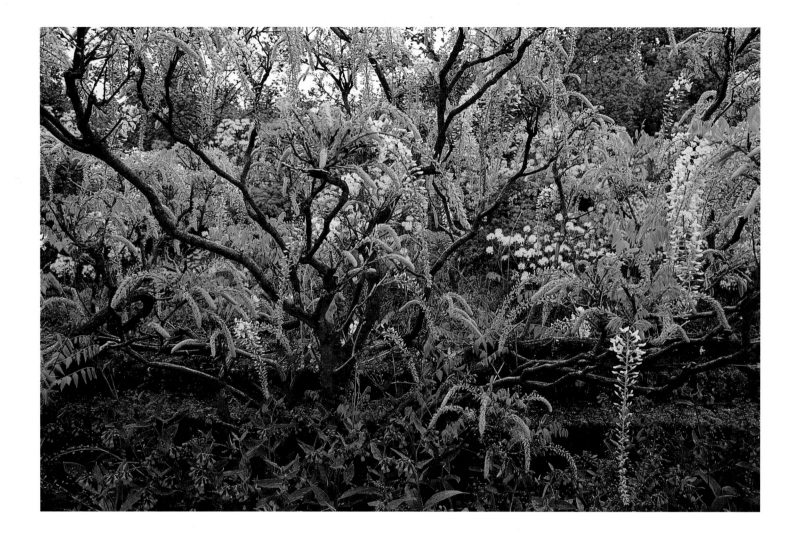

SISSINGHURST, KENT

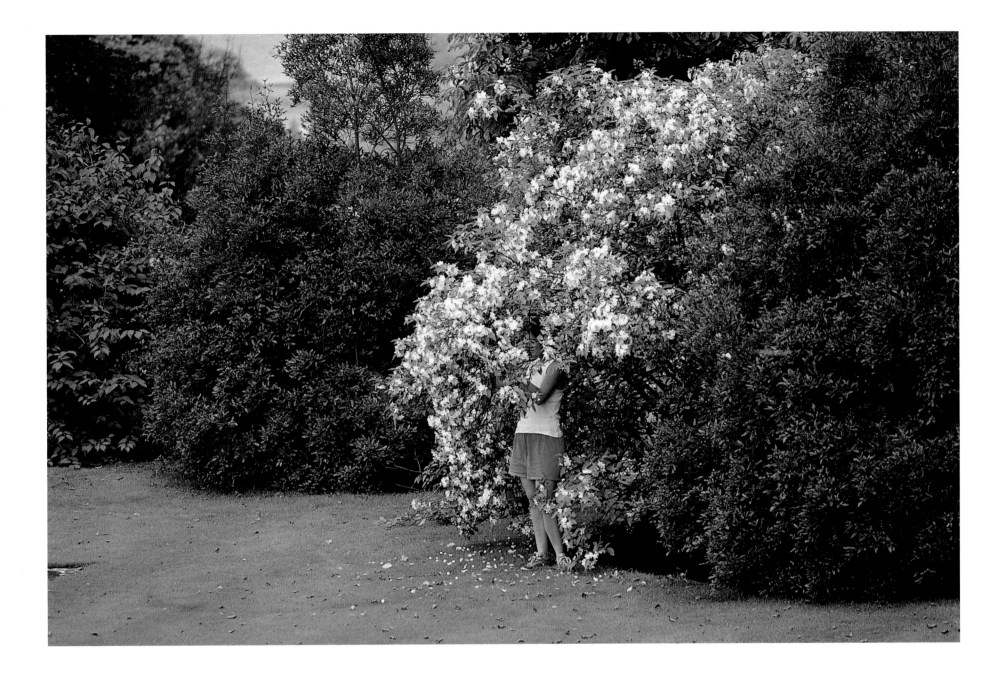

KNIGHTSHAYES COURT, TIVERTON, DEVON

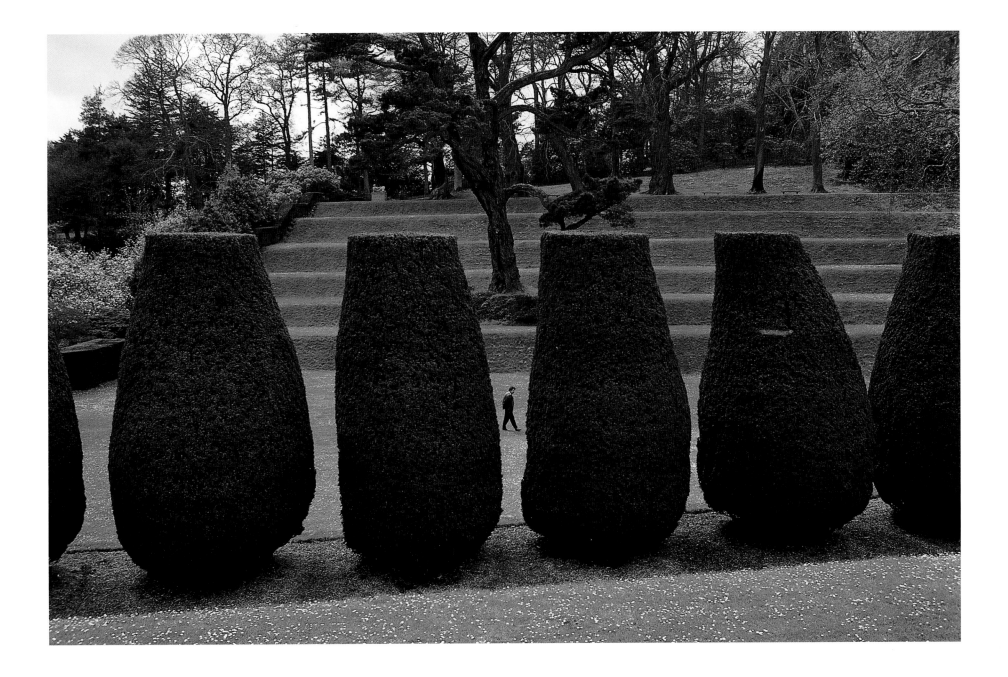

DARTINGTON HALL, TOTNES, DEVON

Gertrude Jekyll and Edward Lutyens were both esteemed in their own fields—she as a plantswoman, he as an architect—when they began collaborating on English country house designs in the early 20th century.

One of the best preserved of their designs is Little Thackham, which sits in its own grounds 120 miles south of London. The edges of this house are deeply indented with garden rooms, courtyards, small ponds, and sheltered sitting spaces. Windows look out onto gardens; doors open into them. There is always a choice of places to be—inside and sheltered, half outside in shade, half outside in sun, or all the way out.

One of my favorite places is at the entrance to a small side courtyard. I liked the expectant feeling of "about to enter." I also liked using tiles to rectangularly frame the already framing form of the stone arch. Lutyens liked this detail, too. It's repeated on the next doorway.

Within the garden room is a dense lawn of dark grass. Rising from it are tulips so luminous they seem like candles.

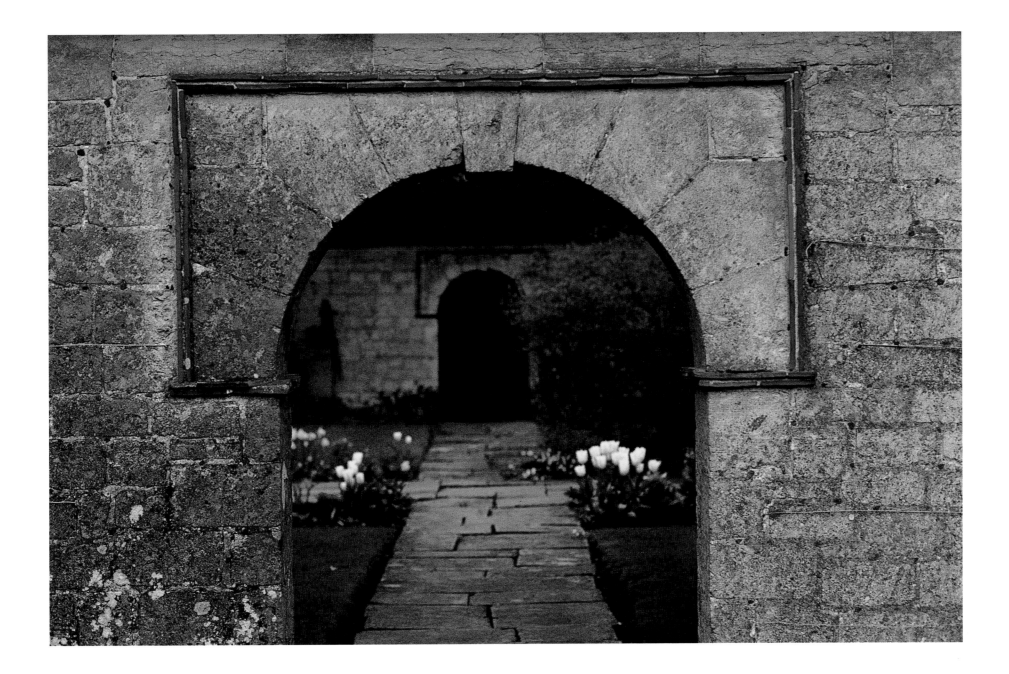

LITTLE THACKHAM, SUSSEX

THE ITALIAN LAKES

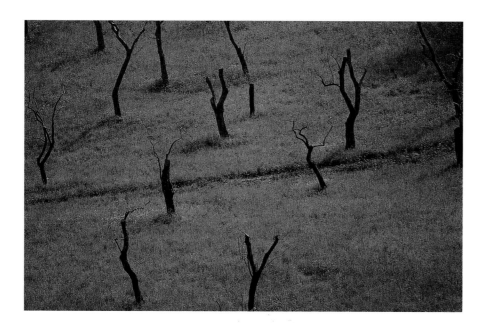

VILLA SERBELLONI, BELLAGIO (DETAIL)

THE SEVEN SLENDER ITALIAN LAKES—Como, Maggiore, Garda, Isea, Lecco, Orta, and Lugano—are situated between the sheltering, south-reaching arms of the Alps. The soft climate, deep fertility, and abundant light combine to create a verdant landscape. Upon it gardeners have for centuries cultivated the Italian ideal of the garden. An element of this ideal is high ornamentation: Trees are pruned, peacocks are bred, statuary is placed, and blossoms fall, all for the sake of art.

At the physical center of this ideal is the village of Bellagio. It sits on the point of a promontory that divides the waters of two lakes, Como and Lecco. The shores and slopes of the promontory are dense with established gardens. At lakeside are the gardens of the great villas. Upslope are vineyards and terraced produce gardens. At the summit of the promontory is a former fort, now a park, which commands a panoramic view of this garden world. When I think of gardens in the grandest sense, I think of this scene.

But I sought a more personal view. It is this book's title page photograph. In it the structure of the trees holds and unifies the lawn, lake, mountains, and sky. The scene is strong but also sublime, combining immediacy with infinity.

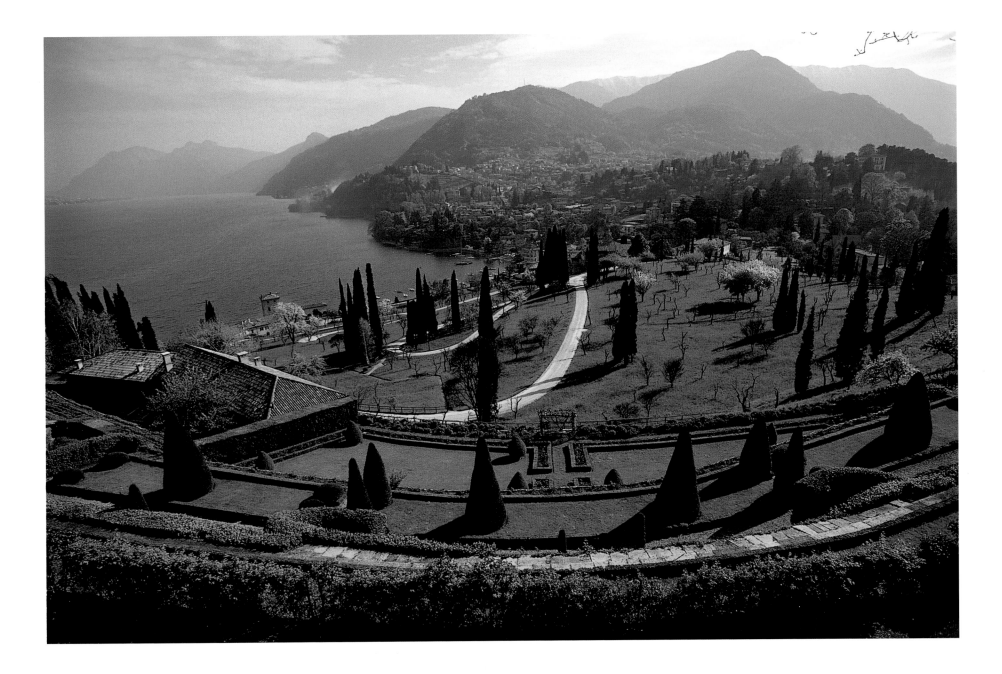

VILLA SERBELLONI, BELLAGIO

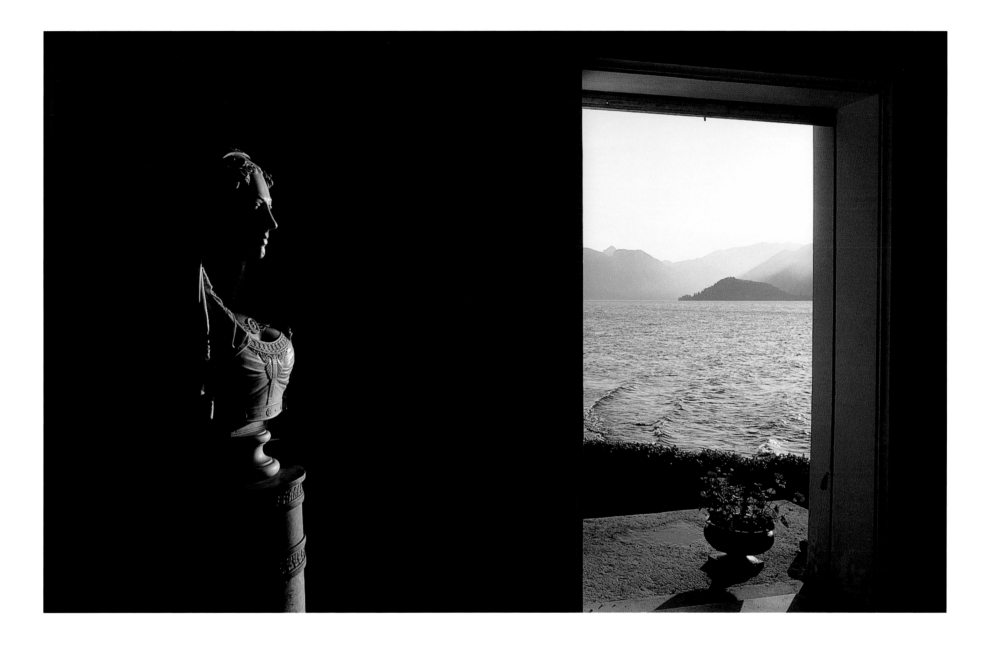

VILLA MELZI, BELLAGIO

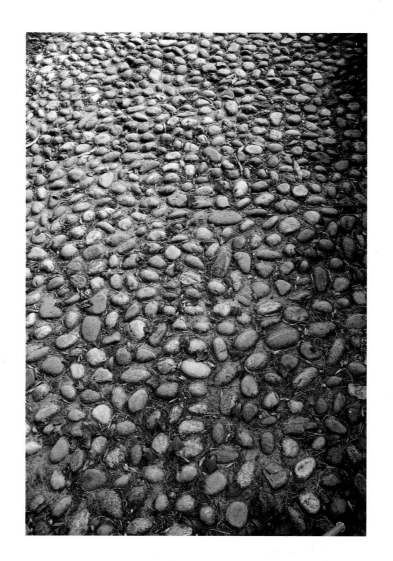

RHODODENDRON PETALS, VILLA CARLOTTA, TREMEZZO

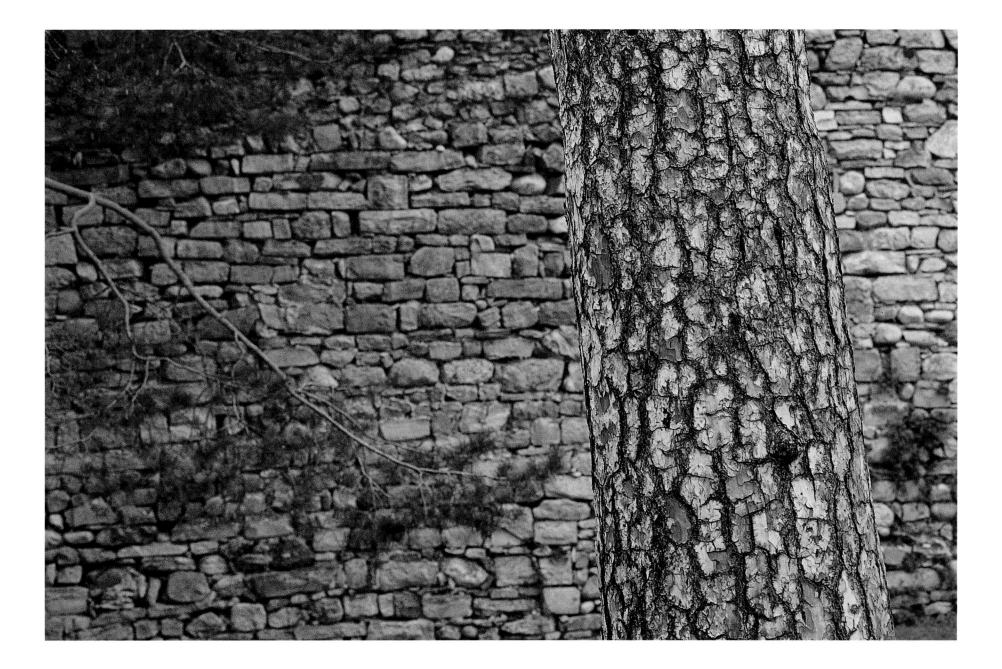

THE CASTLE, VILLA SERBELLONI, BELLAGIO

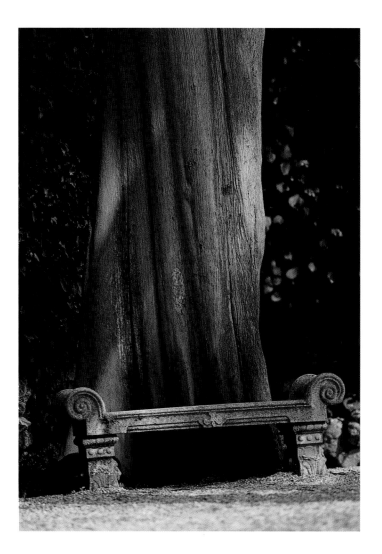

VILLA SERBELLONI, BELLAGIO

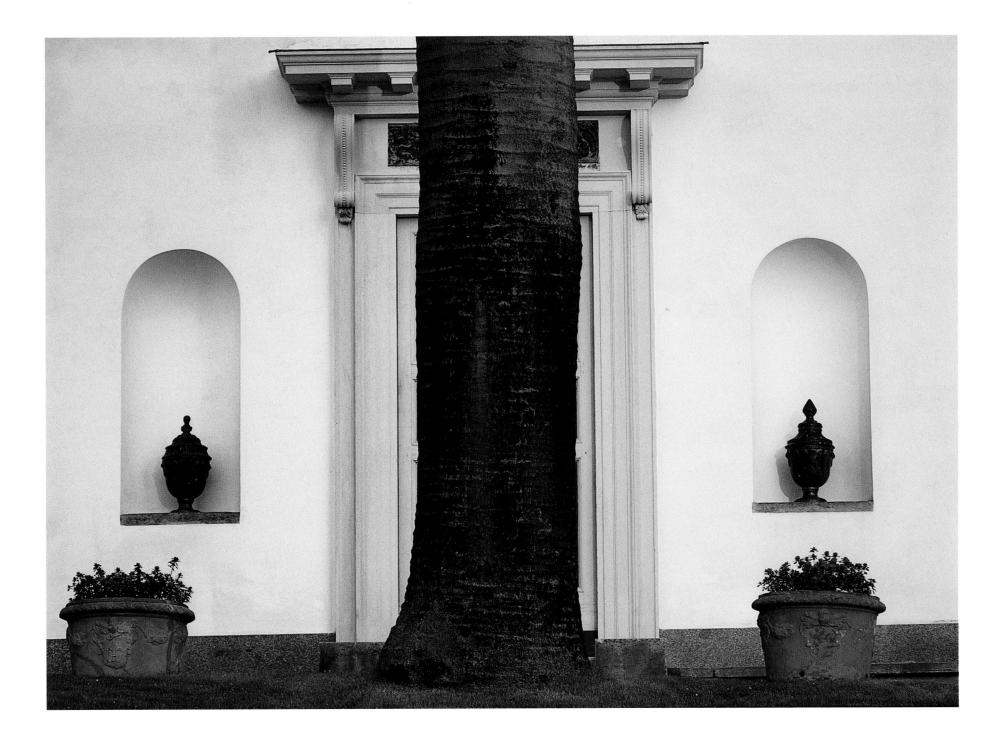

VILLA MELZI, BELLAGIO

There is a grandness to the geography of the Italian lakes that is matched by the gardens of the great villas on their shores. Within the garden of the Villa Melzi the first impression is one of sweep—the long horizontal view of Lake Como rising up to meet the Alps. It is a strong sensation, and gardeners emphasize it in their design and plantings.

But occasionally they break the sweeping view with vertical lines. Here, on the lakeshore, a mature pine towers over an upright Egyptian statue. The small statue, of a cat, holds its own. It has a presence, even an eternal quality, that brought me back to it. In this grandest of gardens the small statue gives scale to the sweeping scene and affirms that details, down to even the personality of statues, still matter.

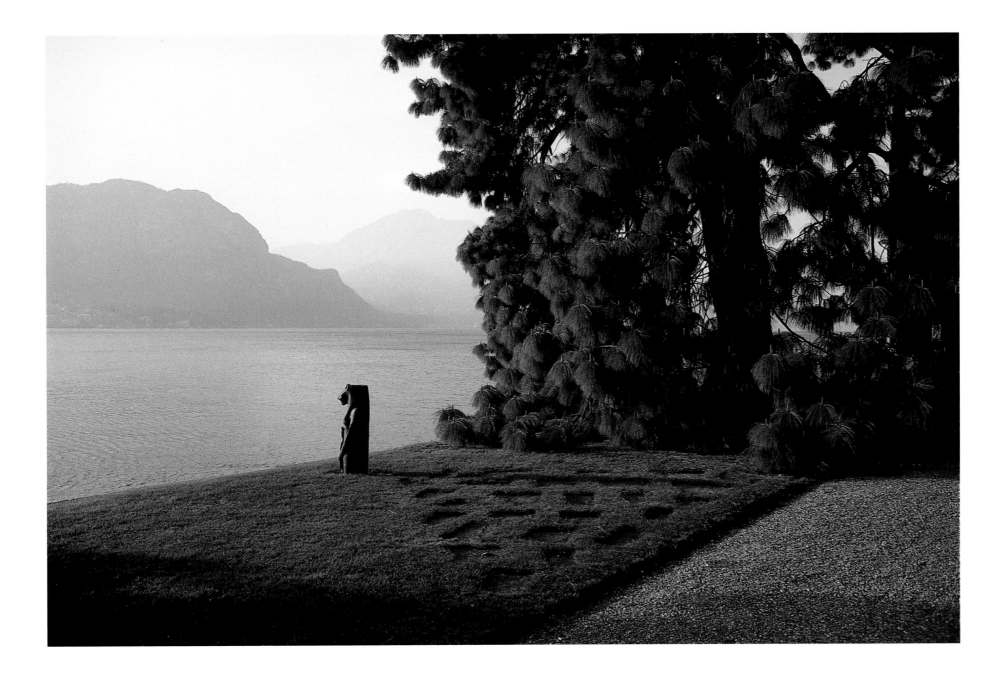

VILLA MELZI, BELLAGIO

A MOROCCAN OASIS

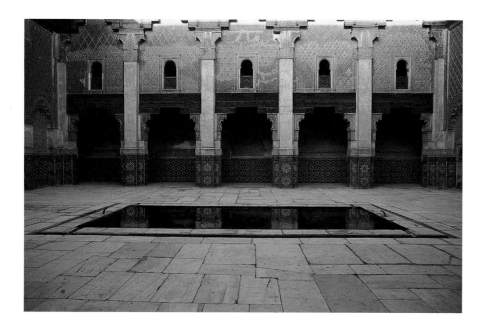

MEDERSA BEN YOUSSEF COURTYARD

THE WORD "PARADISE" comes from Arabian culture and so probably does our idea of enclosing nature with walls. And in arid Morocco, as in the rest of the Arab world, the nature worth enclosing begins with water.

In the case of the Medersa ben Youssef garden, in Marrakesh, it ends with water as well. In a cut-stone courtyard, a dark rectangle of still water reflects the intricate architecture. Otherwise there is nothing—no foliage, no flowers. But in a teeming desert city the effect is cooling and serene.

At the Hotel La Mamounia, a former royal residence, the garden is more truly an oasis with olive trees, date palms, pools, and the sound of running water. In honor of the king's visit, a fountain there was filled to overflowing with rose blossoms. It remains the single most opulent garden image I've seen, and was good preparation for being in the artistic atmosphere of the Jardin Majorelle.

Originally built by the Art Nouveau ceramist Louis Majorelle, the garden is the opposite of the austere Medersa. In his bold plantings and brilliant colors, Majorelle seems to have taken strength from the desert itself, confidently bending its heat and light to his imaginative uses.

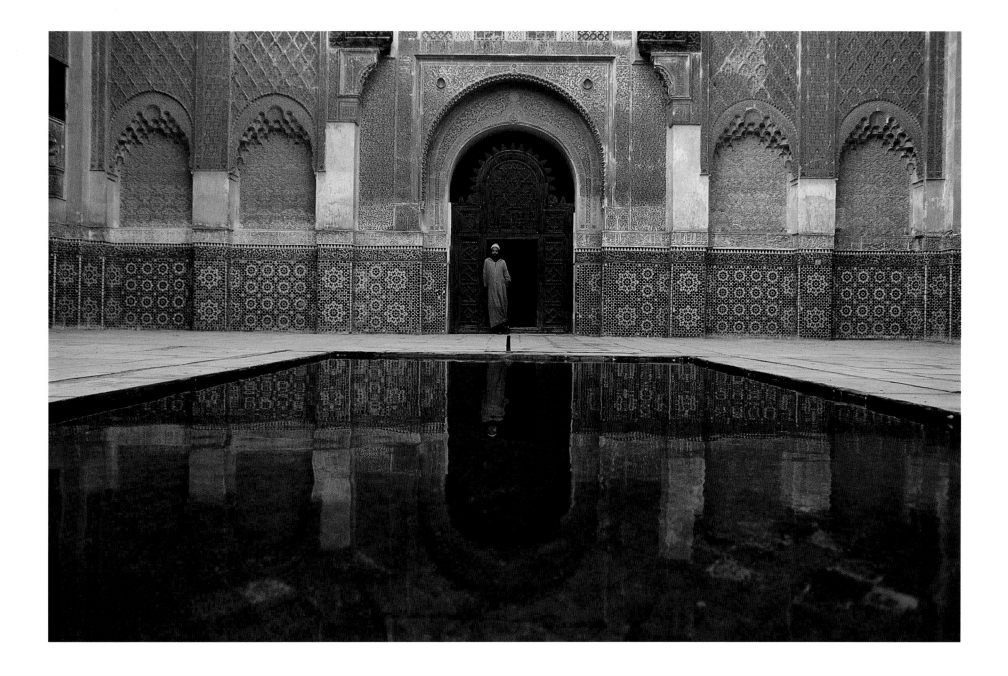

MEDERSA BEN YOUSSEF

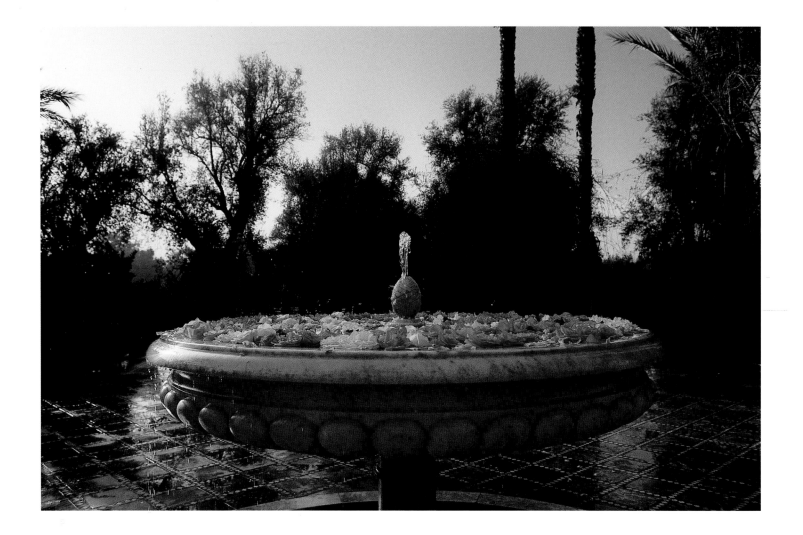

COURTYARD, HOTEL LA MAMOUNIA

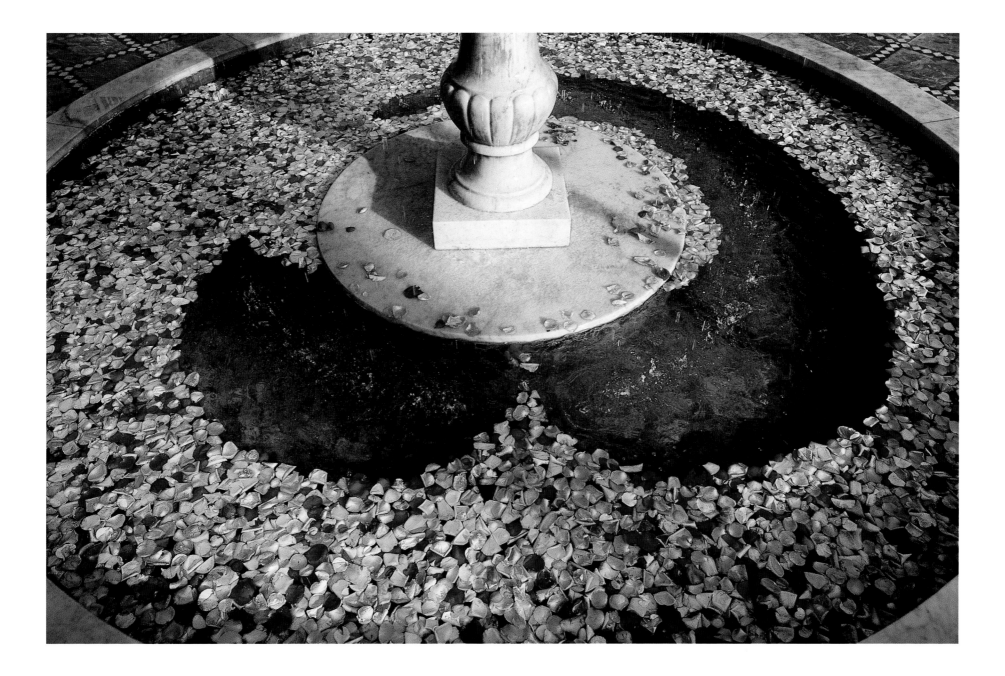

HOTEL LA MAMOUNIA (DETAIL)

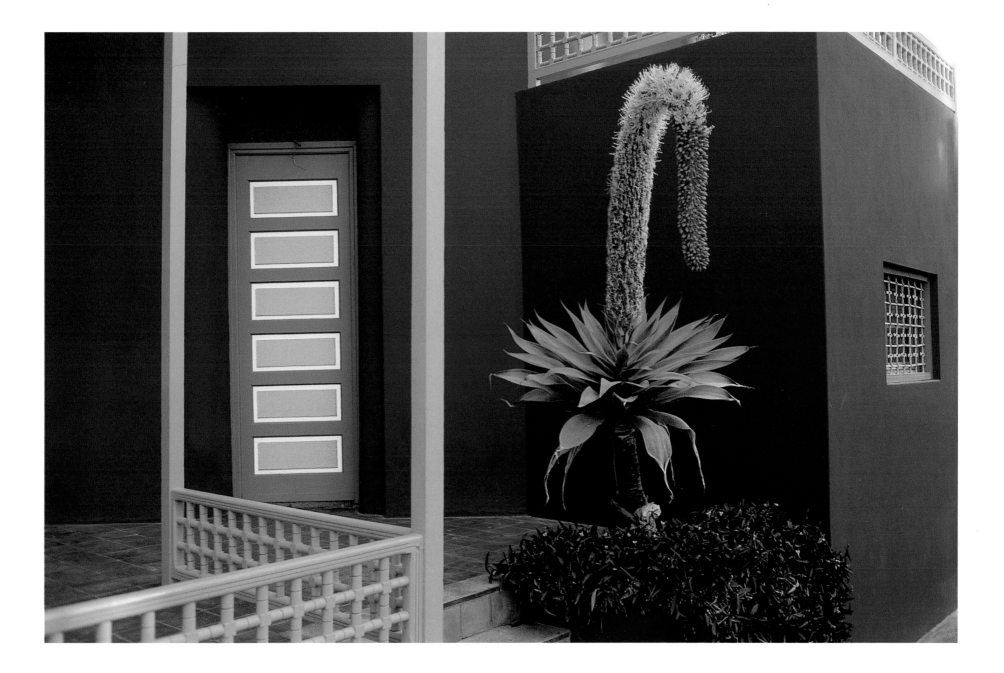

JARDIN MAJORELLE

Sunlight filtering through trees is an animating force in the garden. In breezes the light moves across the surface of walls, adds pattern to paths, and refracts off water.

Oasis gardens take advantage of this animation. The intense desert sun reaches the floor of the garden only after passing through layers of date palm leaves, bamboo, and succulents. By the time light reaches this cool green pavilion, its heat has been taken. Only its sparkling liveliness remains.

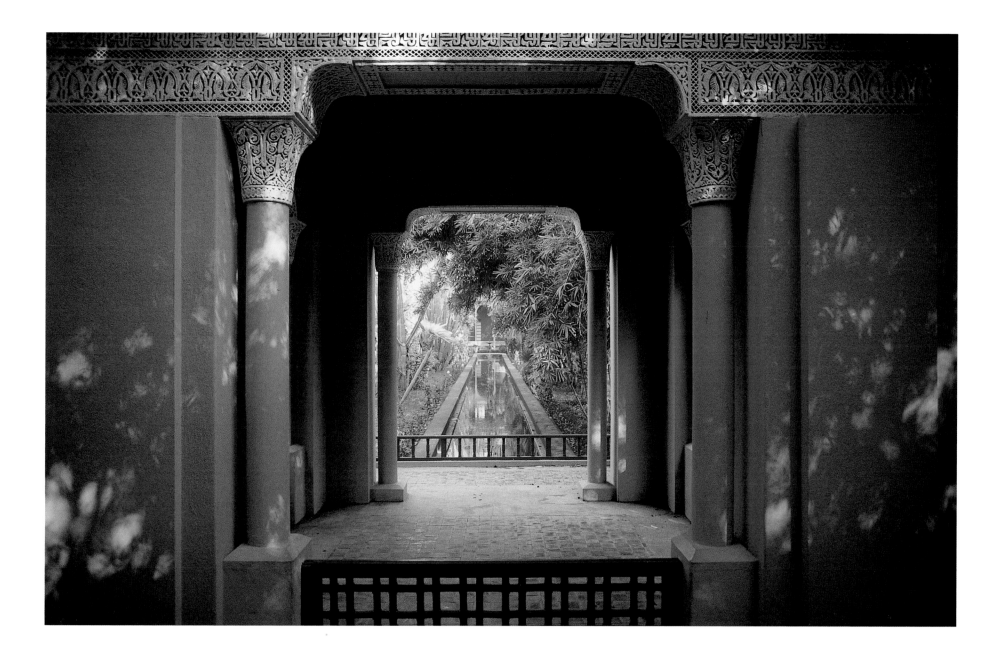

JARDIN MAJORELLE

IN AMERICAN GARDENS

SEATTLE, WASHINGTON

AMONG OTHER THINGS gardens are a calendar of the seasons. And in our town in northernmost Ohio, gardens were also connected to the calendar of life in America. On Memorial Day we wore poppies and took peonies to the cemetery. On the Fourth of July watermelons from the garden were eaten at the picnic table. In August blue ribbons were given at the fair to the finest harvest of the whole county. And the final flowers of the year, chrysanthemums, were worn at fall Homecoming. It was always the same, every year, and in every garden but ours.

My father made our garden different. He never knew life without a garden. He grew up alone with his mother on a small farm in rural Kentucky where he was the gardener. The garden fed both of them in the summer, and in the fall they dried, canned, and pickled produce for winter.

He never forgot that southern garden and each summer planted something from it in our northern garden. One year it was cotton, another year peanuts; another it was Kentucky Wonder Beans. But the best year was when he grew tobacco. Over the winter it cured in the chicken coop, and when it was ripe we sat in the garden and smoked it.

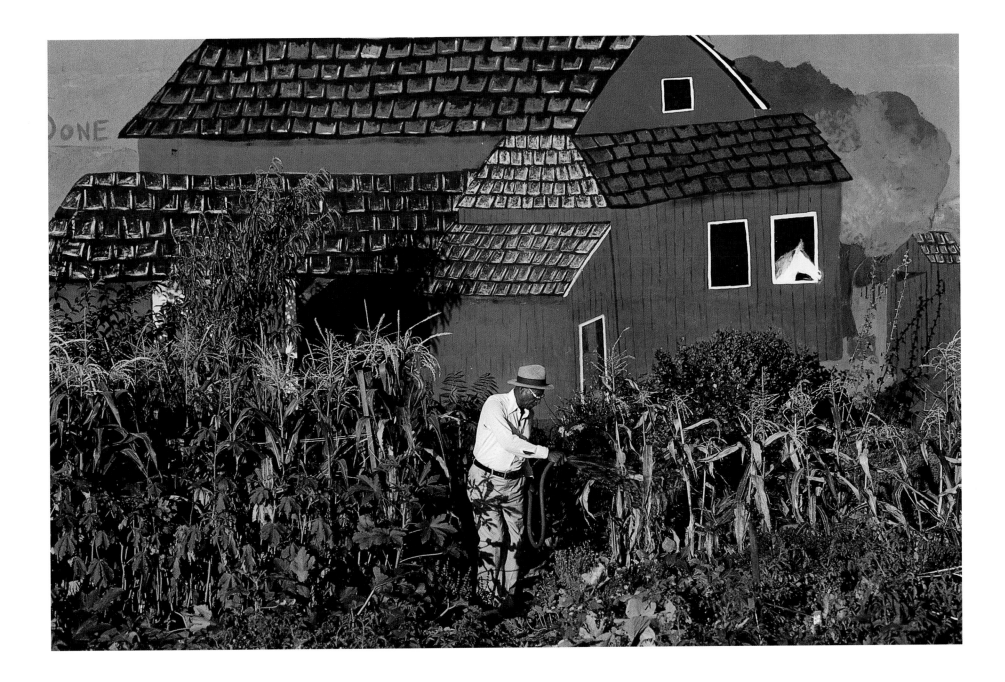

ASPEN FARMS, WEST PHILADELPHIA, PENNSYLVANIA

SUNFLOWER AND SPIDER, PORT TOWNSEND, WASHINGTON

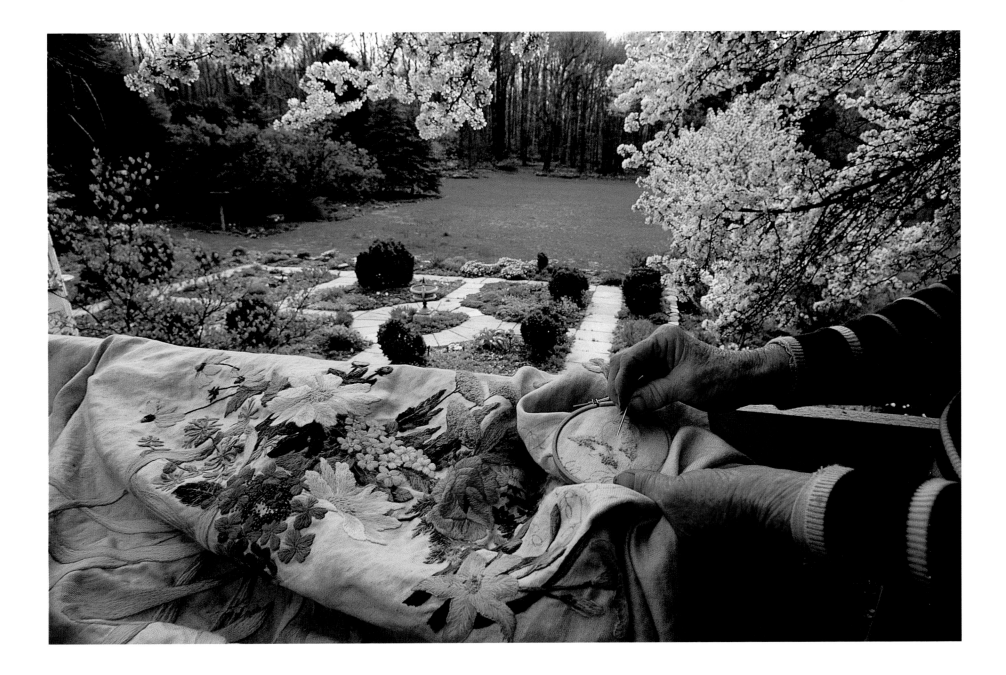

JOANNA REED, MALVERN, PENNSYLVANIA

PERUVIAN BLUE POTATO, ED DUTTON FARM, IDAHO

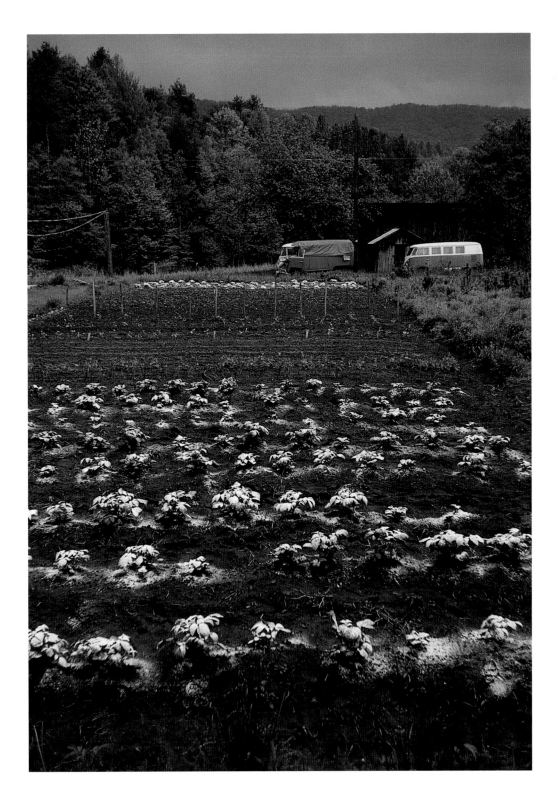

SHENANDOAH VALLEY, VIRGINIA

Gardening reminds me of other gardeners. When I'm in the garden I think of my father and of the thoughts of writers Henry Mitchell and Eleanor Perényi. I also think of my friend Doug Gosling.

For 25 years he's been gardener, teacher, and garden manager at the same place, now named the Occidental Arts and Ecology Center. The renowned beauty of the one-and-a-half-acre garden and orchard flows from this philosophy: Plant vegetables, flowers, and fruits together in such a way that the garden will teach visitors the lessons of preserving biodiversity, primarily through the saving and growing of heirloom and ancient seeds.

The garden has, in one form or another, more than 3,000 plants, seeds, and fruits in it. So prolific is the garden that at times it seems as if everything is in bloom at once.

If that were so, it would be because of the garden soil. For 26 years it has been "farmed" with hand tools. So deeply rich in organic matter is the soil that visitors would have to plunge their arms far into the raised garden beds before touching bottom.

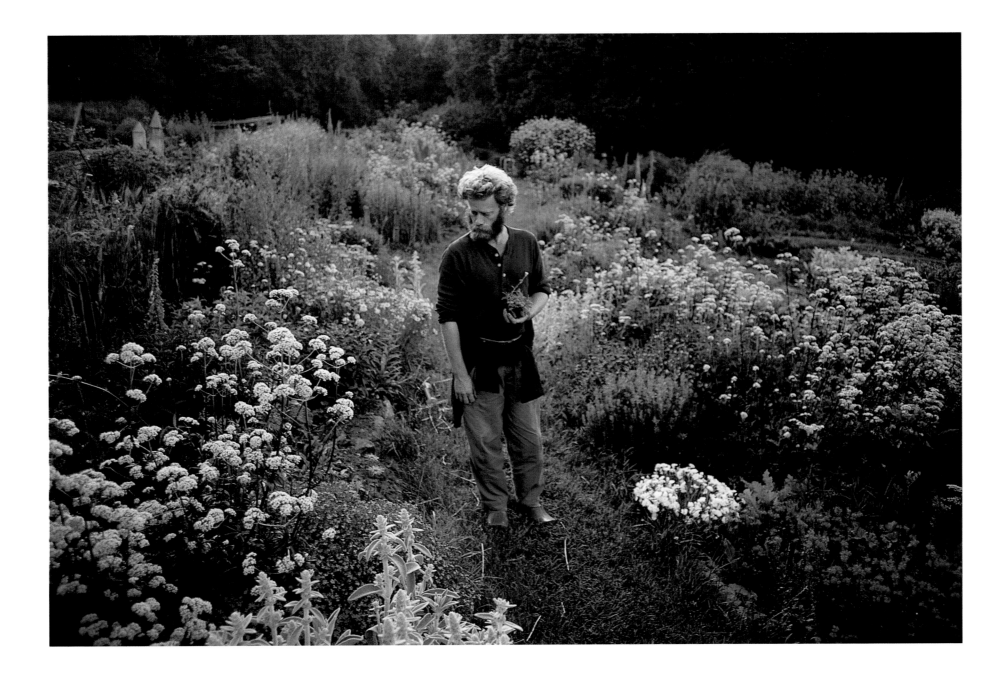

DOUG GOSLING, OCCIDENTAL, CALIFORNIA

GREENHOUSE GARDENS

CHELSEA PHYSIC GARDEN

In summer the northern landscape of my youth was softened by heavily tasseled corn that went in regular rows to a level horizon blurred by waves of heat.

In winter that horizon hardened. Farms became frozen fields of mud and stubble. The polar cold seemed personal.

There were compensations though, and one of the best was to step inside Fitkin's Greenhouse in December to select a poinsettia. It was always a pleasant shock to go from the cold gray monochrome of winter into the colorful warmth of that greenhouse. Just before my glasses steamed over, I saw what we had come for: hundreds of perfect red poinsettias disappearing into the distance. Somehow one of these would be more ideal than any other, and while my mother worked on this pleasant problem with her friend Marge, my brother and I explored.

Ever since then I've sought out the edges and outbuildings of gardens and gone into every greenhouse I could. Even empty ones are interesting. The reason is the soft, wrapping light and the way glass houses, by half separation from the world, create a secluded, sheltering atmosphere—not only for plants but also for people.

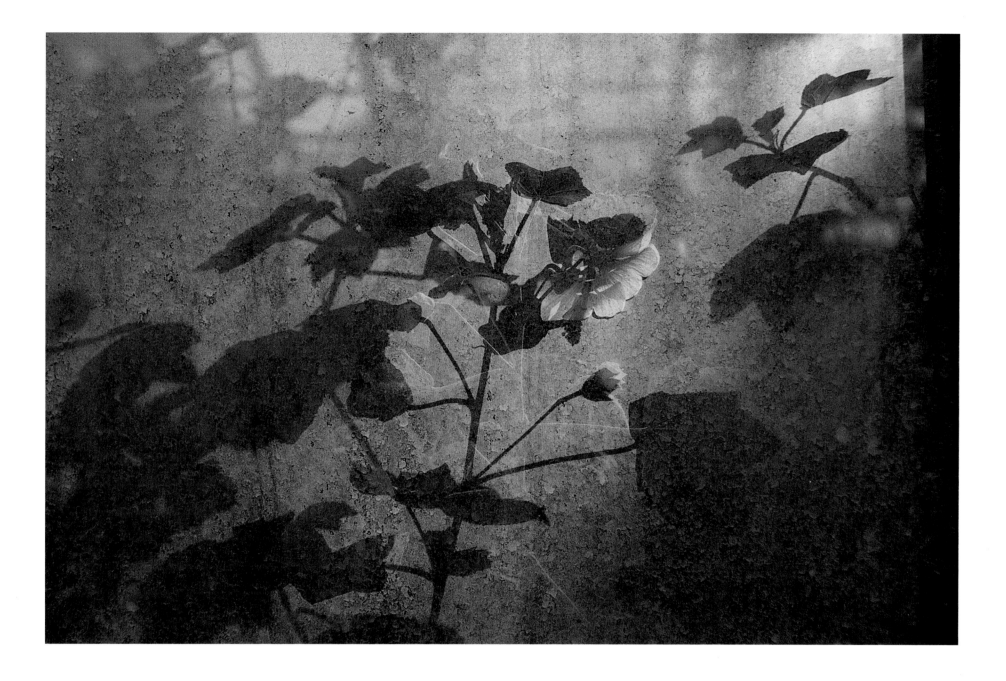

ROSE MALLOW, CHELSEA PHYSIC GARDEN, LONDON

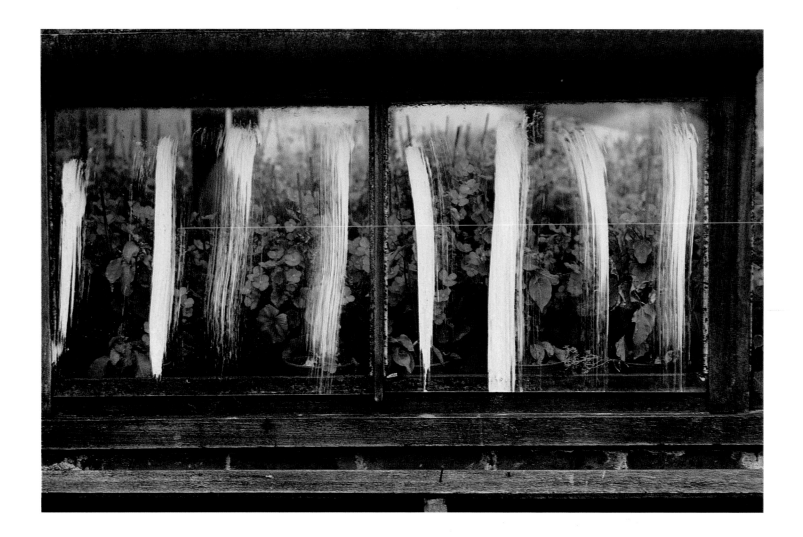

KENT, ENGLAND

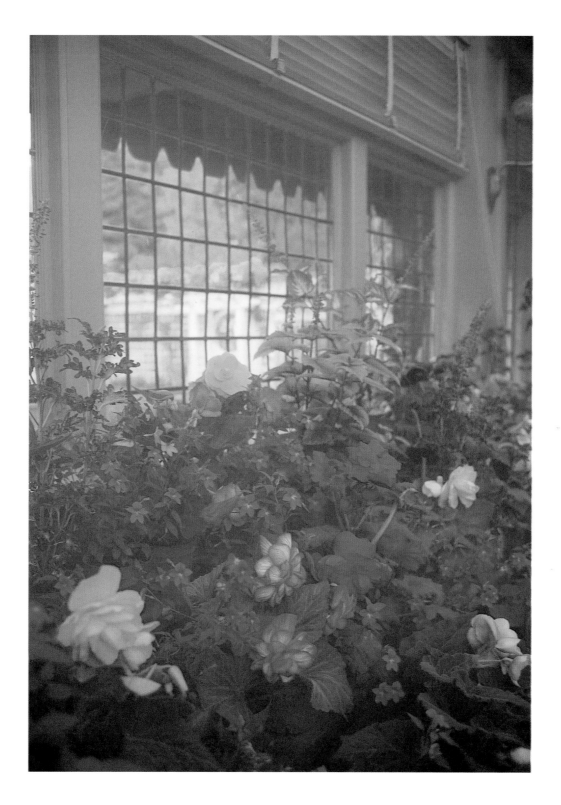

BUTCHART GARDEN, VICTORIA, BRITISH COLUMBIA

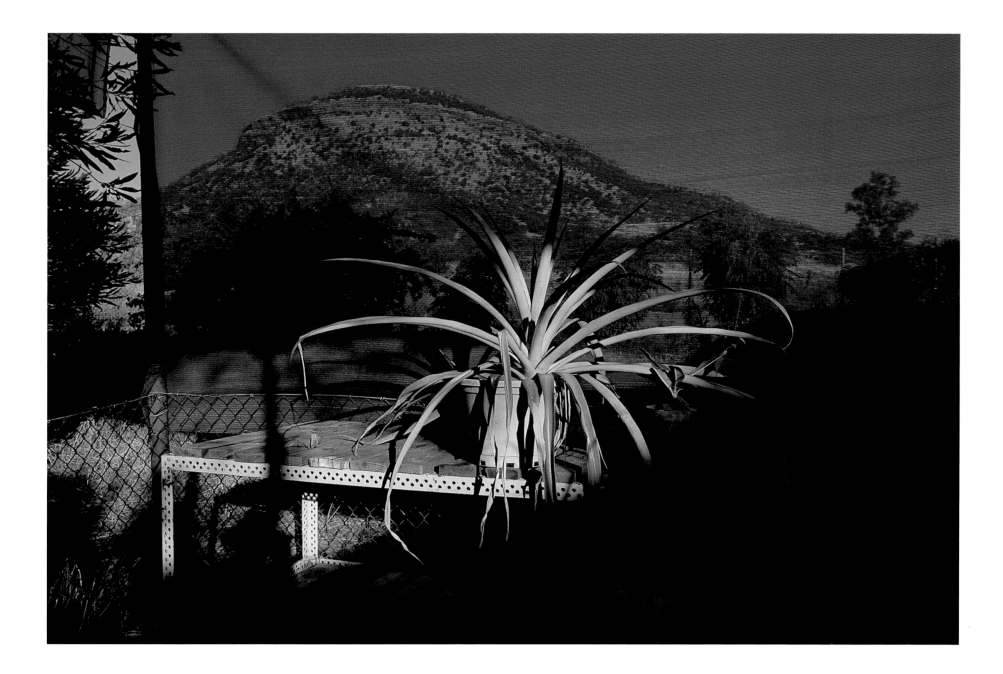

WYNDHAM, WESTERN AUSTRALIA

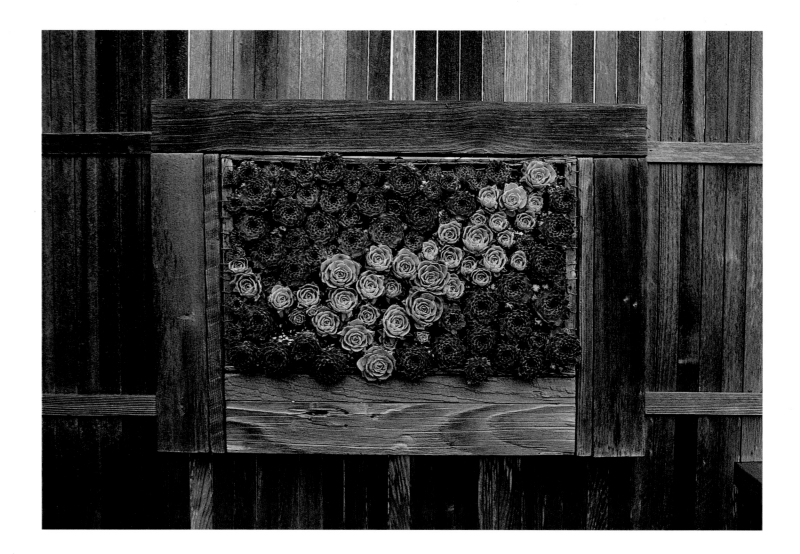

HANNELI REEVES GARDEN, MENDOCINO, CALIFORNIA

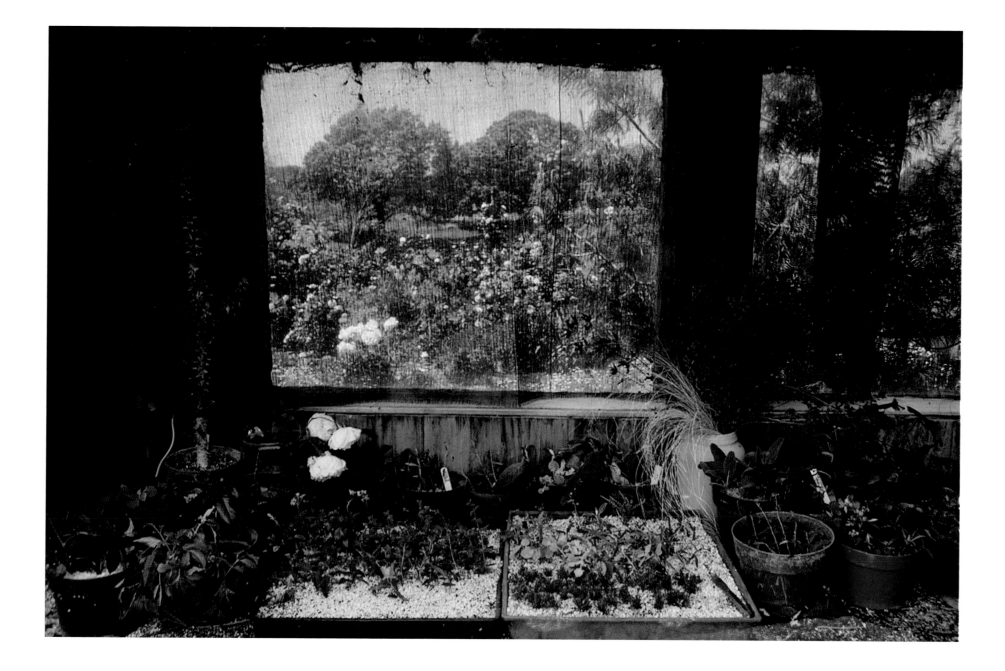

SANTA ROSA, CALIFORNIA

The first greenhouse I photographed was this one, in 1977. It was plastic. I couldn't get over that. Compared to glass, plastic seemed so insubstantial. I wondered if it would last, but now I see plastic greenhouses all over the world.

To me what mattered was that the plastic was as visually interesting as glass greenhouses had been. I like pictures where there is a degree of displacement. Is the photograph made from inside looking out, or the reverse?

The atmosphere inside this greenhouse was relaxed. The place was still under construction, but a farmer was already using the trapped warmth to ripen tomatoes placed on a plank. The outside was also warm. Weeds pressed against the plastic while in the distance clouds passed by.

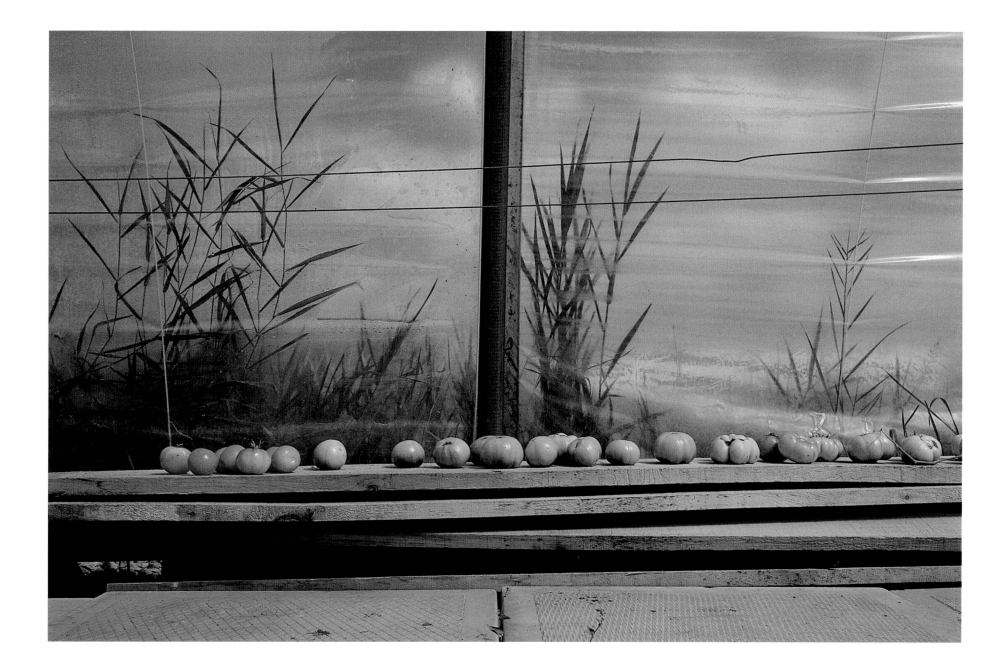

KITCHENER, ONTARIO, CANADA

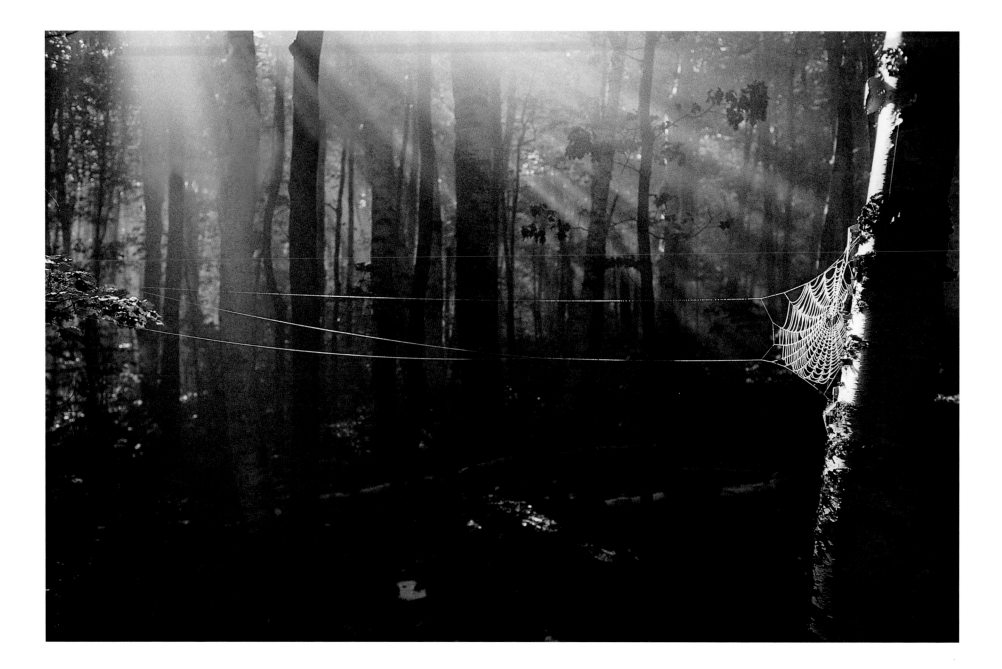

APPALACHIAN TRAIL, VERMONT

WILD GARDENS

IT TOOK LEAVING HOME for summer camp in Michigan, when I was ten, to open my eyes to gardens in the wild. The camp was a small but complete world, with sandy paths, old oak forests, a silent lake, strong stone buildings, and places with straightforward names: Pine Circle, Long Lake, Sunset Hill.

There was a northern optimism to those Augusts away from home. At camp I first slid a wooden canoe onto still water, saw the last sparks from a campfire disappear into the night, and learned that the moon casts enough light to walk by.

It was arcadian. And nature became the subject of my first sustained photography. The camp is gone now, developed out of existence. Often I think that a lifetime of wilderness travel has been a search to find, and replace, that lost summer camp of my youth.

Only its ideals remain. Among other things, summers at camp taught me to see the character of a particular place. To me that character is often garden-like. Now I find gardens not only in settled society but also in forests and swamps, arctic lakes, and desert snowstorms. The more austere a landscape and the further it is from traditional garden imagery, the more intriguing the search for its character becomes.

Gardens exist in nature's smallest scale. They are also visible from afar. And we have learned that farthest from home—from space—the Earth itself composes a color picture. It is of a garden.

Appalachian Trail

MAINE

"The long green tunnel" is the name given the Appalachian Trail by through-hikers—those backpackers who attempt to walk the entire trail, Georgia to Maine, in one long summer. Calling the trail a tunnel is a complaint ("not enough views"), but calling it green is a compliment.

The AT is a 2,100-mile path through the dense wilderness of America's eastern mountains. Without the trail, hikers would have difficulty walking in the mountains: The plant life is too great. With the trail in place the forest opens up. In garden-design terms the Appalachian Trail is a classic, albeit long, stroll garden.

Hikers on ridges walk in rocky forests of skeletal trees and low lichens; in sheltered valleys the trail takes them through a terrarium of giant ferns and heavy mosses. At every elevation the forest floor presents a picture of growth and decay in the same composition.

From my home I can see the ridgeline of the Appalachian Mountains. It is early summer. The through-hikers are coming north, heads down, making miles. Their eyes are on the trail. It's a good view.

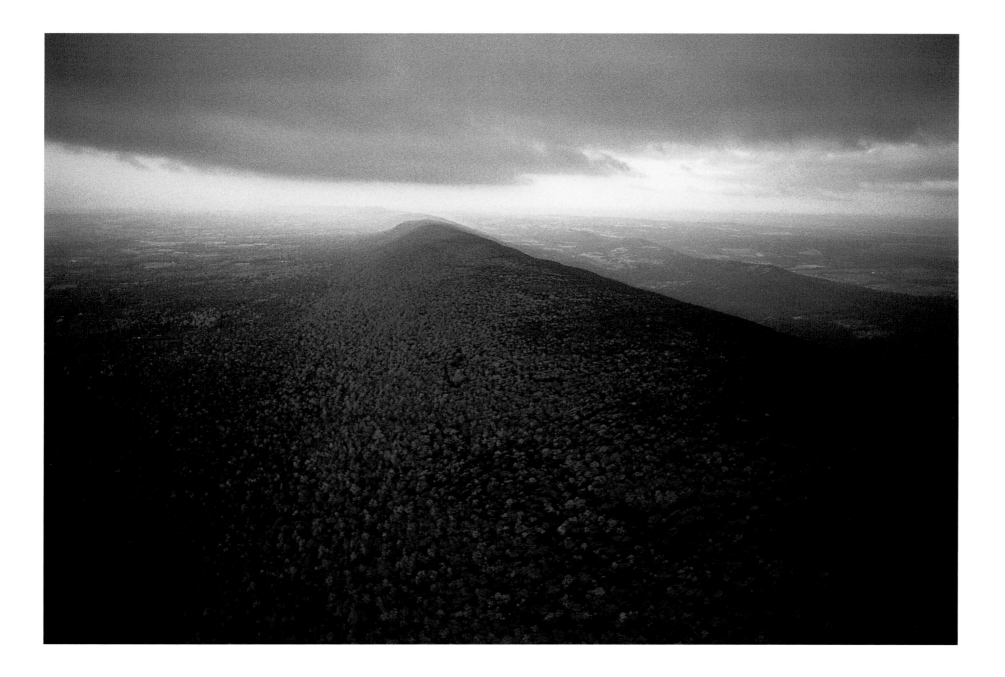

PENNSYLVANIA

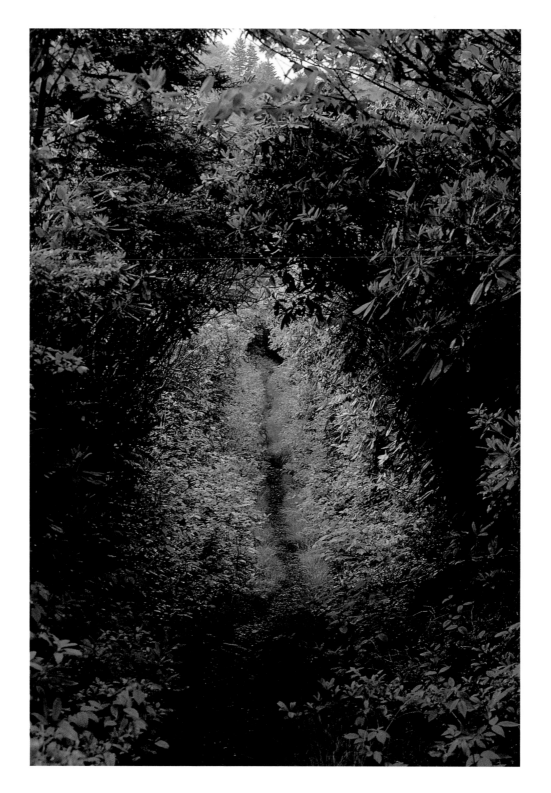

GREAT SMOKY MOUNTAINS, NORTH CAROLINA

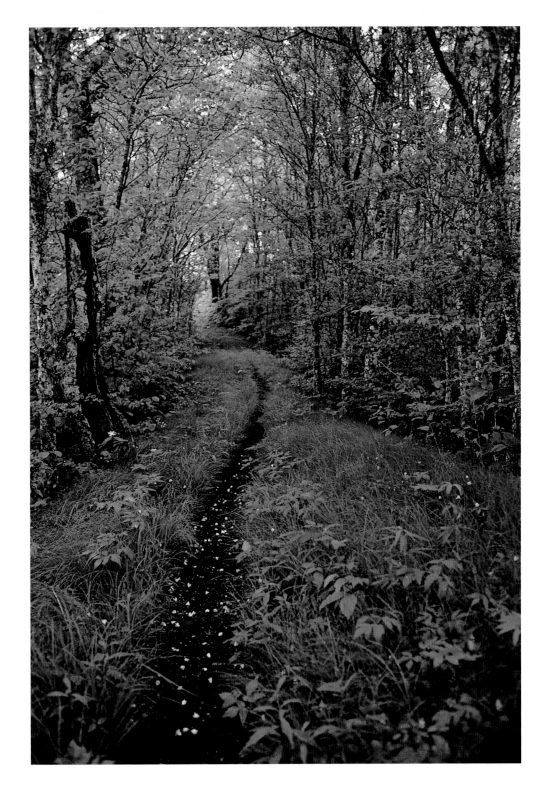

BLUE RIDGE MOUNTAINS, VIRGINIA

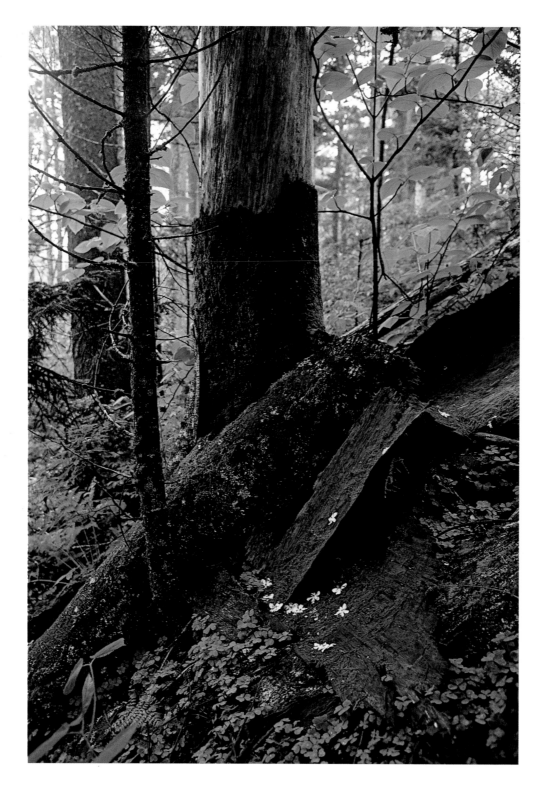

GREAT SMOKY MOUNTAINS, NORTH CAROLINA

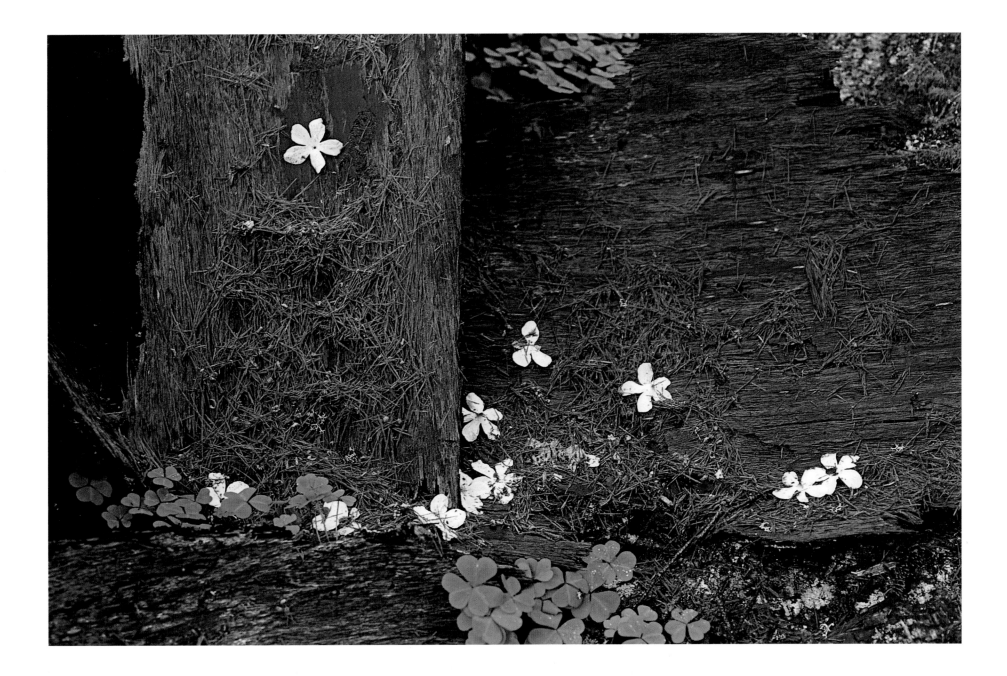

GREAT SMOKY MOUNTAINS (DETAIL)

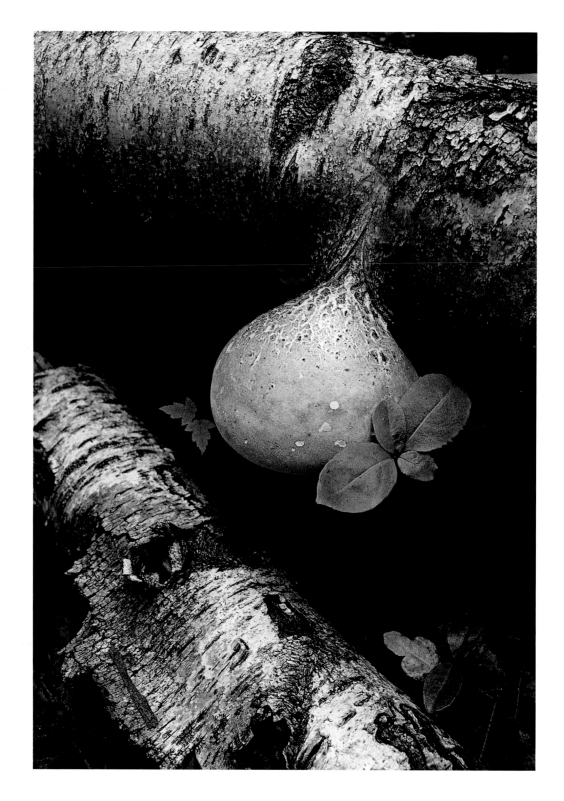

NEW HAMPSHIRE

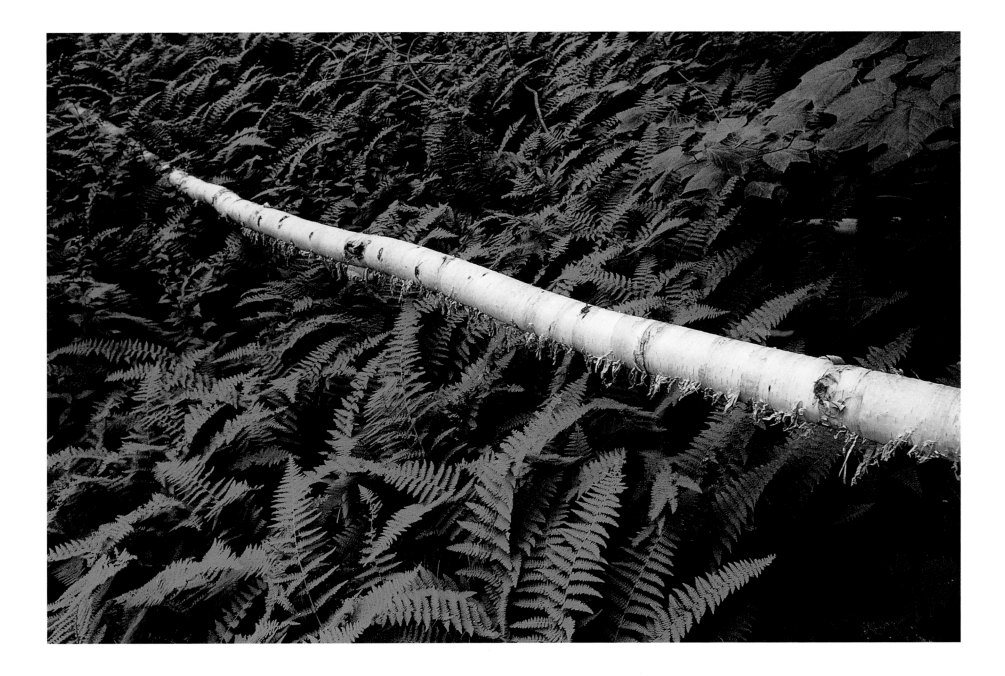

VERMONT

SANDSTONE GARDENS OF THE SOUTHWEST

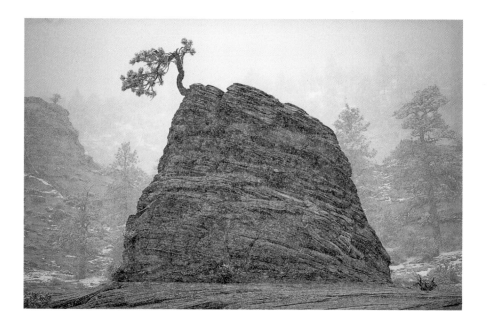

ZION NATIONAL PARK, UTAH

MY FIRST INDEPENDENT PHOTOGRAPHIC TRIP was to document a summer archaeological dig in Arizona. Because of the heat and oppressive light we were up and working at dawn and finished by noon. What made it bearable, and memorable, were the occasional storms and the sweet smell of sage that followed them. I thought then that the fragrance of living landscapes would recur often in my life, and it has, but not as strongly as on those mornings.

That summer gave me a taste for desert storms, and on subsequent trips to the Southwest I've sought them out. I've been particularly drawn to the canyons of Utah and Arizona because storms so change the look of this country. Water reddens the rock and gives a smooth varnish to the rough surface of sandstone. When the air is filled with snow and meltwater is running off slickrock, the still world seems set in motion.

The unabsorbed water streams off sandstone into runnels, pockets, crevices, and canyons. Wherever it runs freely, water gives to soft sedimentary rock the fluid lines of motion itself. Wherever the water pauses, plants root, trees take hold, and desert gardens grow, filling the air with fragrance.

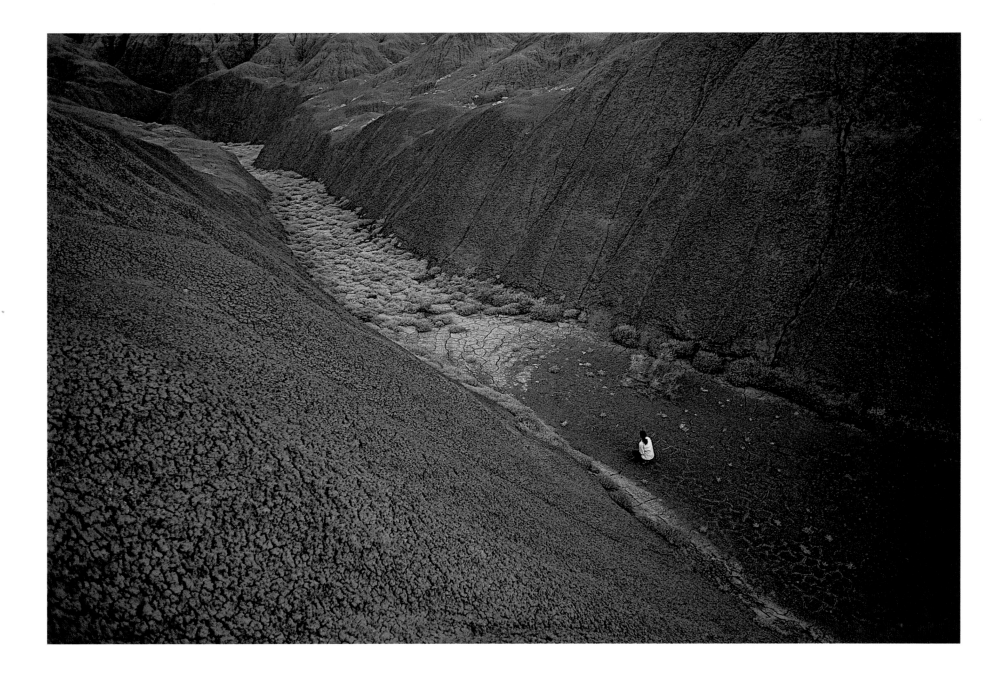

NAVAJO RESERVATION, ARIZONA

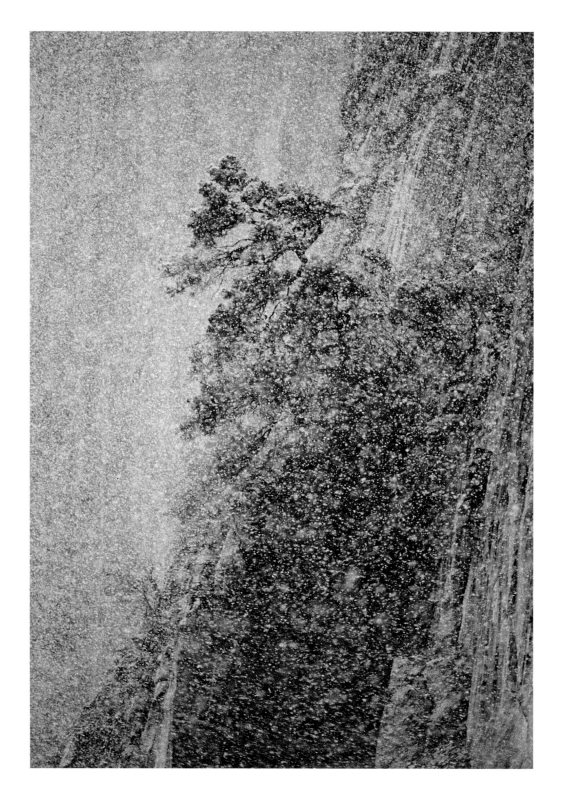

ZION NATIONAL PARK, UTAH

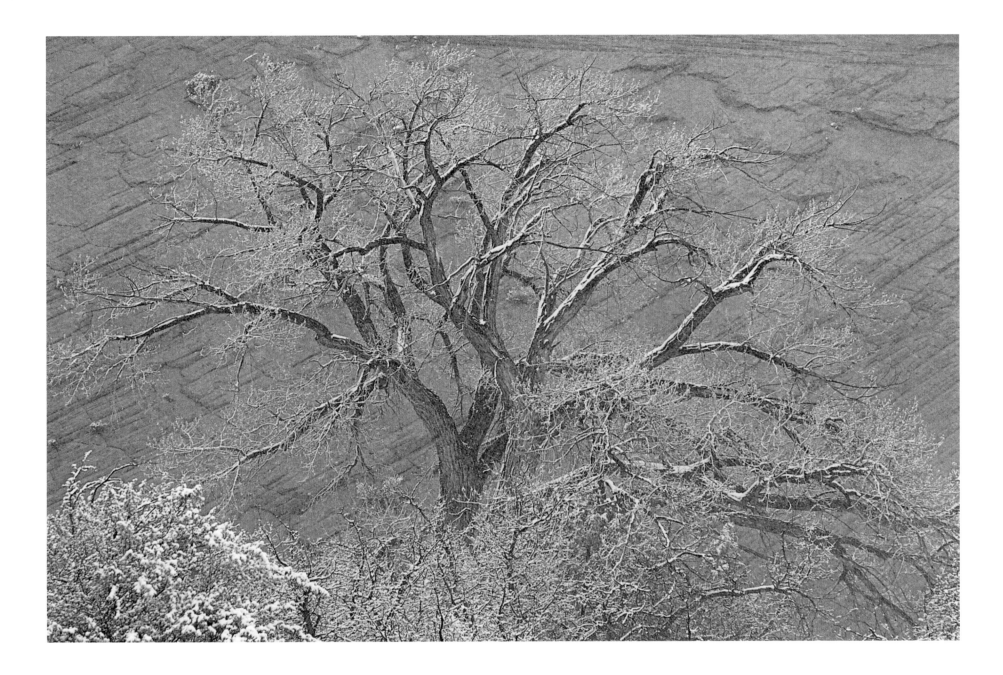

ZION NATIONAL PARK, UTAH

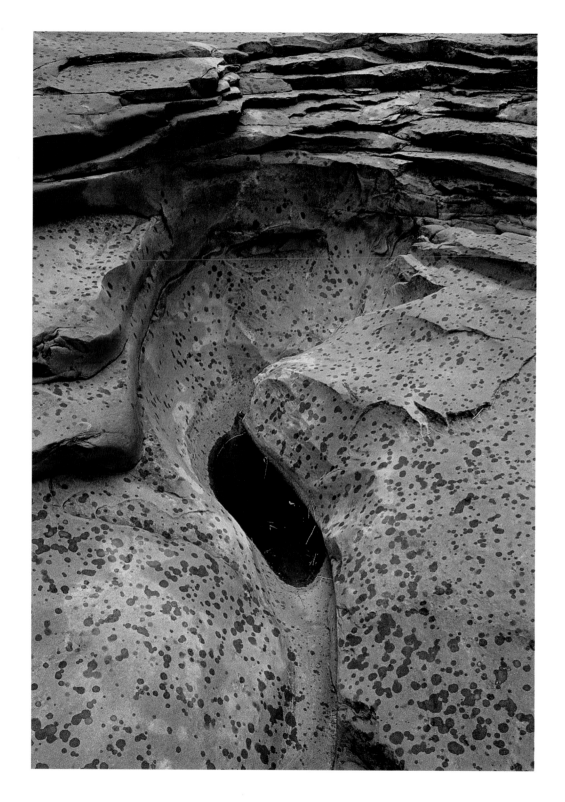

GRAND CANYON, ARIZONA

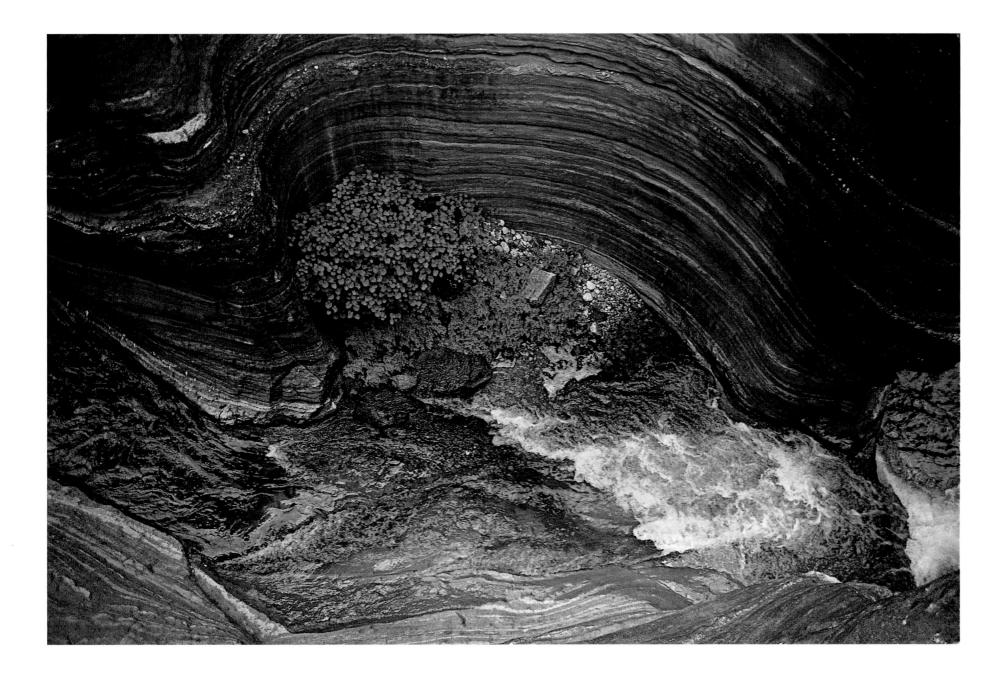

GRAND CANYON, ARIZONA

In 1963 Glen Canyon was flooded, drowning a little-known landscape of great beauty. Just before the dam was constructed, Elliot Porter documented the canyon in color photographs and published the results in an influential book, *The Place No One Knew*. I remember two things from the book: One, how the hard desert light was softened and warmed by bouncing off the canyon walls, and two, how the deep interior of Glen Canyon was an intimate and life-filled place. In his pictures were many small sculpted spaces, and within most of them were delicate gardens.

Years after seeing Porter's photographs, I floated the Colorado River. Some miles below the Glen Canyon Dam I made this photograph of a seep. It seemed like a small shrine and reminded me of Elliot Porter's life and work.

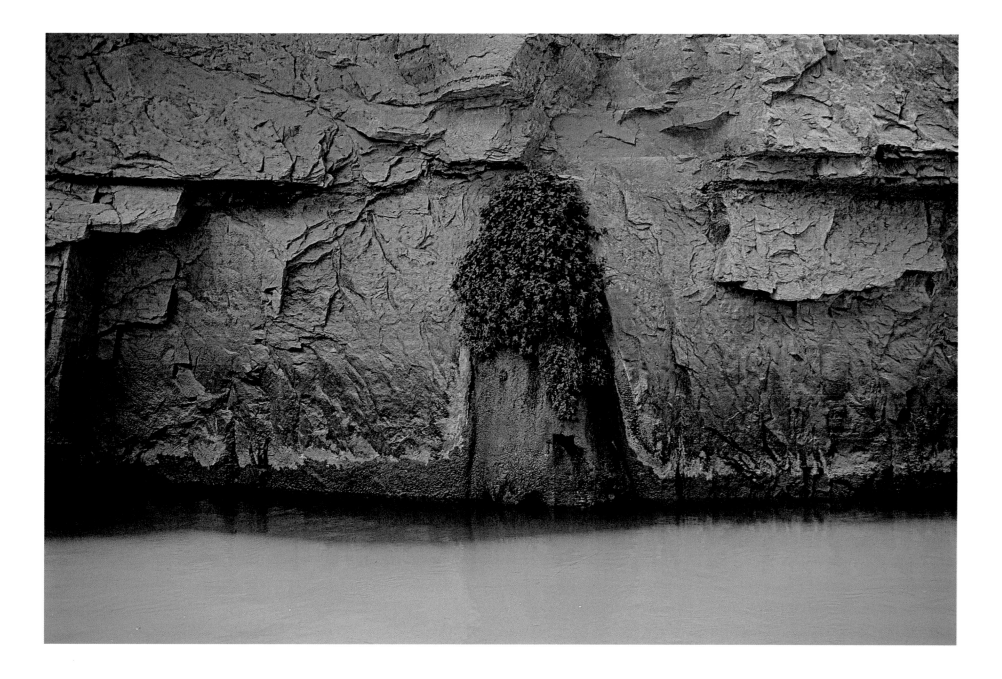

GRAND CANYON, ARIZONA

WATER GARDENS OF THE OKEFENOKEE

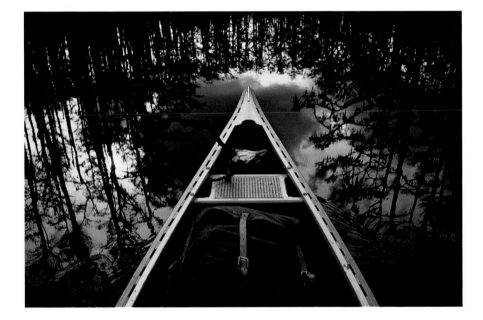

MINNIES LAKE

IF A GARDEN IS SUPPOSED TO REMOVE US from ordinary existence, then the wilderness of the Okefenokee Swamp, in Georgia and Florida, accomplishes this separation more surely than any garden I have ever entered.

Canoeing across the Okefenokee is to travel far back in biologic time to a world of plants and animals that seems disconnected from the known world. The experience of disconnection is deepened because Okefenokee is a blackwater swamp. Tannic acid from the dark peat floor of the swamp makes it so. In its inky water, reflections are almost perfectly mirror-like. Every aquatic plant, every flower, every cypress tree, and the eye of every alligator is doubled.

This world of inverted imagery cast a spell on me. A single water lily seen in sunshine seems paradoxically to be set in a starry night sky. Spent golden clubs declining into the swamp seem, in reflection, to look newly formed even though they are among the most ancient flowering plants on Earth.

In a canoe at the center of the swamp, it is possible not only to think that this is a garden but also to believe that from such settings the inspiration for all gardens arose.

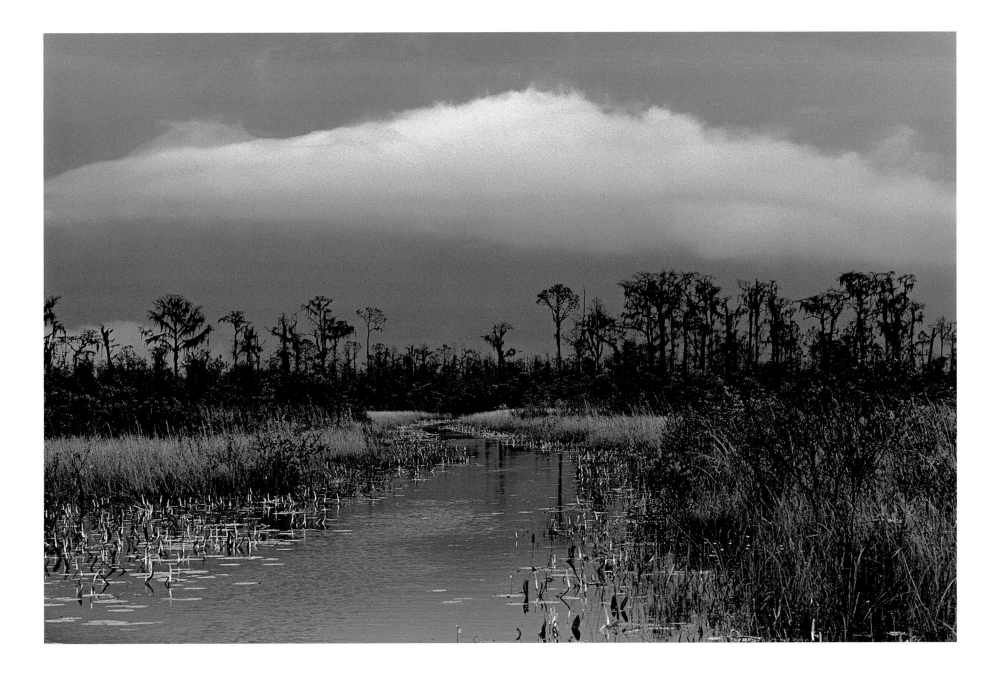

MAUL HAMMOCK LAKE

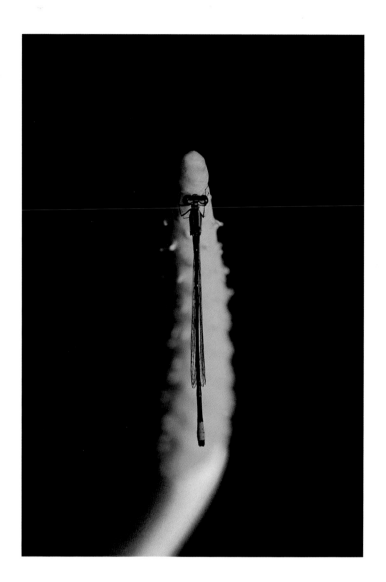

DRAGONFLY, MINNIES LAKE

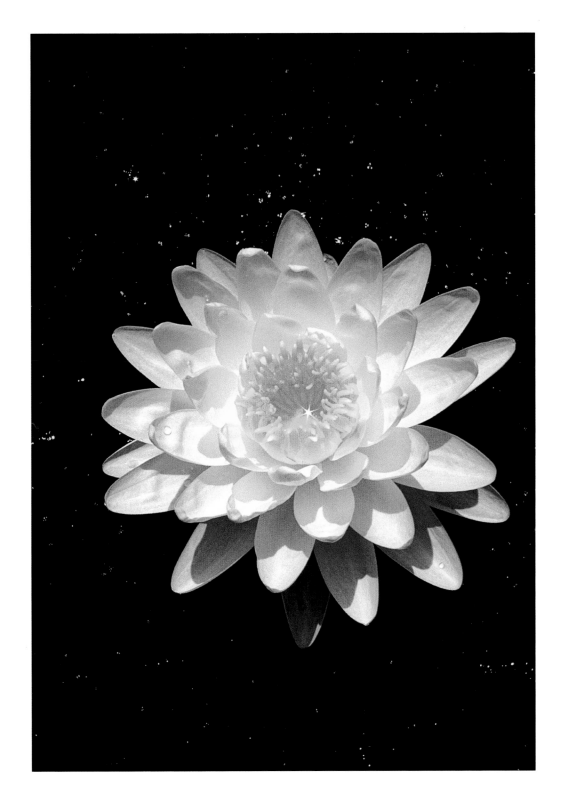

WATER LILY, MINNIES LAKE

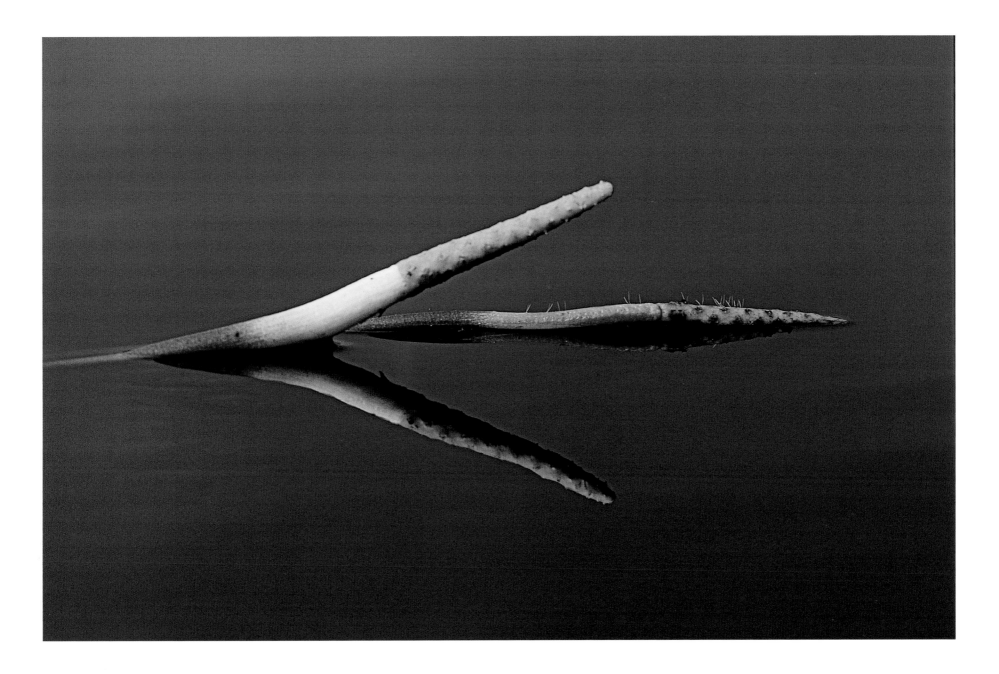

GOLDEN CLUB, MINNIES LAKE

The spell of Okefenokee is sustained by more than one can see. The quiet, surreal scenes of a humid summer day give way by evening to the mesmerizing, mingled sounds of frogs, insects, and alligators.

Only in winter is this chorus muted. Then the short day dims suddenly into a dark and disquieting stillness.

Apprehension wraps around the visitor who stays too long in the swamp and gets lost at night, as I once did.

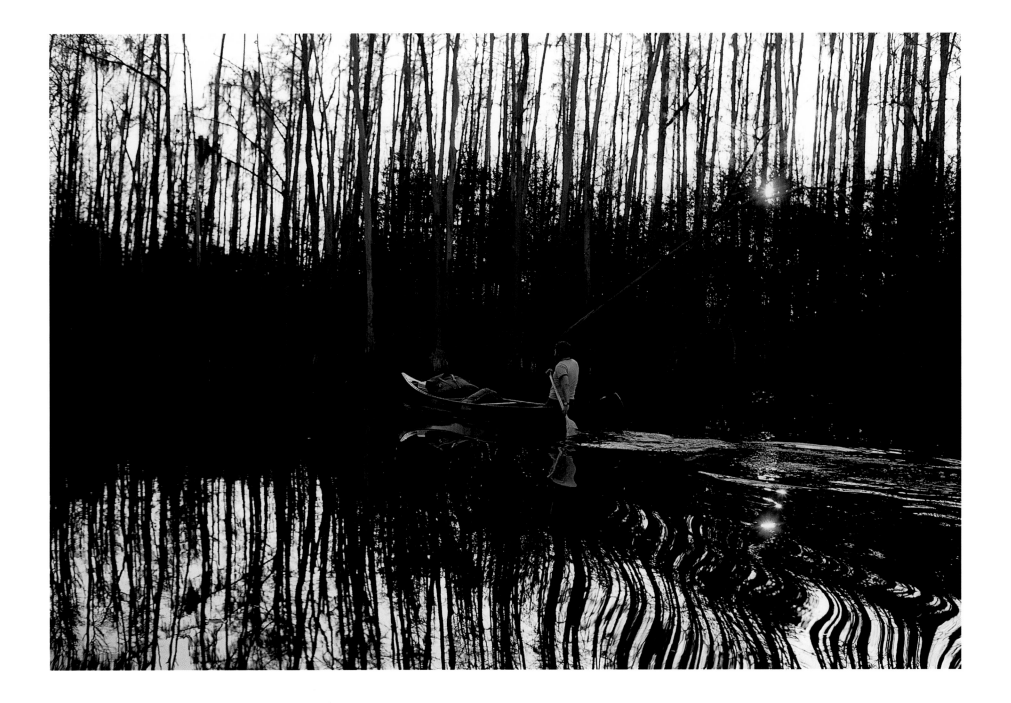

MINNIES LAKE

ARCTIC GARDENS

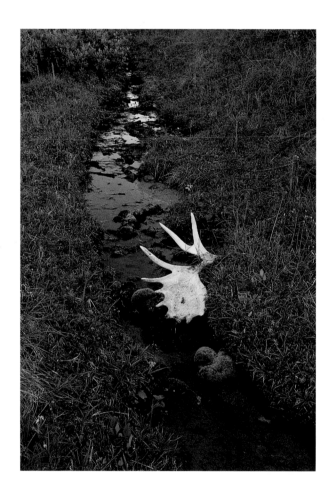

THE LOW, FAST-MOVING STORM was headed our way, but how far off was it? The clear air and treeless terrain of the Arctic made judging distances difficult.

From our perch on an isolated knoll the whole of the Arctic plain was visible, including our tiny tents in the path of the storm. My companions hiked down to secure things. I stayed behind to see the storm in.

Seeing storms in was not new to me, but seeing them on this scale was. Wilderness travel in the lower 48 states had not prepared me for the Arctic. Other wild places had boundaries or were cut up by roads and wires. But the Arctic was whole, undivided and borderless.

In summer, light from the never setting sun illuminates a vast and silent landscape. The effect is the rarest one in wilderness travel: unbroken immensity.

Within this immensity details stand out. An antler in moss, a patch of unmelted snow, a bouquet in mud, muddy tracks on a rock, a fallen tree, an approaching owl—all are emblems of the short, spare life in the Arctic garden.

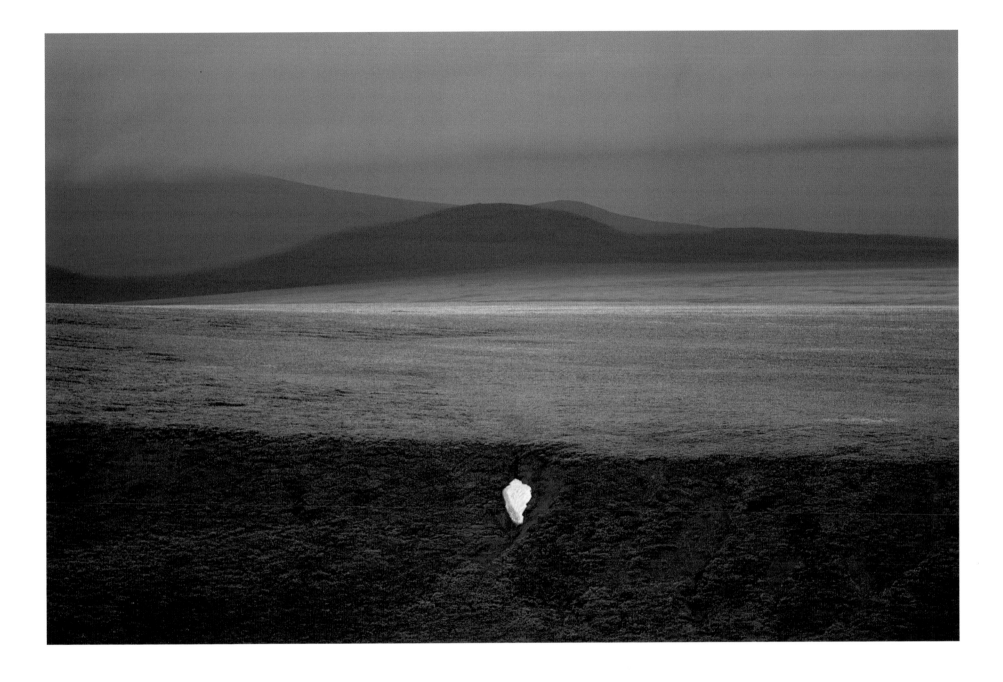

FIRTH RIVER VALLEY, YUKON TERRITORY

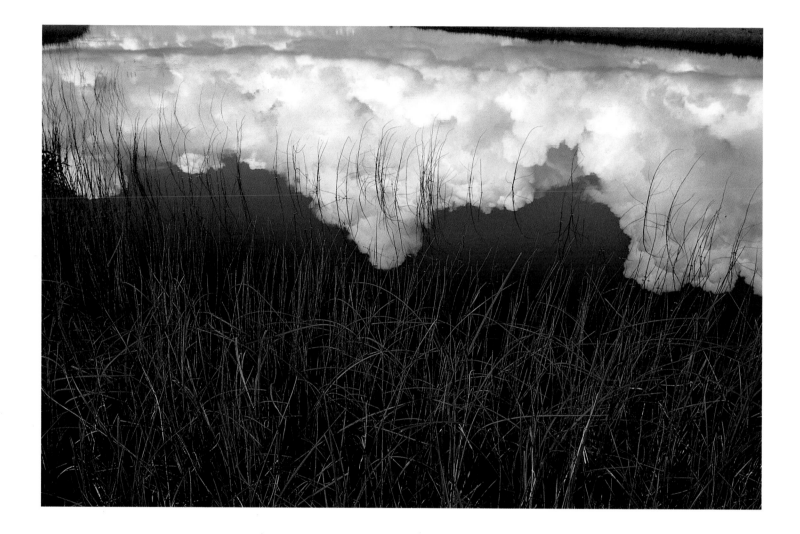

NOATAK RIVER VALLEY, ALASKA (DETAIL)

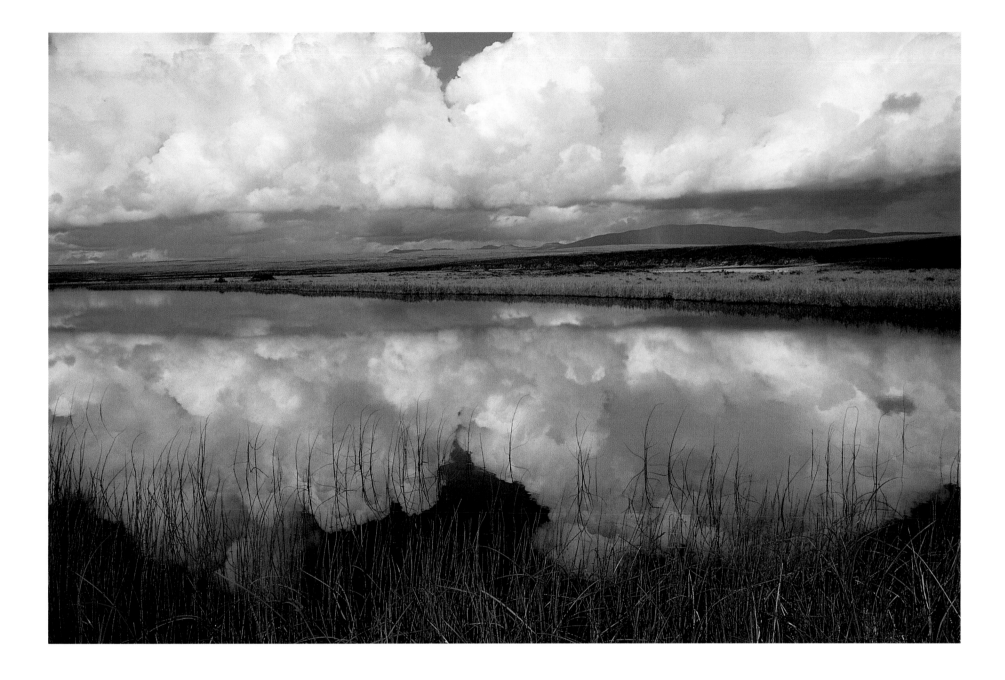

NOATAK RIVER VALLEY, ALASKA

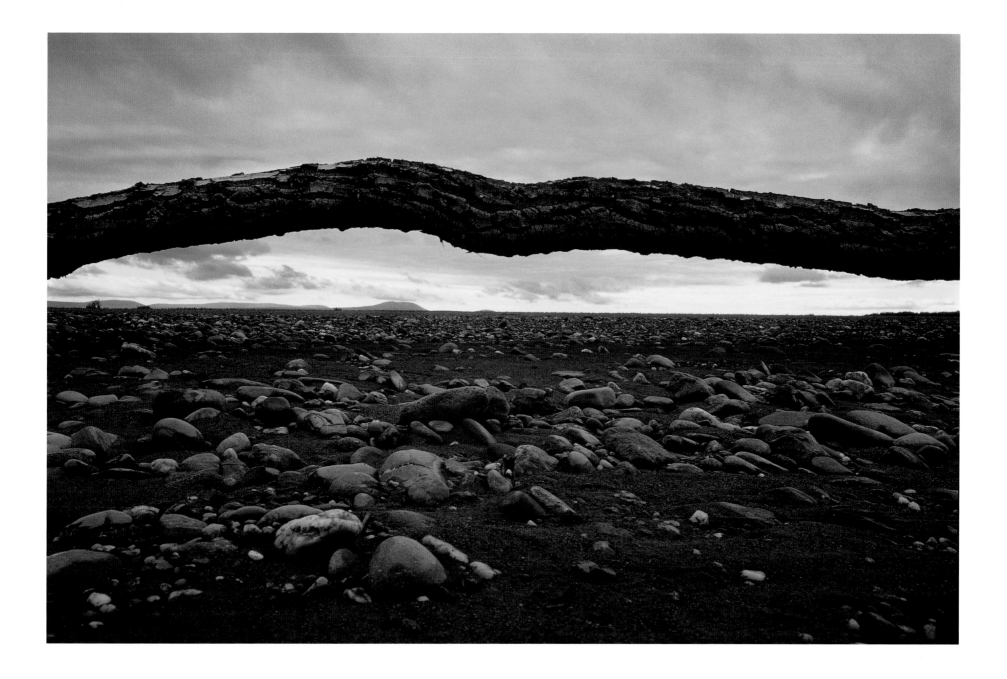

NOATAK RIVER DELTA, ALASKA

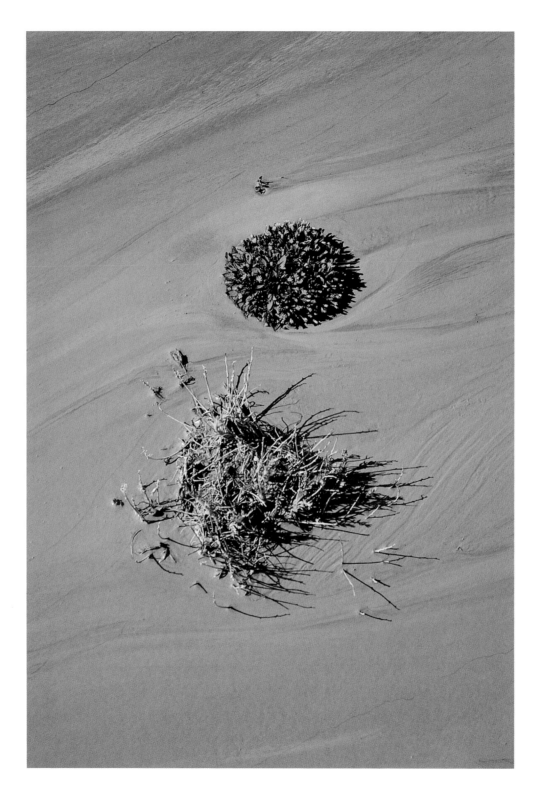

YUKON TERRITORY, CANADA

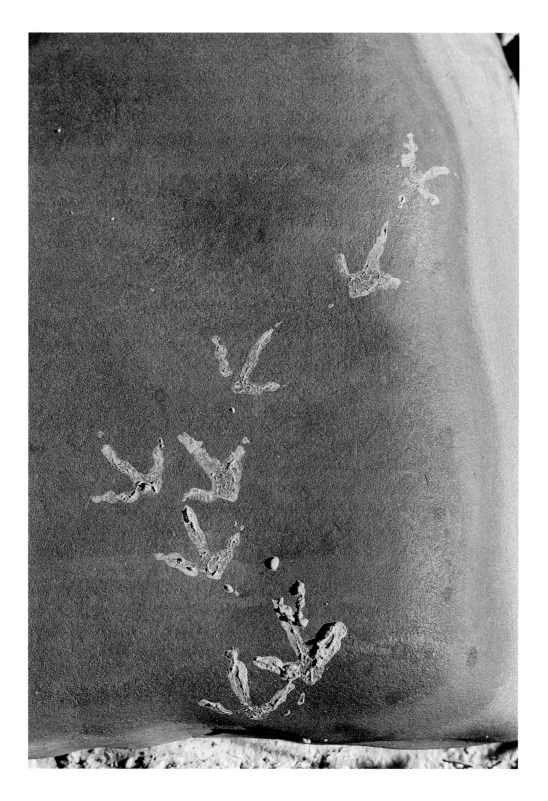

SANDHILL CRANE TRACKS, ALASKA

I lost my main cameras, lenses, and most of my film in a capsizing midway through a monthlong canoe trip in the Arctic. After that mishap only long solitary walks across the tundra raised my spirits.

The open tundra was consoling. Most of the low plants were new to me, but some I recognized from home. Here, though, they were miniaturized by the severe growing conditions.

I was thinking about this when an owl and I surprised each other. It flew up abruptly but then didn't fly off. Instead, it silently circled my head several times at close range. I didn't move until the owl flew away to the horizon.

When it returned, my camera was raised. I pressed the shutter as the owl rose over my head, taking on the shape, for a moment, of the bird that sits atop a totem pole.

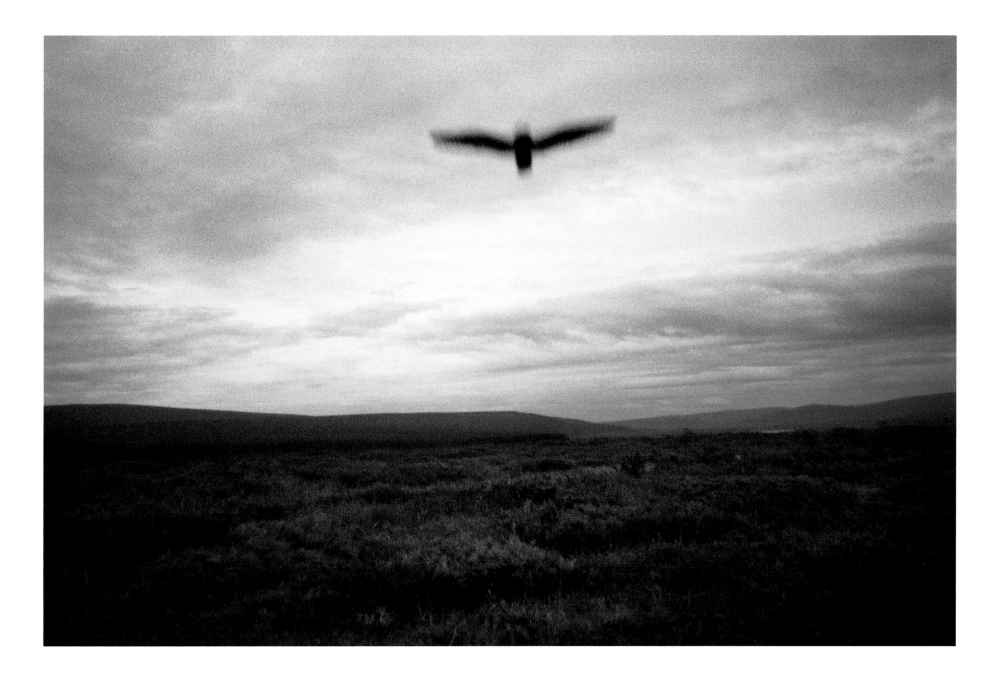

NOATAK RIVER VALLEY, ALASKA

RAIN FOREST GARDENS

ABANDONED ORCHARD, QUEEN CHARLOTTE ISLANDS

IN THE TEEMING SEA-LEVEL CLOUD FOREST of the North Pacific coast every niche seems to support life. The steady temperate rain creates almost perfect conditions for growth. The result is a roll call of the mightiest trees on Earth: redwood, Douglas fir, Sitka spruce, and the great all-purpose tree of the totem pole Indians, the western red cedar. These towering trees shelter a thick, complex plant community of mosses, fungi, ferns, and flowers.

Because of the almost impenetrable growth, Native Americans congregated on the coast and traveled, hunted, fished, and gathered food by boat. Kayaking is still the most intimate way to explore their cool, two-tone, watercolor realm of gray and green.

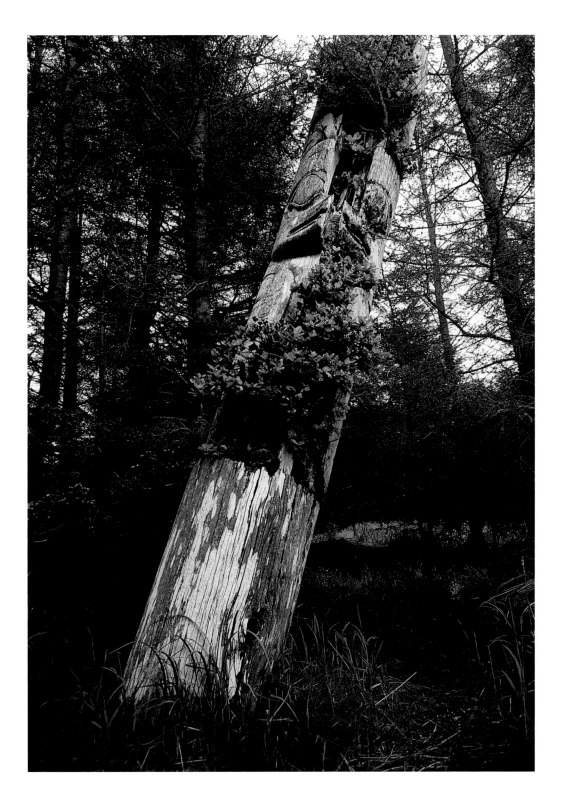

SKEDANS, QUEEN CHARLOTTE ISLANDS, CANADA

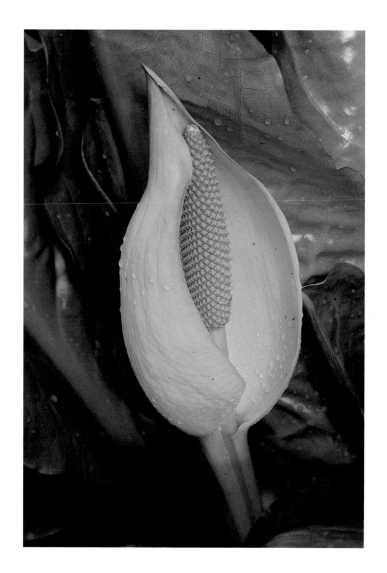

SKUNK CABBAGE, OLYMPIC PENINSULA

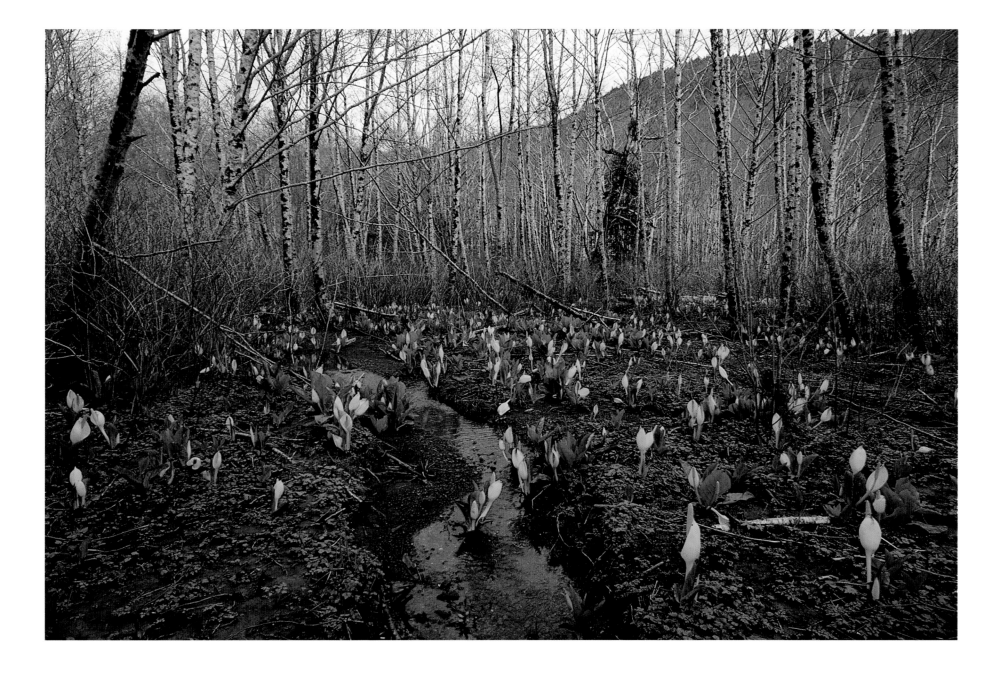

OLYMPIC PENINSULA, WASHINGTON

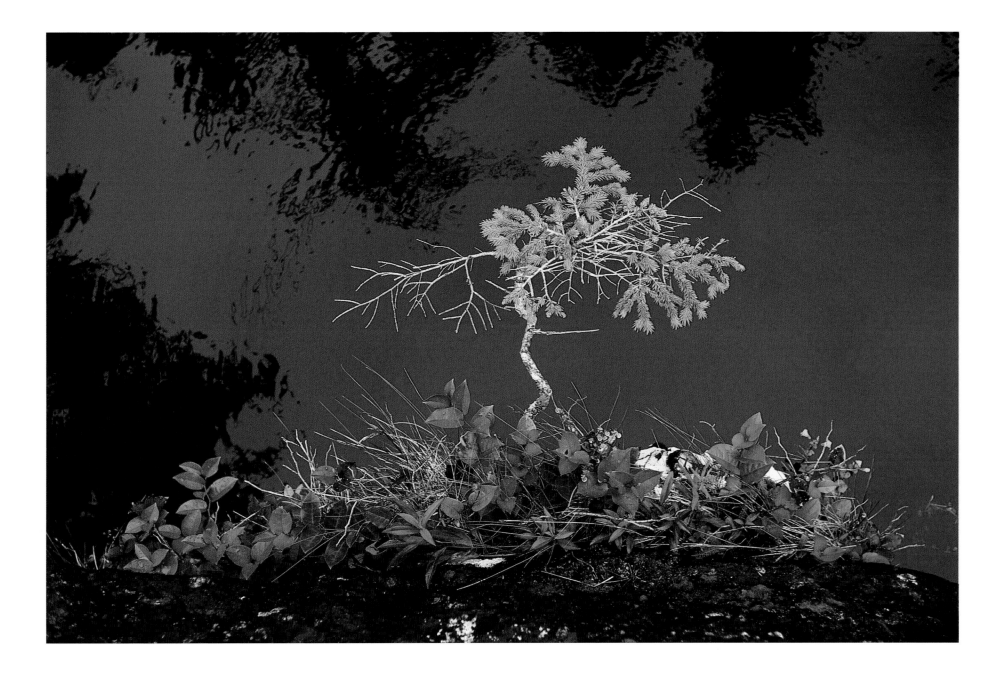

VANCOUVER ISLAND, BRITISH COLUMBIA, CANADA

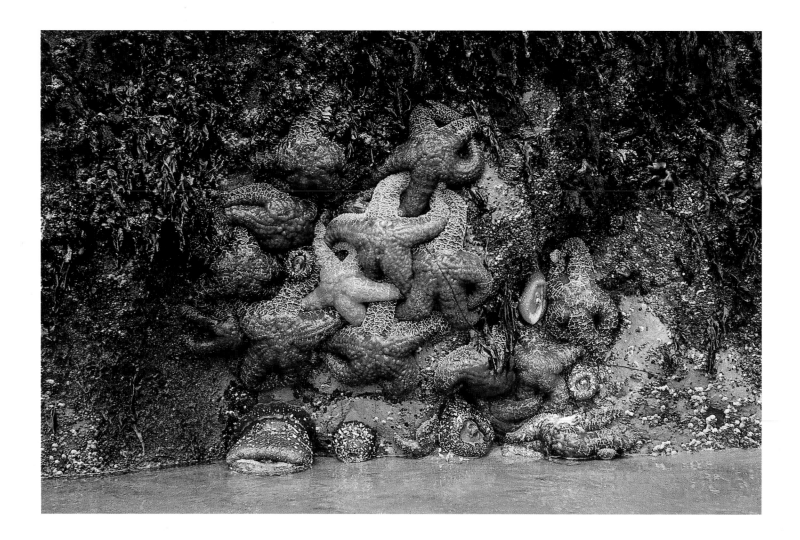

VANCOUVER ISLAND, BRITISH COLUMBIA

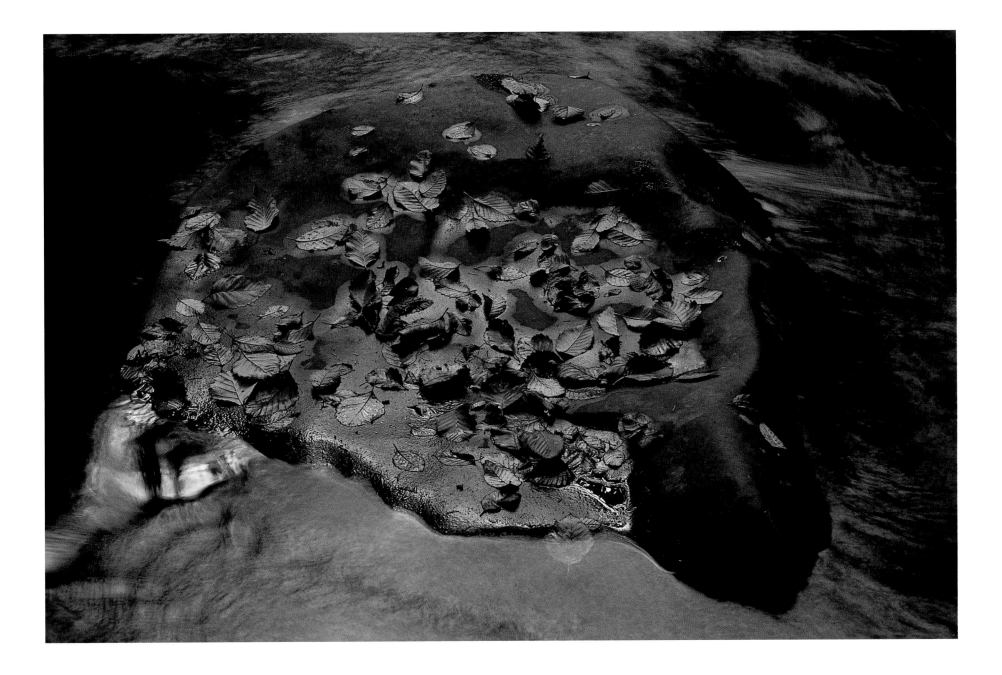

OLYMPIC PENINSULA, WASHINGTON

In the quiet rain and luminous light of this northern coast, plants grow on anything available or abandoned, even upon themselves. When the great trees fall their life isn't over. Their trunks become "nurse logs," nurturing the next generation of giants in their deep and mossy roots.

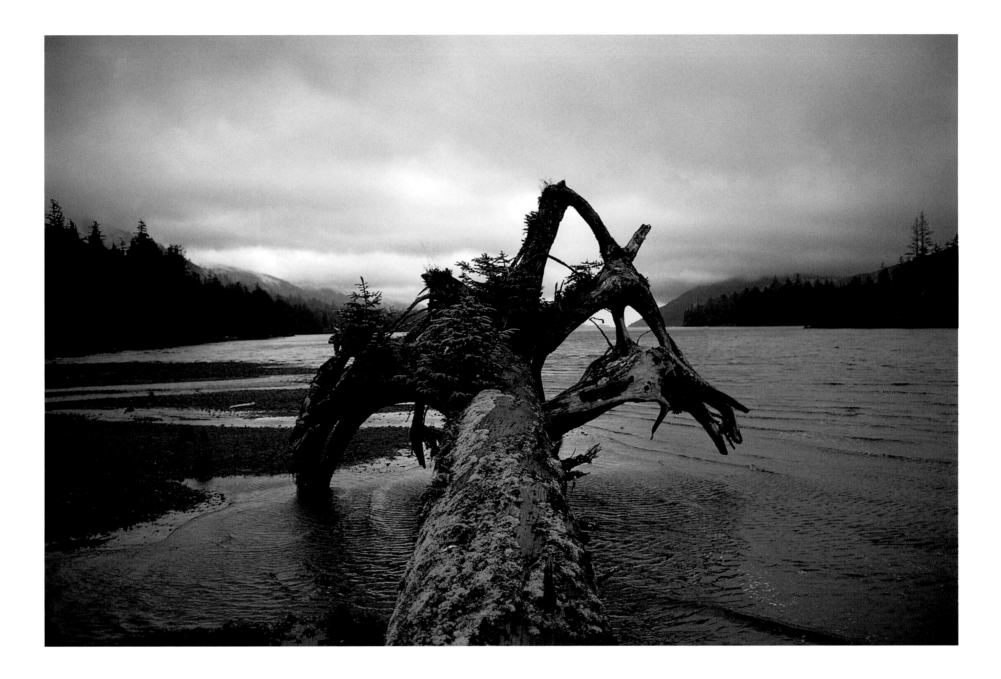

QUEEN CHARLOTTE ISLANDS, CANADA

LANDSCAPE GARDENS OF THE AUSTRALIAN OUTBACK

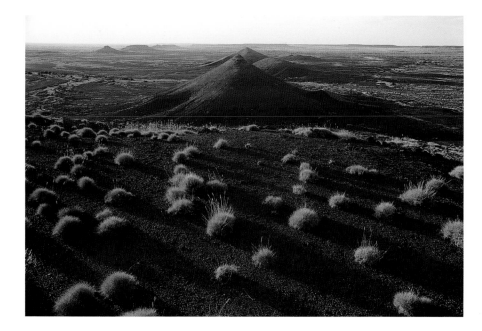

BALGO HILLS

To MY EYE the landscape of the Balgo Hills was blistering. I'd never seen a dry landscape so hot and bright that it shone.

To the Aborigines accompanying me, it looked different. They saw the green stream of vegetation draining into the desert. Beneath it, they knew, was a real stream of water, and in and around it was food. It was their garden, which wouldn't last long in the heat of the Great Sandy Desert.

Almost all of interior Australia is forbiddingly dry. But for a hundred thousand years Aborigines have existed here by following the water and gathering life from it. This timeless way of life is lived out on an ancient landscape.

Canyons in the western desert cut through the oldest exposed rocks on Earth, while in the north epic cycles of rain and fire shape land and the life on it. So light is the hand of man on this austere land that the design of the Earth is evident. I saw it as sculpture.

I also saw it as a setting for life and death in the wilderness garden. A 900-year-old boab tree I photographed one year was struck by lightning the next. A year later it was gone, eaten by green ants, absorbed into the outback.

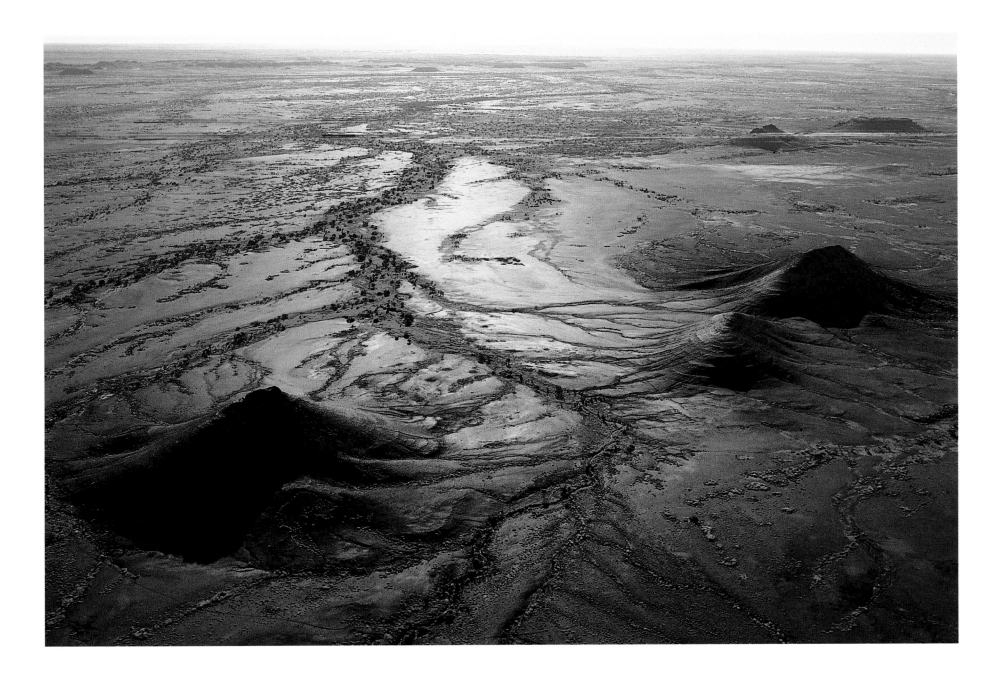

BALGO HILLS, GREAT SANDY DESERT, WESTERN AUSTRALIA

Australians refer to the wild north of their country as the "top end," an almost empty region of gum trees and termite towers. The few cattle stations and Aboriginal settlements are far from one another.

During much of the year the undisturbed land bakes in an atmosphere of ever increasing heat. The climax of this buildup is a short, intense, and apparently destructive season of wildfires. In fact the fires are cleansing. Before the land was peopled, fires were set by lightning strikes. But now, and for millennia, Aborigines set the fires.

They do it to clear the land and start the cycle of regeneration. I've seen them do it. And I've come to believe they have another reason for setting the fires, one we share. The fires are beautiful to watch.

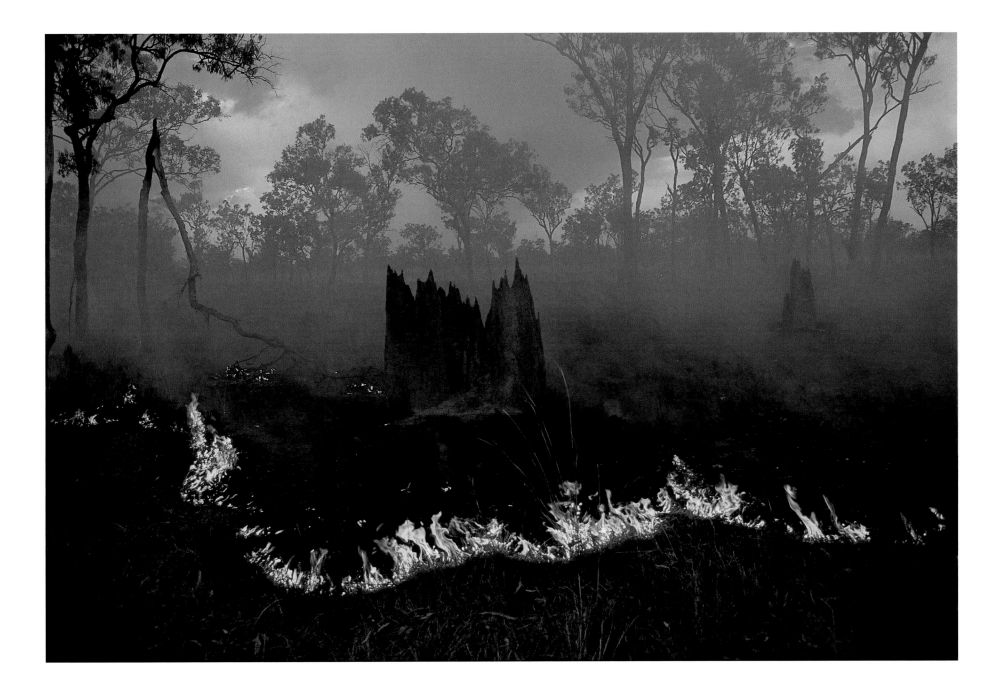

CAPE YORK PENINSULA

"The Wet" is the short name for the long season of rainstorms that annually inundate the top end of Australia.

The name fits. At the peak of the season nothing is dry. Monumental rains wash out roads and bridges, strand cattle stations, and isolate whole villages. The Wet can last for months. At the end of the season rain falls only on water. The land has disappeared.

Eventually the rains stop and the land responds with one of the Earth's great greenings. The top end is a tropical garden again, and all of aboriginal Australia is an oasis.

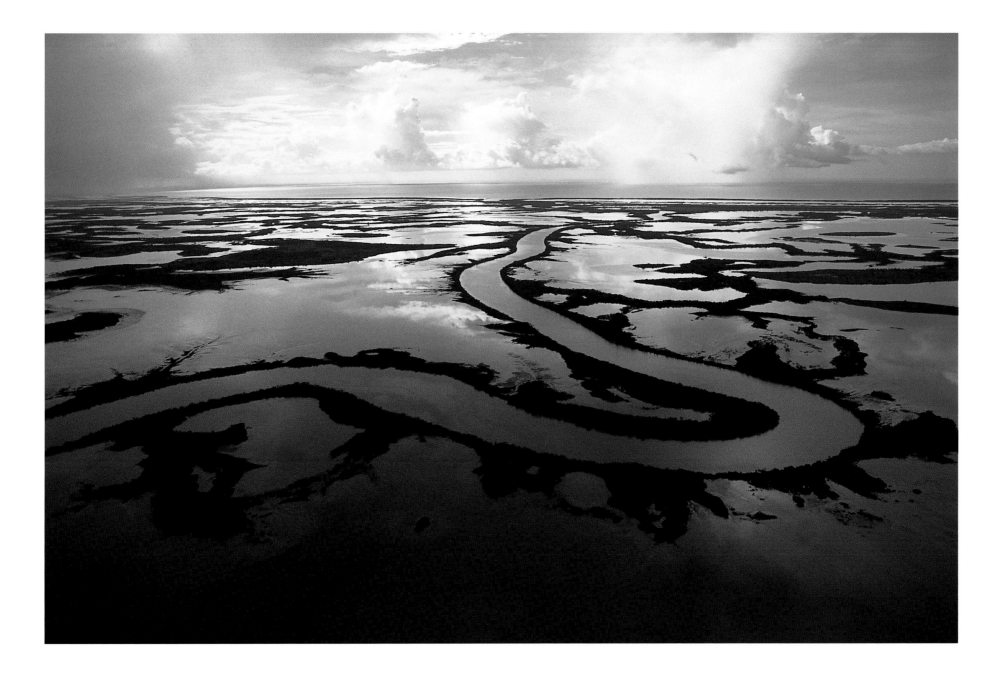

CAPE YORK PENINSULA

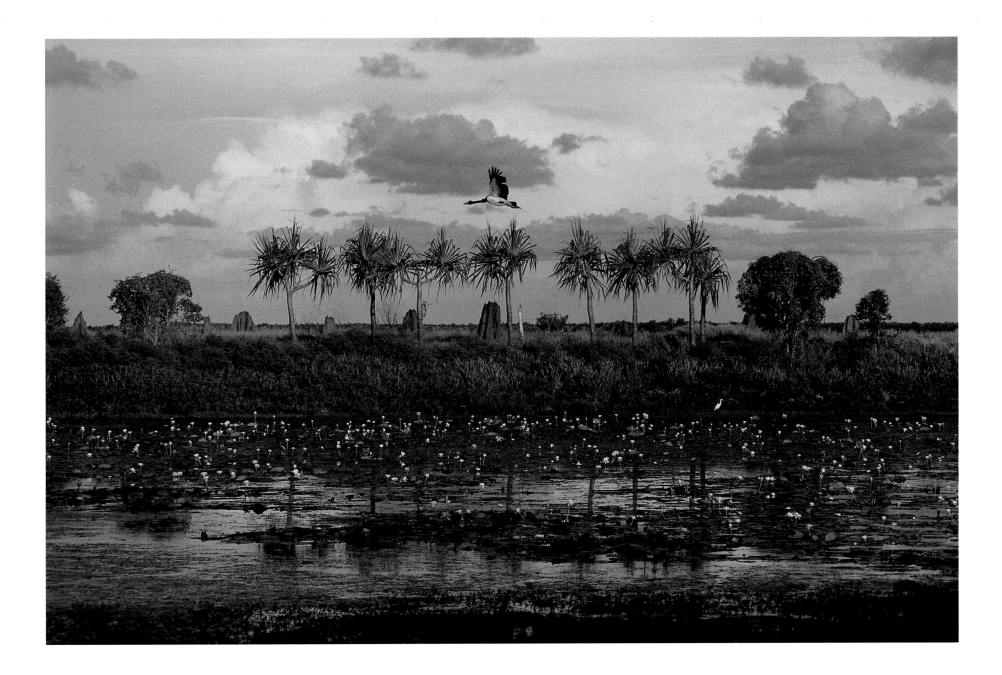

AURUKUN WETLANDS, CAPE YORK PENINSULA

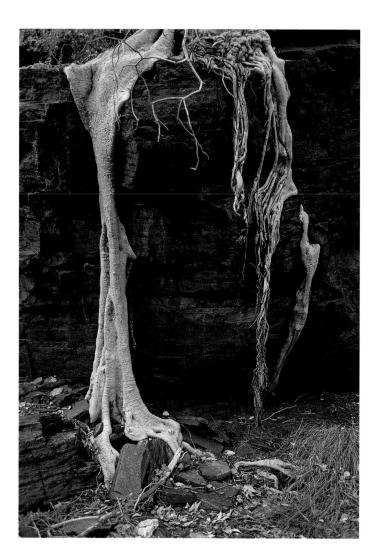

GUM TREE, HAMERSLEY RANGE, WESTERN AUSTRALIA

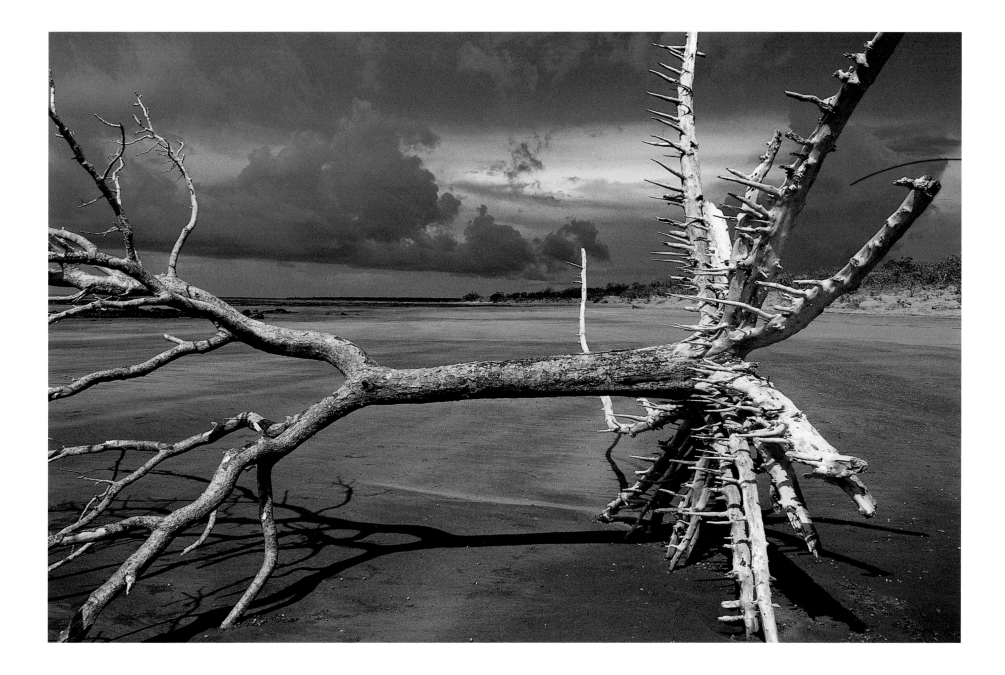

MANGROVE TREE, NORTHERN TERRITORY

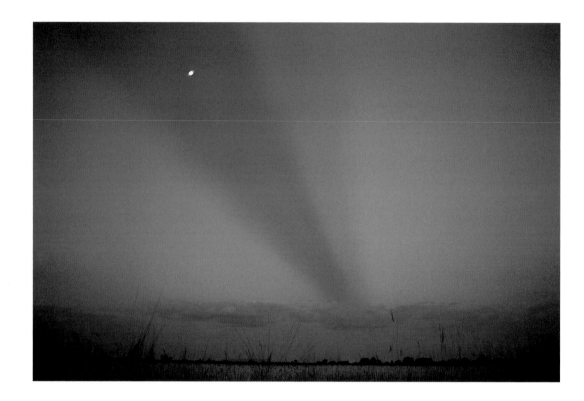

BOAB TREE SITE, 1995

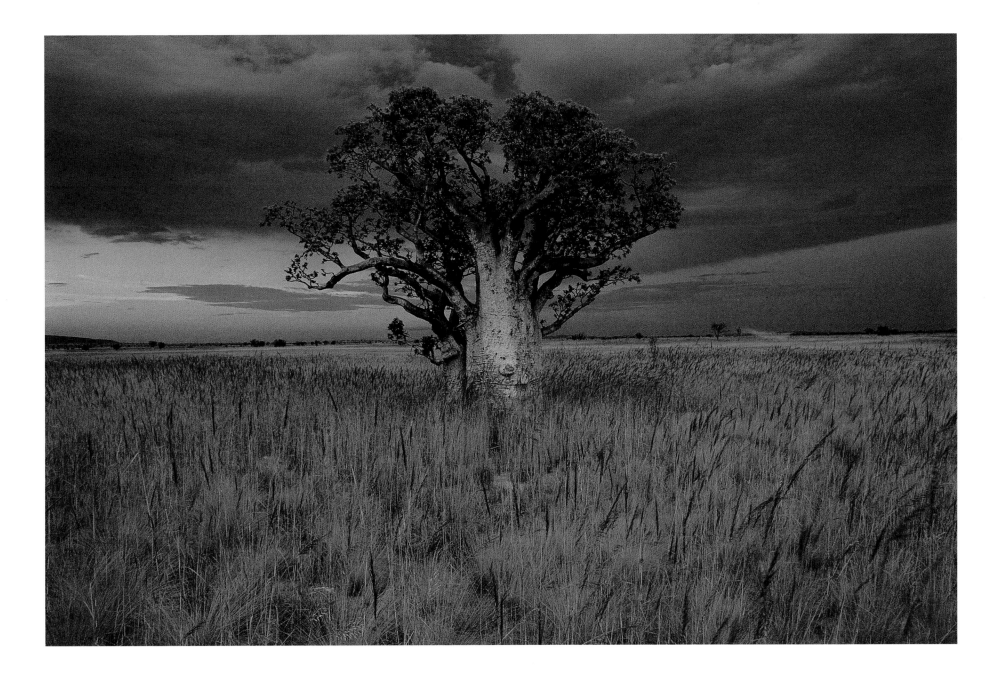

BOAB TREE, KIMBERLEY, WESTERN AUSTRALIA, 1989

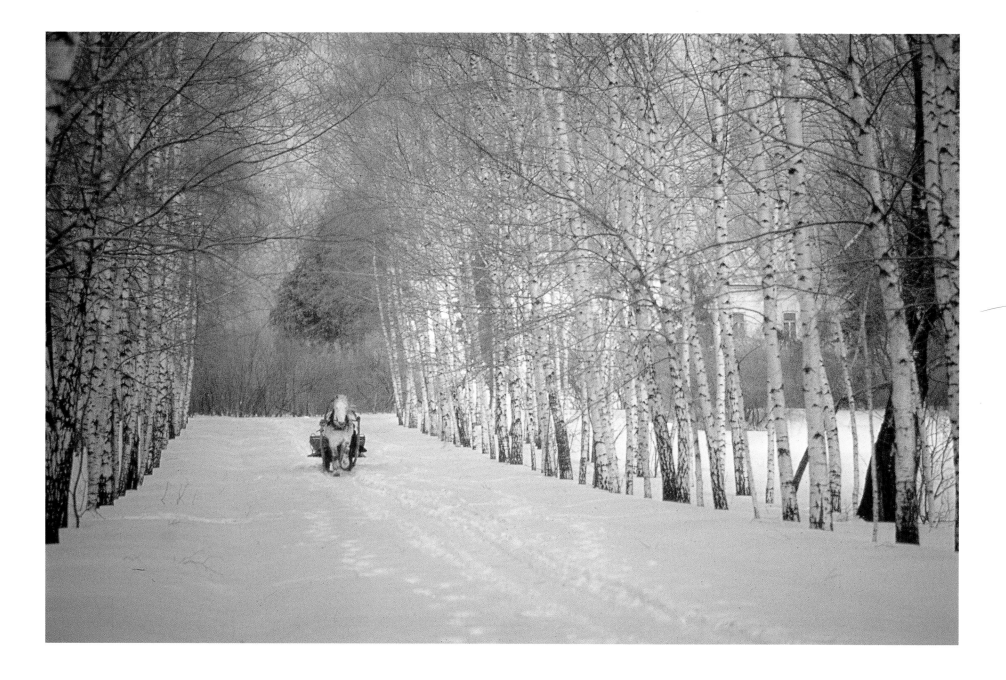

THE BIRCH ALLÉE, YASNAYA POLYANA, RUSSIA

CULTURAL GARDENS

MY PARENTS BELIEVED there was a close connection between travel and learning, and our vacations were spent visiting cultural shrines. The value placed on these trips apparently took hold, because I continued them as an adult. One of the things I learned is that the line between imagination and the garden is an invisible one. Tolstoy wrote, "Without my home Yasnaya Polyana I find it difficult to imagine Russia and my relation to it." Jefferson, thinking of Monticello and America, felt the same. It's hard to separate the mind of either man from his estate.

In England Lewis Carroll based the fictional Wonderland on the real garden the actual Alice played in while he secretly watched from above. And Thomas Hardy placed his heroines in the closely hedged landscape of the English countryside where he himself lived and farmed. Hardy's rustic, verdant hedgerows came in from the countryside to become the indispensable living walls of almost every English ornamental garden.

In America the Shakers strived to create a culture of heaven on Earth. Their spiritual society was grounded in practicality and centered on the garden. Nearly gone, the Shakers are more thought of today than ever before. People come to their settlements to admire their work, to ponder their spiritual ideas, and to gaze on their prolific gardens.

Finally, when a culture wants to give greatest expression to its collective emotion, it memorializes land. There is a Civil War memorial in almost every eastern American town. At the center of this emotional archipelago are battlefield parks. They are our national sculpture gardens. One doesn't have to be military-minded to be moved by them.

TOLSTOY'S GARDEN

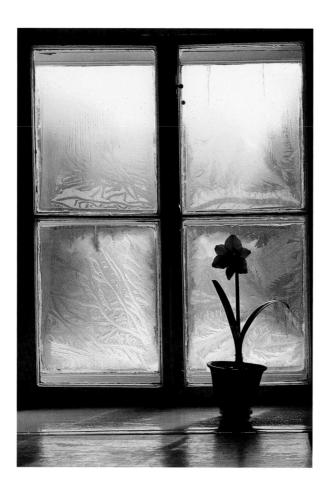

AMARYLLIS

As a boy Leo Tolstoy believed a green stick was buried in the woods at the back of the family's estate, Yasnaya Polyana. He and his brothers thought the stick was inscribed with the secret of happiness for all people, and the boys played a game of trying to find it. The memory of this was so persistent and influential that Tolstoy wanted to be buried on this spot, and he is.

Yasnaya Polyana (Clear Meadow) was Tolstoy's home for the greater part of his long life. It was here that he wrote the books for which he became world famous. Much of the atmosphere and factual foundation of his fiction is based on Yasnaya Polyana.

The estate, 120 miles south of Moscow, still exists. It has a distinct Russian character that comes from Tolstoy's belief in using native plants, not European imports. The result is a Russian realm of birch and linden allées, meadows of rye, garlands of native grape, and paths bordered by wild roses. One of these paths winds through the woods to Tolstoy's grave, covered by fir branches in winter and ferns in summer. Visitors are asked to remain silent when approaching Tolstoy's grave. I never heard a word spoken.

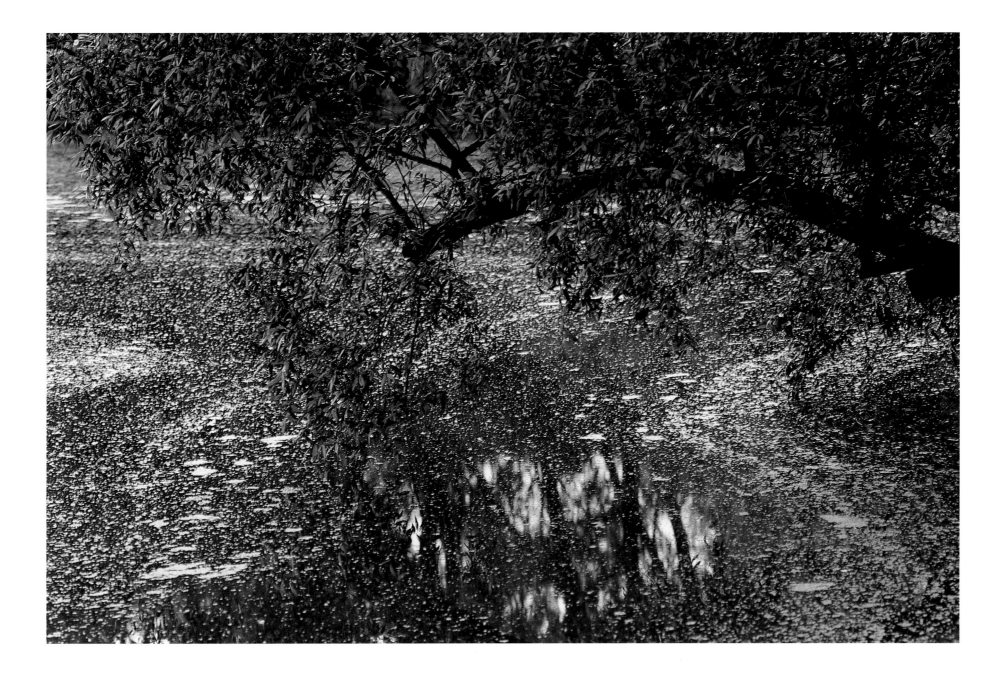

THE BIG POND

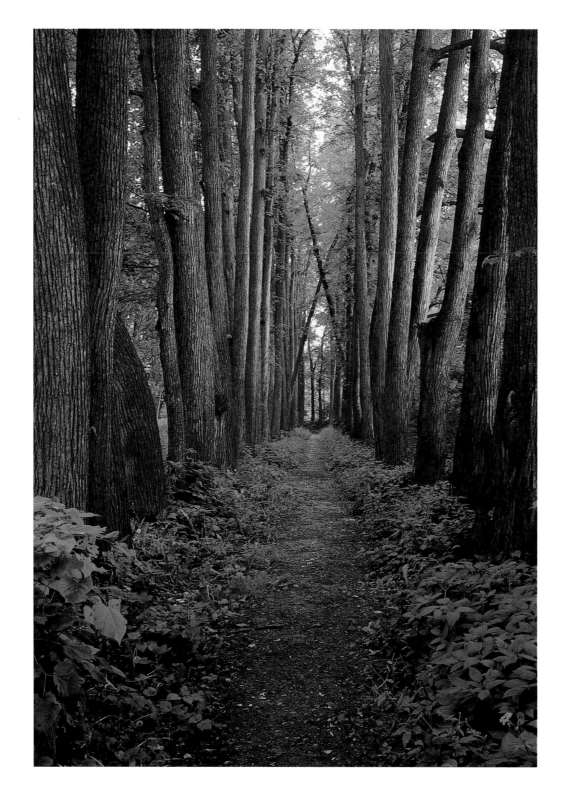

LINDEN ALLÉE

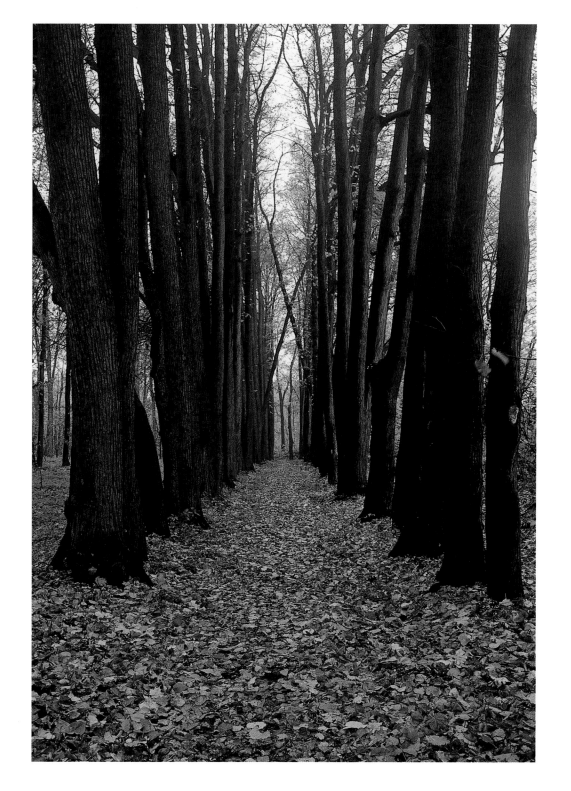

LINDEN ALLÉE

VEGETABLE GARDEN

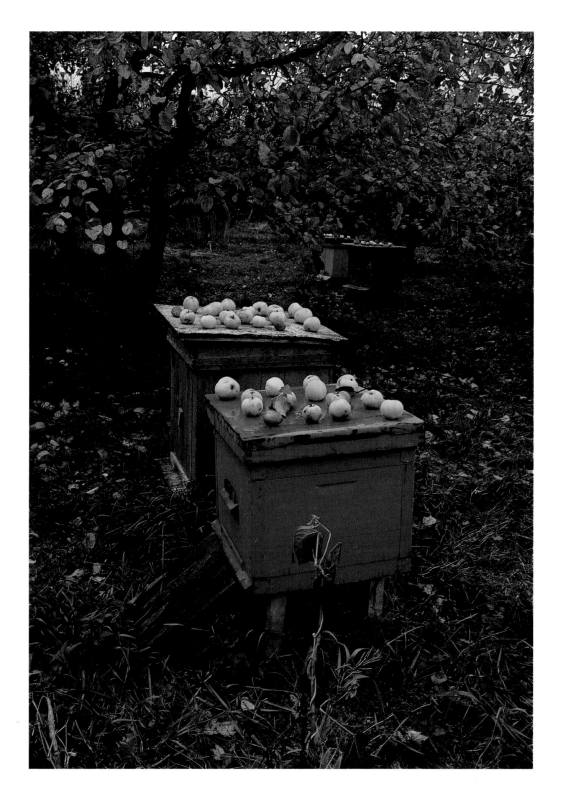

THE ORCHARD

The verandah was my favorite place at Yasnaya Polyana. I had that in common with just about everyone. All eight of the Tolstoy children remembered the verandah fondly. It was a child's place—attached to the security of the main house, but separate and spacious enough to be an outdoor world of one's own.

At Yasnaya Polyana the Tolstoy family and their many guests ate from the garden. Tolstoy himself was a strict vegetarian and imposed his diet on the family. This called for ingenuity on the part of his wife Sofia. In her cookbook are recipes and clever instructions for turning grain and vegetables into meat-like dishes.

One day we arranged to have a meal prepared using her recipes and served on the family china. The entree was "veal cutlets," which looked appetizing but tasted bland. Nevertheless, the meal was memorable because we sat at the family table on the sunny verandah, listening to stories of Yasnaya Polyana in the time of Tolstoy.

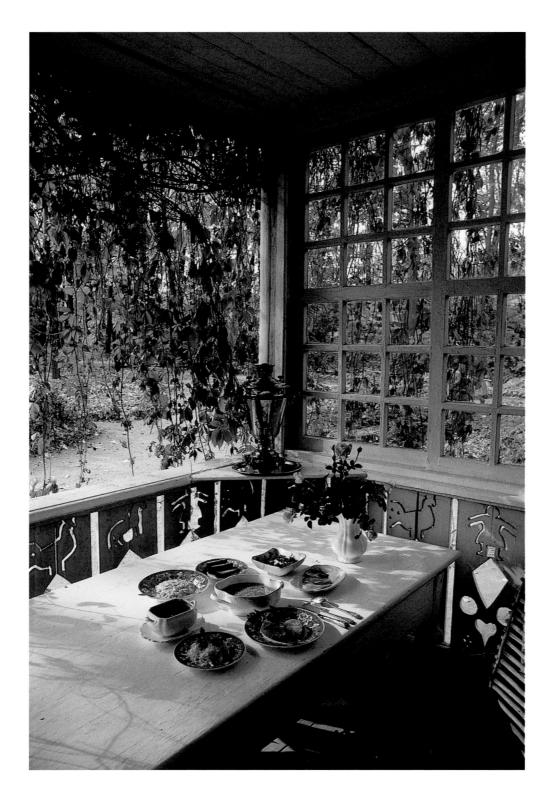

THE VERANDAH

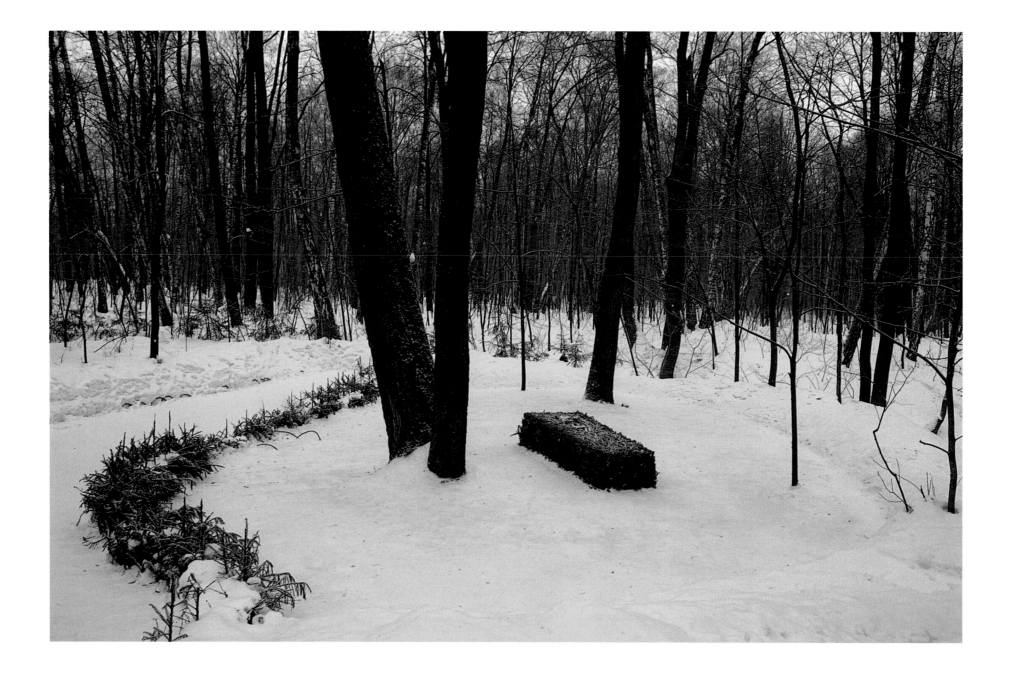

TOLSTOY'S GRAVE

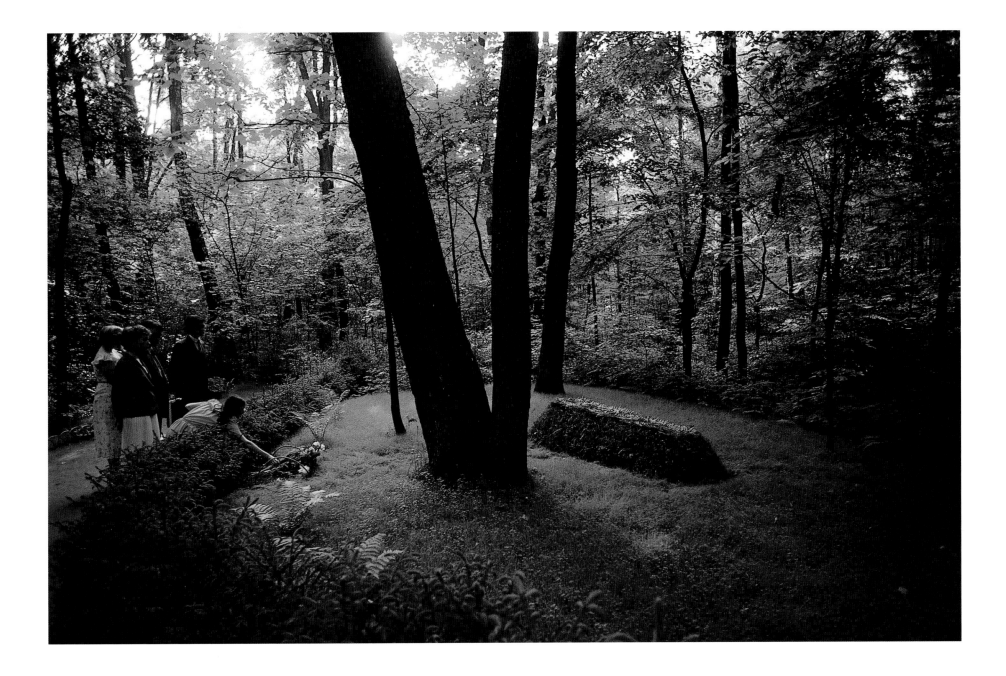

WEDDING PARTY, TOLSTOY'S GRAVE

Tolstoy died on this bed in the tiny town of Astapovo, far out on the steppes of rural Russia. He had been traveling by train with a friend when his chronic pneumonia recurred. He was taken from the train and laid down in the stationmaster's bedroom.

He lingered for a week while all Russia, and a respectful world, waited. He died on November 20, 1910, at the age of 82. Before Tolstoy's body was removed, a local man traced the writer's profile on the floral wallpaper beside the bed. His pencil profile is now faint, but still distinctive.

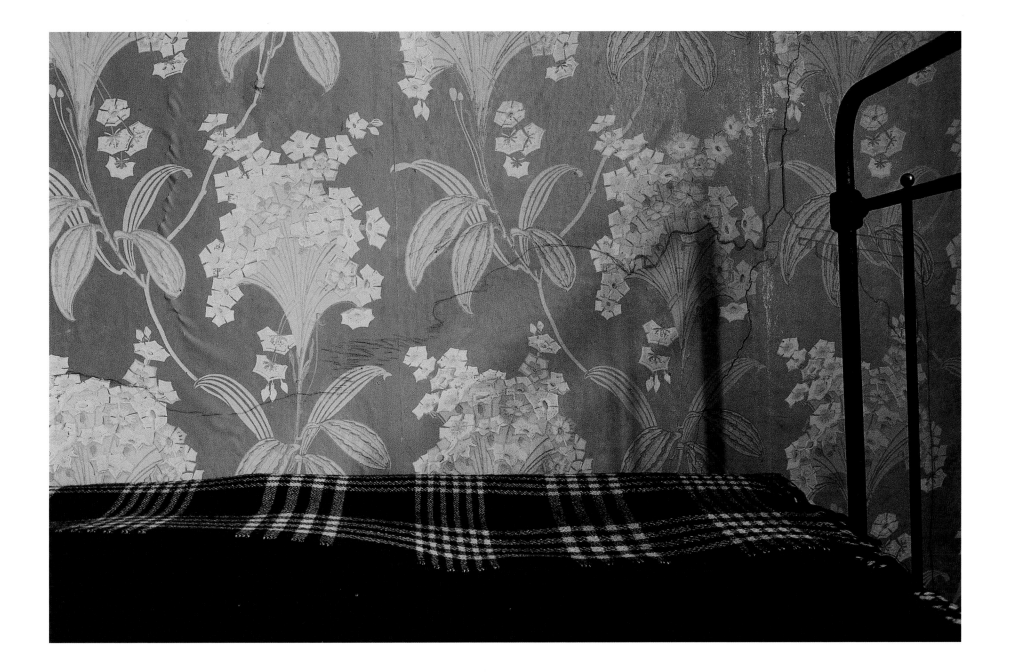

STATIONMASTER'S HOUSE, ASTAPOVO

Lewis Carroll's Garden in Wonderland

DEANERY GARDEN

"I MARK THIS DAY WITH A WHITE STONE," wrote Charles Dodgson in his journal on April 25, 1856. That day he looked down from a second-story library window and saw Alice Liddell at play with her sisters in the secluded deanery garden at Christ Church College, Oxford.

Alice was three, the daughter of the dean of Christ Church. Dodgson was 24, an esteemed mathematics professor, deacon of the Church of England, and author with the pen name Lewis Carroll.

Dodgson ardently pursued a friendship with Alice. He became her storyteller, puzzle maker, photographer, and companion on long walks and boating parties.

One summer day in 1862, adrift on the River Isis, Alice demanded Dodgson amuse her with a story. He then spun out the tale that became *Alice's Adventures in Wonderland*, one of the most beloved books in literature.

Much of the imagery in the story comes from the garden Alice was playing in the day Dodgson first saw her. The garden today is almost unchanged, and one may stand at the window where Dodgson stood, look down, and easily imagine the real Alice, alive in Lewis Carroll's garden.

DEANERY GARDEN

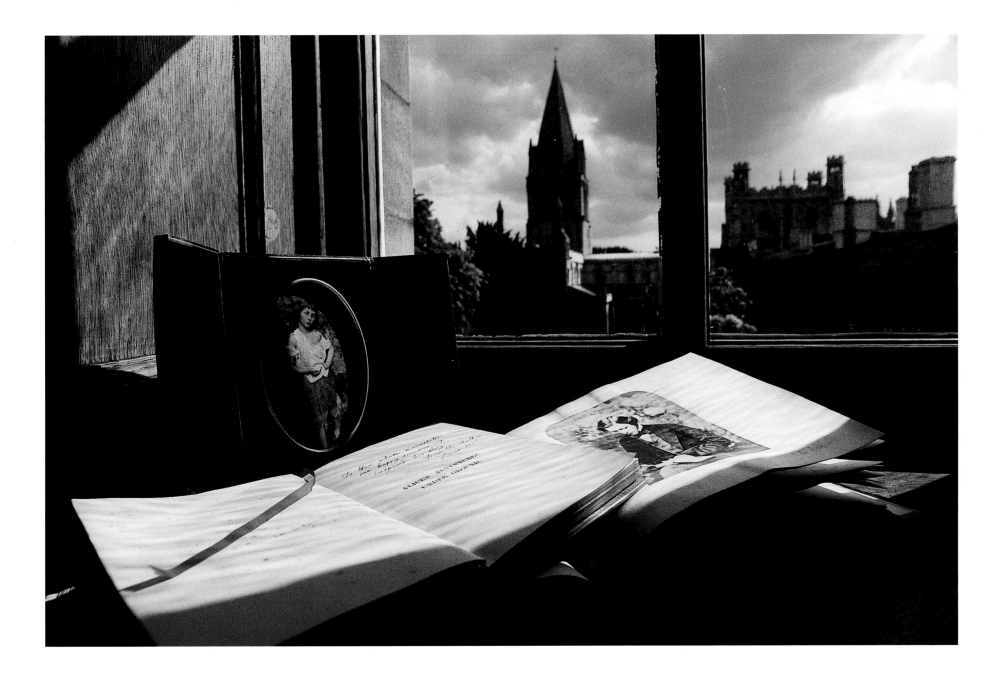

THE LIBRARY WINDOW, CHRIST CHURCH, OXFORD
ALICE LIDDELL (FRAMED) BY CHARLES DODGSON; DODGSON (SELF-PORTRAIT);
FIRST COPY OF *ALICE'S ADVENTURES UNDERGROUND*, INSCRIBED BY DODGSON TO ALICE.

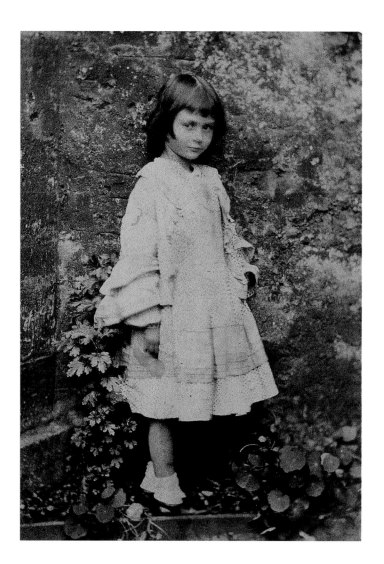

ALICE LIDDELL BY CHARLES DODGSON

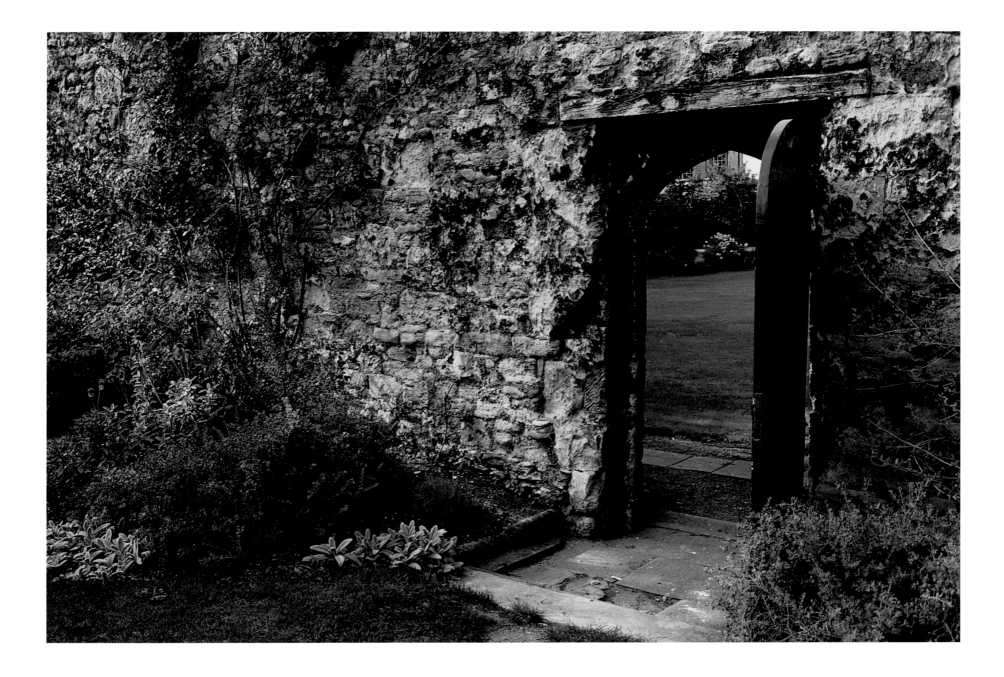

THE DEANERY GARDEN

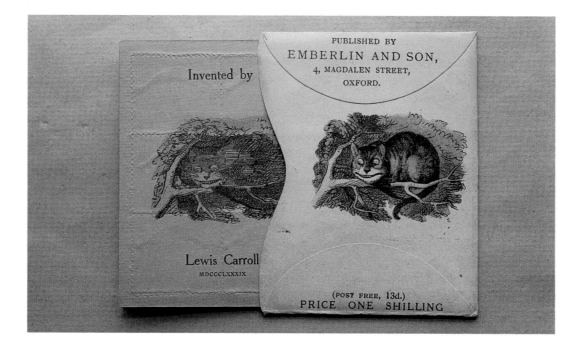

Invented by

Lewis Carroll

MDCCCLXXXIX

PUBLISHED BY
EMBERLIN AND SON,
4, MAGDALEN STREET,
OXFORD.

(POST FREE, 13d.)
PRICE ONE SHILLING

CHESHIRE CAT STAMP PACKET

CHINESE PLANE TREE, CHRIST CHURCH

To Her whose namesake
one happy summer day
inspired his story:
from the Author
Xmas. 1886.

ALICE'S ADVENTURES
UNDER GROUND.

INSCRIBED FIRST COPY
TO ALICE LIDDELL FROM CHARLES DODGSON

THE RIVER ISIS, OXFORD

BRITAIN'S HEDGEROWS

HAWKRIDGE, SOMERSET

FOR CENTURIES farmers have been unintentional gardeners, shaping and seeding the Earth for practical purposes while also incidentally beautifying it. Evidence of this is plain in the west of England, where from a hilltop the landscape rolls away to the horizon—a living patchwork quilt of pastures, grainfields, and woodlots visually held together by the stitching of hedgerows.

For more than a thousand years hedgerows have existed in England. As forests were cut and fields cleared, the hedges became home for almost all of Britain's inland wildlife. Birds moved in and brought with them the seeds of wildflowers. Practically the best wildflower walk in England is down a closely hedged lane fragrant with the scent of foxgloves, hedge garlic, and primrose. Add birdsong, the flight of butterflies, and the rustling of small mammals, and all the elements of a wild garden are in place. Except they aren't wild. Hedgerows are as man-made and maintained as an English topiary garden.

In winter hedges seem as dense and intricate as a basket. But in spring they become long leafy walls holding both the history and future of the great English countryside garden within their woven branches.

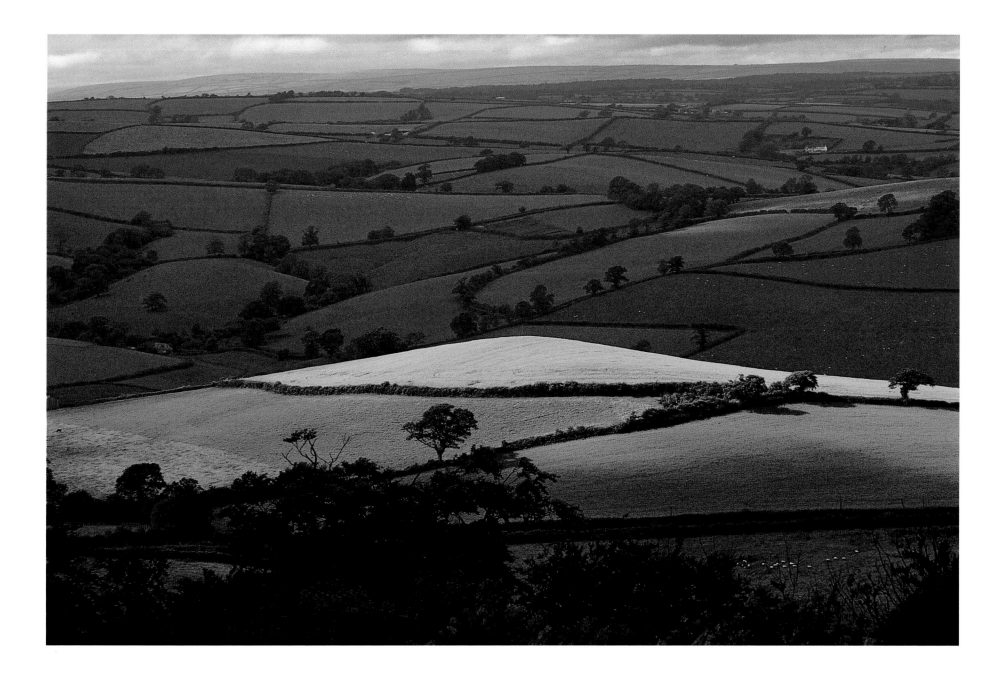

DEVON

Most people experience hedgerows from a speeding car. Driving fast down a closely hedged narrow road is an exhilarating, edgy experience. The hedges whip past, tunneling you forward into tight turns and around blind curves. I wanted to convey that in a photograph.

The chance came in Wales. I got into the back of a vintage three-seat Land Rover driven by a farmer. His son and their dog were passengers. Off we went. Almost at once the familiar feelings welled up: beauty and danger. As I photographed the onrushing road the dog, for a moment, looked back at me. His expression seemed to mirror my own thoughts: What's around that bend?

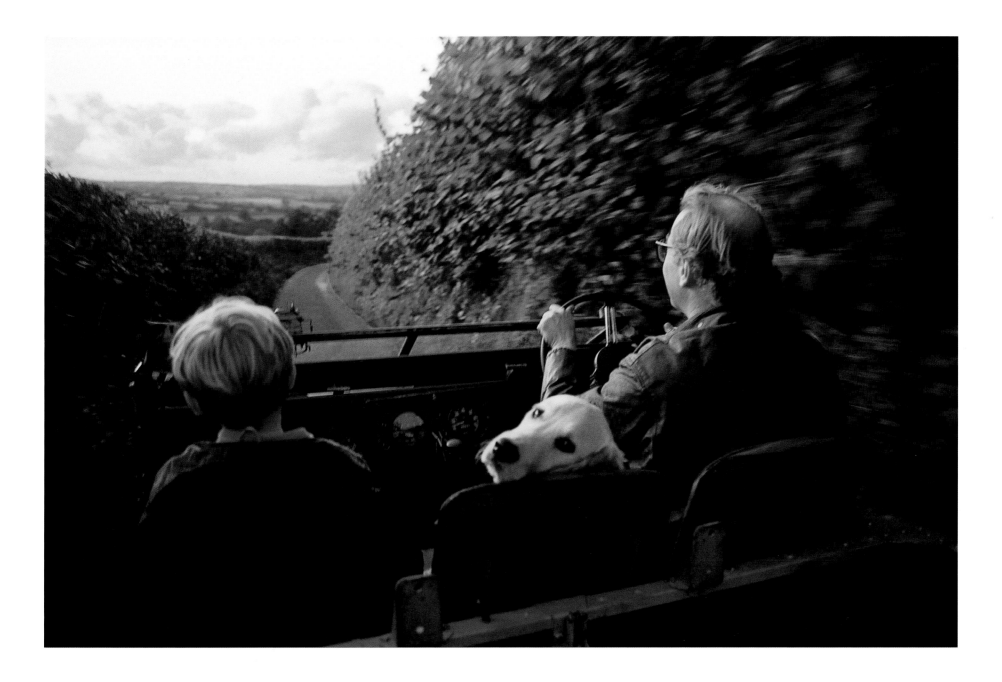

ROBIN PICKERING FARM, WALES

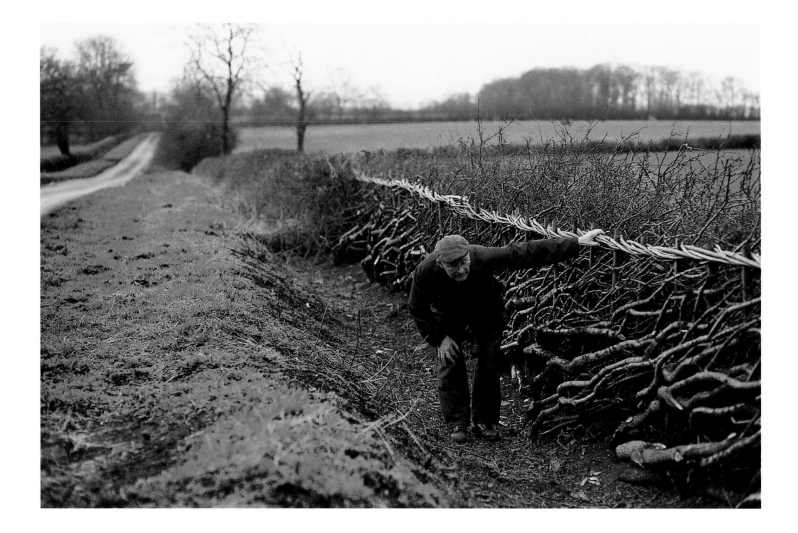

WALTON ON THE WOLDS, ENGLAND

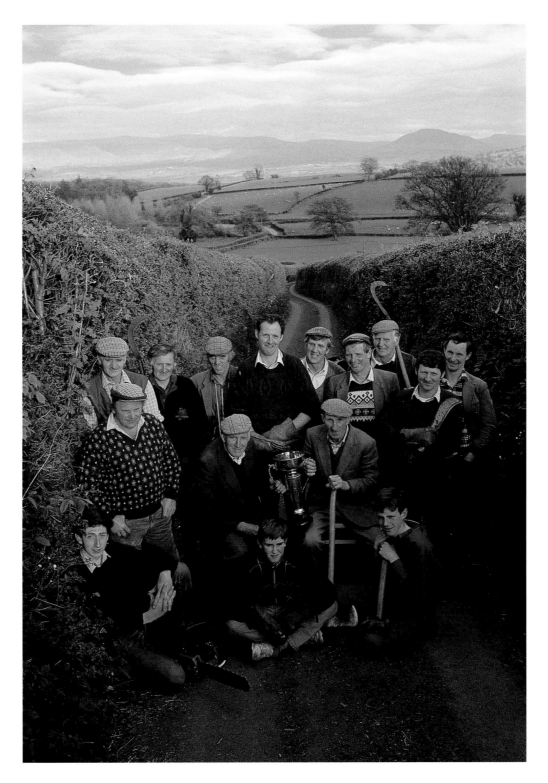

DAVIES FAMILY, CHAMPION HEDGERS, BRECON, WALES

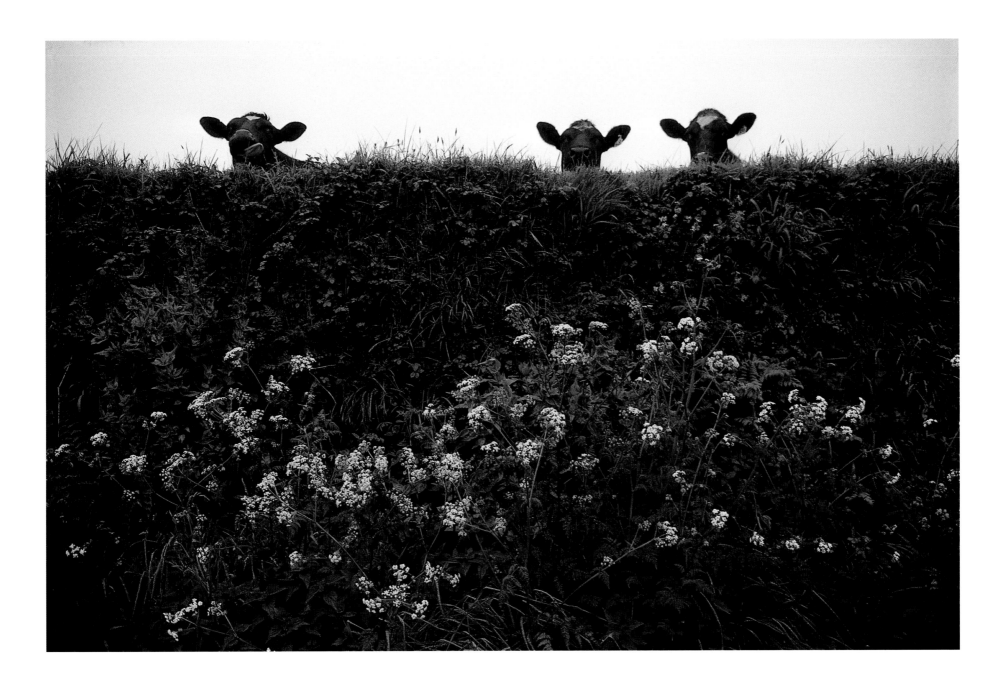

HEDGE BANK, CORNWALL

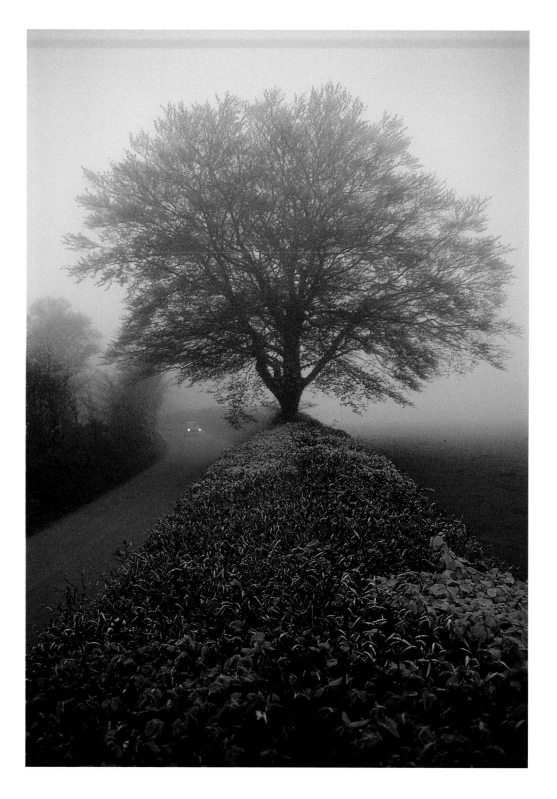

HAWKRIDGE, SOMERSET

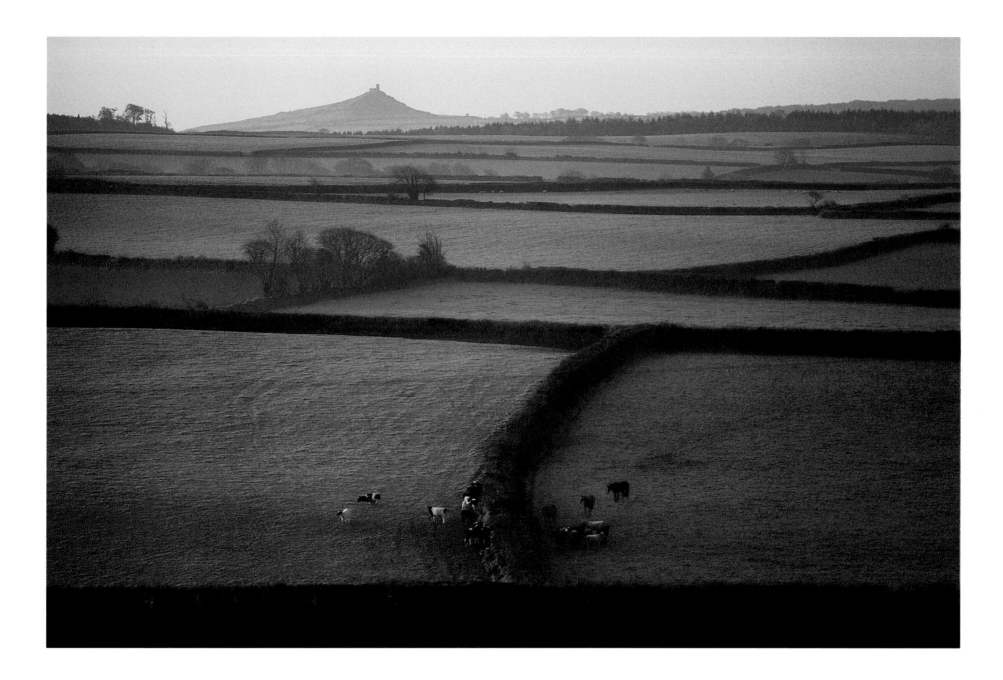

DEVON

Britain's hedgerows are disappearing. Since 1945 a third of them have been "grubbed out" by bulldozers. In an era of large-scale mechanical farming, the hedges are in the way. In one generation much of eastern England became a prairie of grain—"like Kansas with pubs," as one man put it.

Gone, too, is the hedged home of birds, wildflowers, and small mammals that have also been disappearing at an alarming rate. People have taken notice. Now there are government incentives to maintain the 250,000 miles of hedges remaining in Britain.

Stand atop western England, on the shoulders of the moor, and look out. Beyond the wild ponies and fog-filled valleys are the ancient hedges. They are living lines and, to the eye, the essence of England itself.

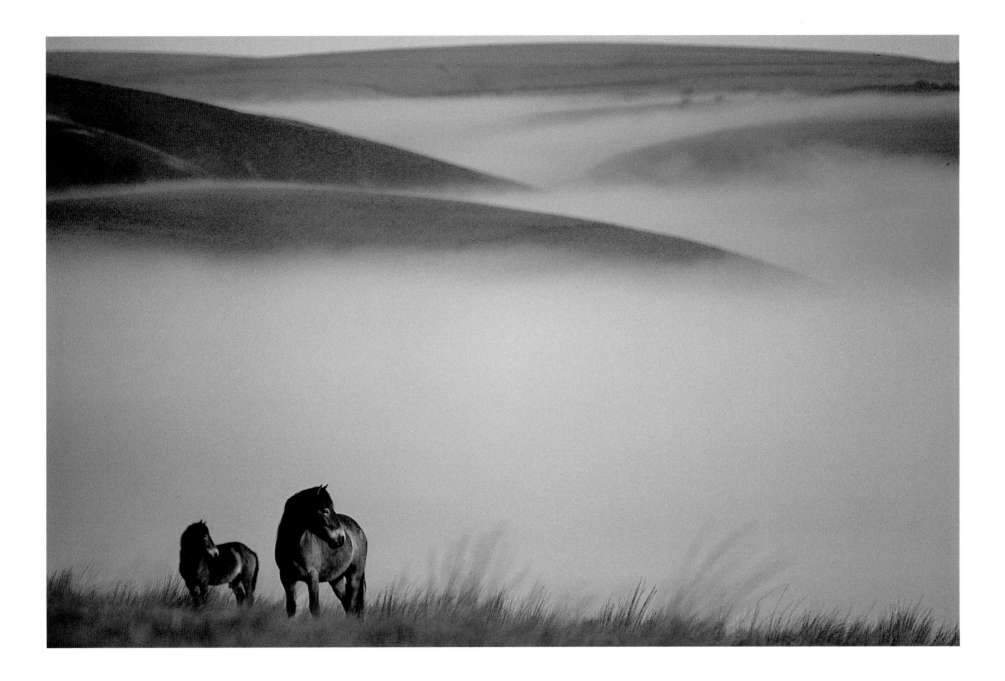

EXMOOR

THE SHAKERS' BRIEF ETERNITY

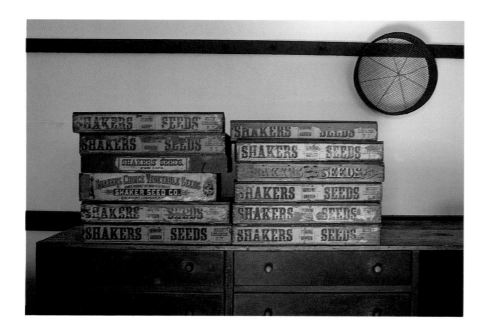

PLEASANT HILL, KENTUCKY

"HANDS TO WORK, HEARTS TO GOD" is the phrase that best expresses the beliefs of the Shakers. They were a religious sect that lived in ascetic, celibate communal villages scattered across eastern America beginning in 1787. At their peak, around 1845, there were 4,000 of them living in two dozen villages.

Today their restored settlements have become historic shrines. Because the Shakers were self-reliant and innovative, the villages are noteworthy for industriousness and invention. And because they believed the grace of God should show in their work, Shaker objects, from churches to clothespins, are beautiful.

At the center of their society were the gardens. Initially the food was only for the community, but the world also wanted what they grew. Eventually the Shakers produced food, herbs, and seeds for sale. Shakers at Pleasant Hill, Kentucky, exported their seeds to the world via the Kentucky River.

In a small way this is still happening. The seven Shakers who remain at Sabbathday Lake, Maine, raise herbs for sale. To plunge your hands deep into a bin of their rose petals is to release the memory of the Shakers' brief eternity.

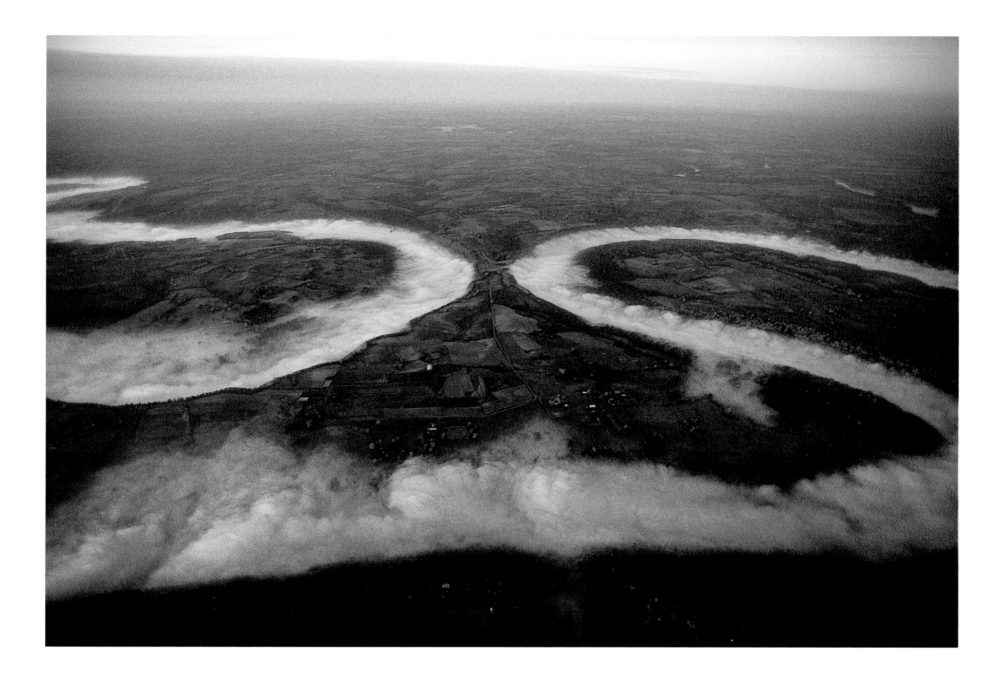

KENTUCKY RIVER, NEAR PLEASANT HILL

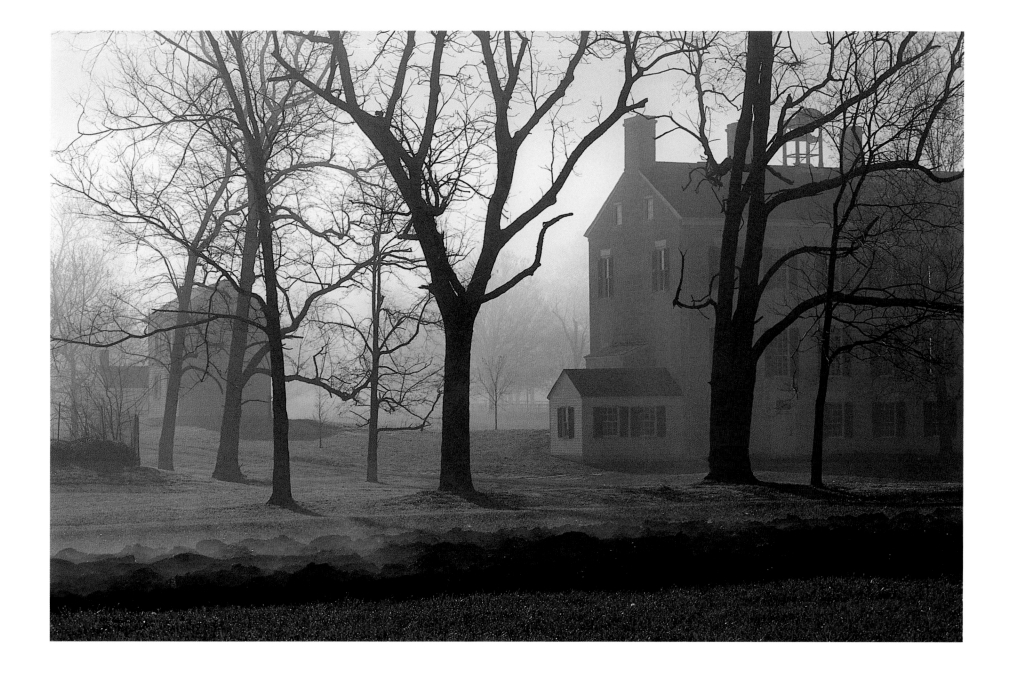

NEWLY TURNED EARTH, PLEASANT HILL, KENTUCKY

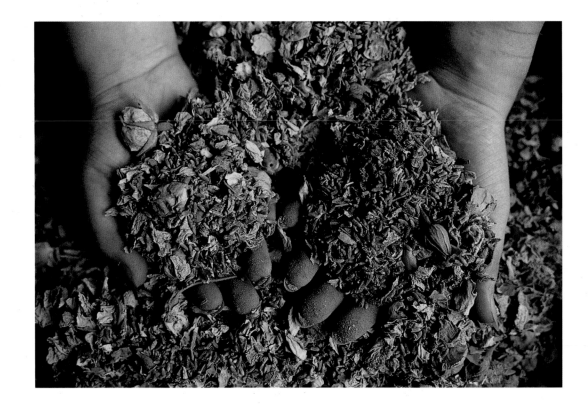

SABBATHDAY LAKE, MAINE

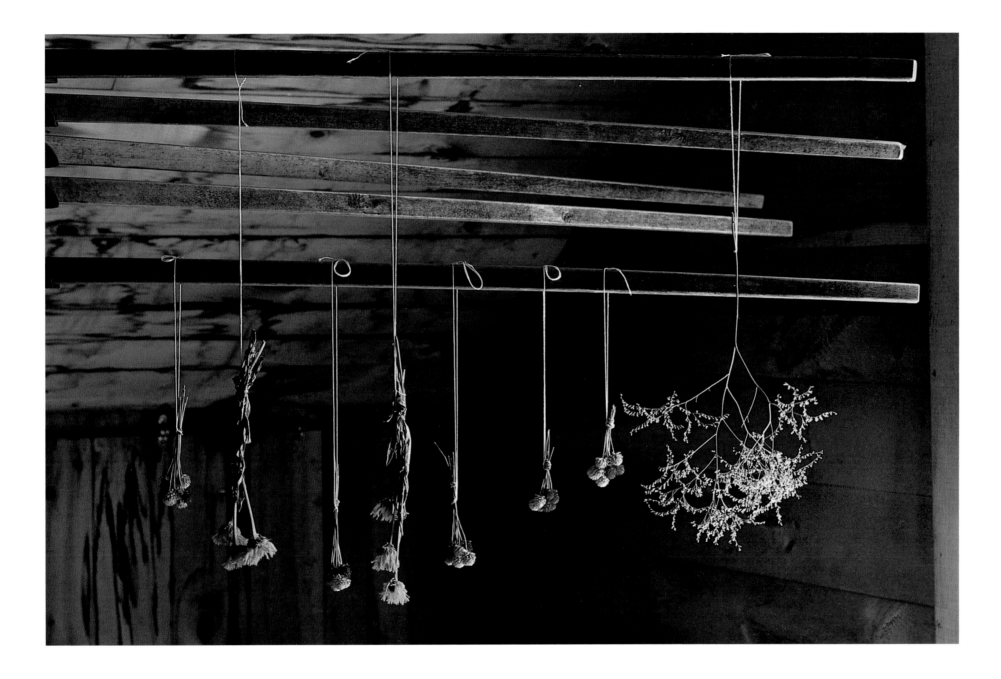

SABBATHDAY LAKE, MAINE

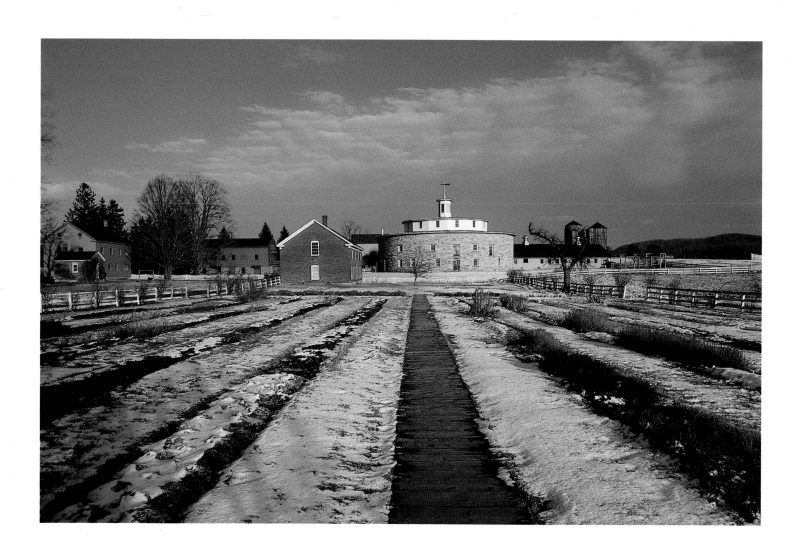

HANCOCK, MASSACHUSETTS

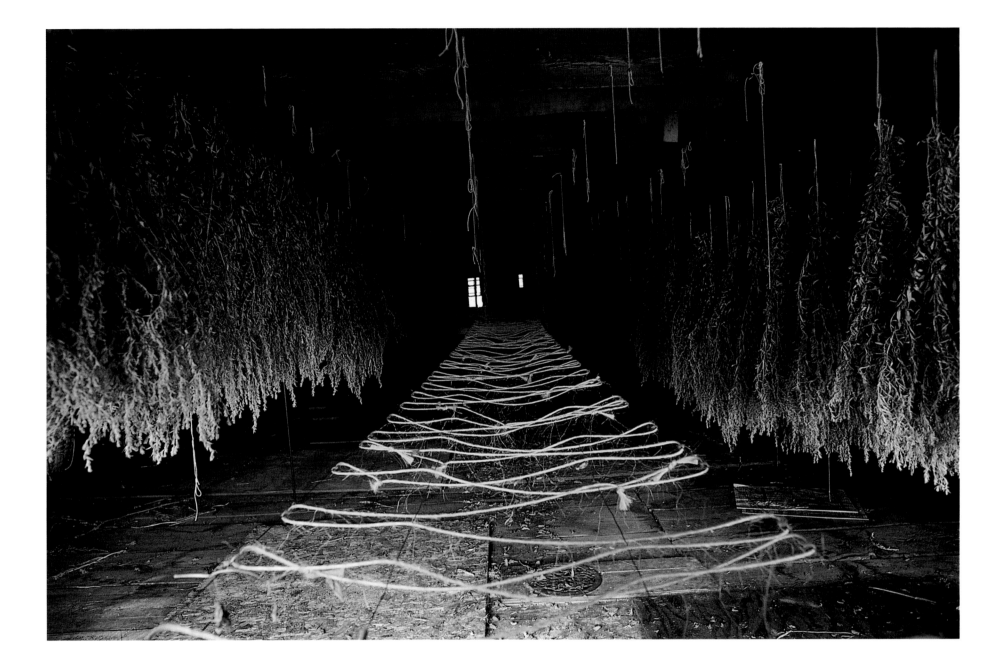

SABBATHDAY LAKE, MAINE

SCULPTURE GARDENS OF THE CIVIL WAR

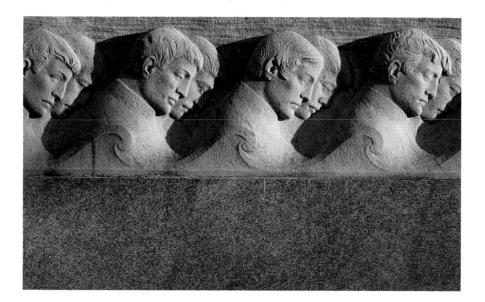

SHILOH, TENNESSEE

ON OCTOBER 18, 1864, two Confederate soldiers were captured by a Union patrol near Flint Hill, Virginia. In retaliation for the recent execution of a Union soldier, one of the captured Confederates would die. Lots were drawn. The loser pled for his life, citing his family.

The other soldier, Albert Gallatin Willis, a chaplain on leave from Mosby's Rangers, was moved by the plea. He was single, and he offered his life in place of the condemned man. Willis was hanged, cut down, and buried.

One hundred and ten years later I moved to Flint Hill. Willis's small grave was in my backyard. The simple headstone and low fence gave a solemn dignity and sense of history to the otherwise ordinary yard.

His grave was also a garden, tended by Boy Scouts who clipped the grass and painted the picket fence white. On Lee-Jackson Day there were flowers and a small flag.

So it is elsewhere in the East and South. After the Civil War the scorched ground of the great battlefields was set aside and statues erected. More than a century of seasons has passed. Around the modest graves and mighty battlefields the landscape has quietly grown graceful.

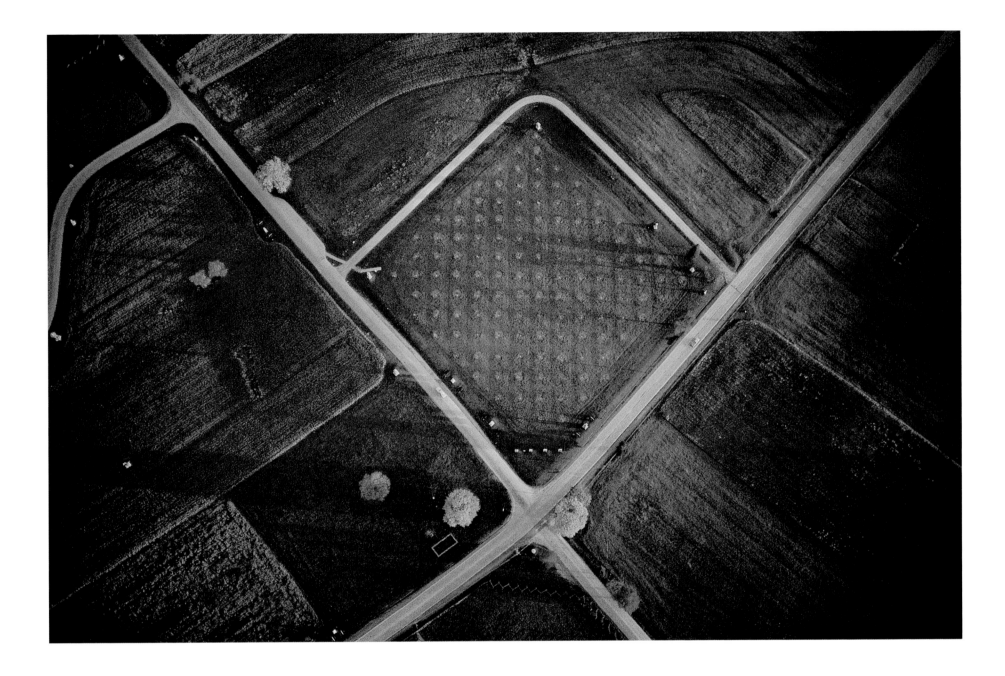

THE PEACH ORCHARD, GETTYSBURG, PENNSYLVANIA

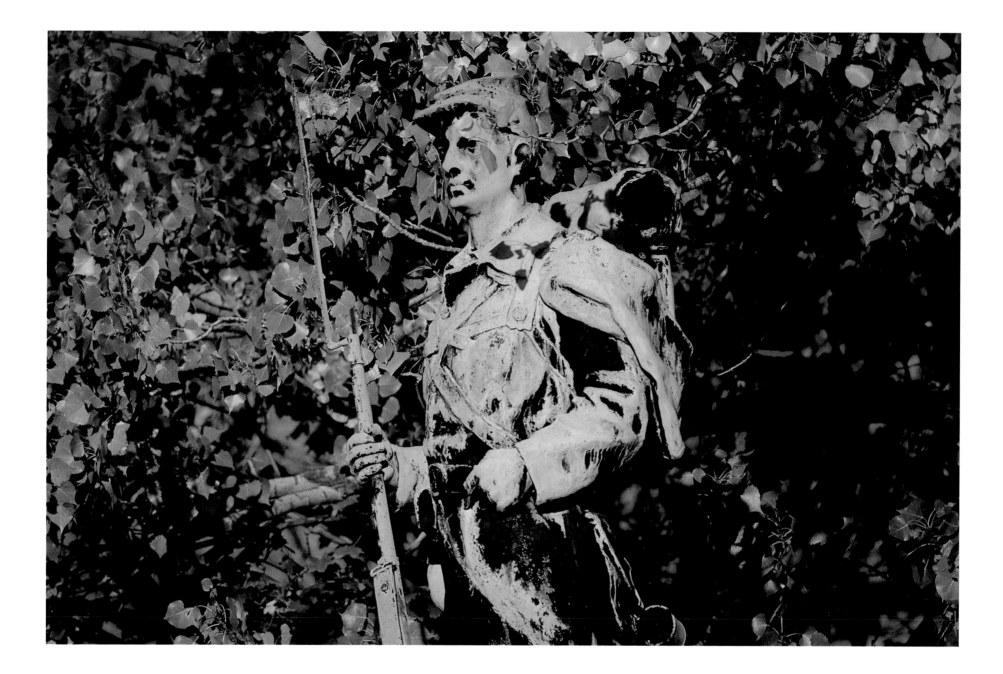

ANTIETAM, MARYLAND

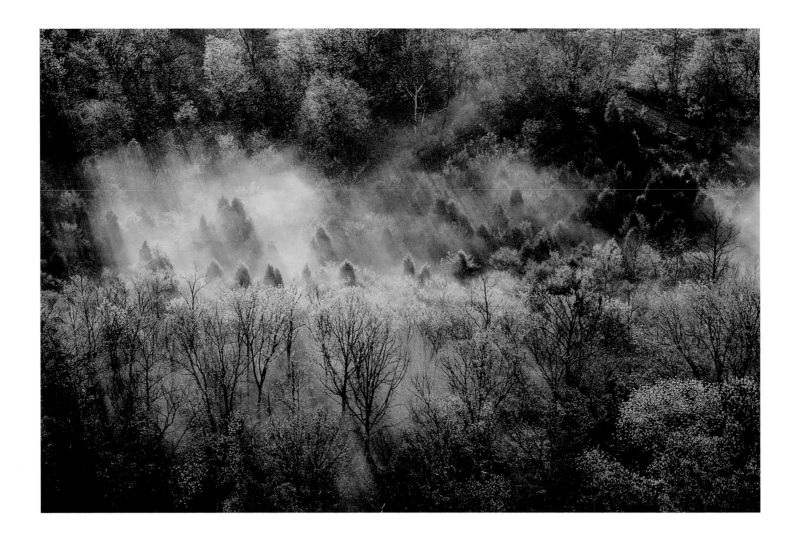

KELLY'S FORD, VIRGINIA

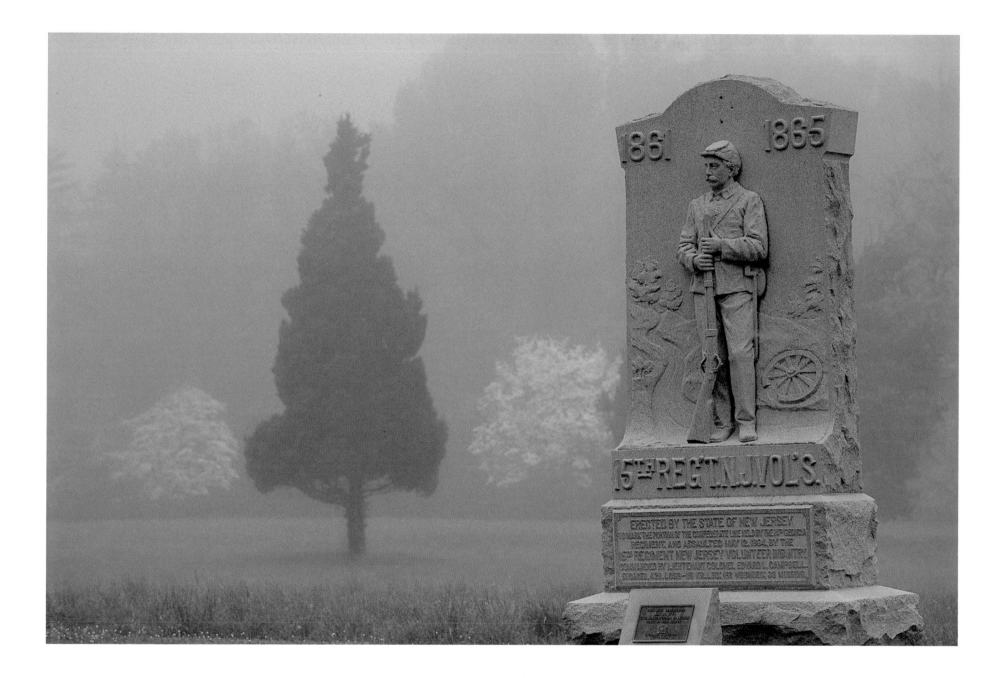

THE WILDERNESS, VIRGINIA

Terrain mattered in the Civil War. It was personal. Often a soldier might live or die depending upon whether a ditch was close by. Men lived, fought, and died in cornfields, orchards, and sunken roads they chanced into.

But when they had the time soldiers remade the land. The city of Vicksburg endured a long and grim siege. Men lived in handmade trenches for so long that the ground itself seemed like home.

Time has softened the edges of those once muddy trenches. On this quiet Thanksgiving morning, fog isolated the earthworks, giving to them shape and a presence.

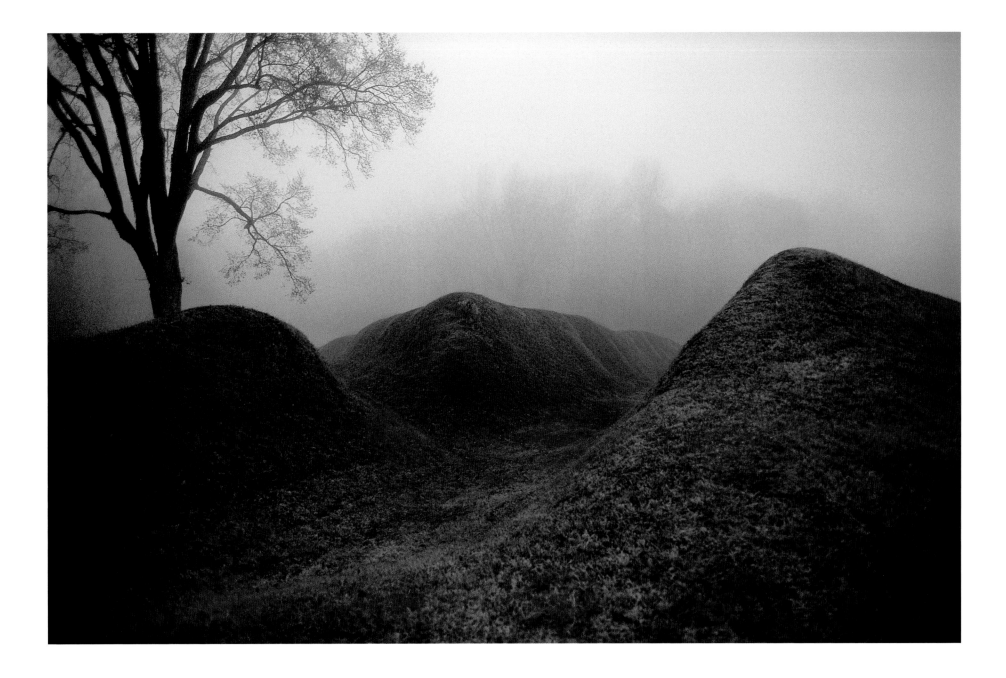

SIEGE WORKS, VICKSBURG, MISSISSIPPI

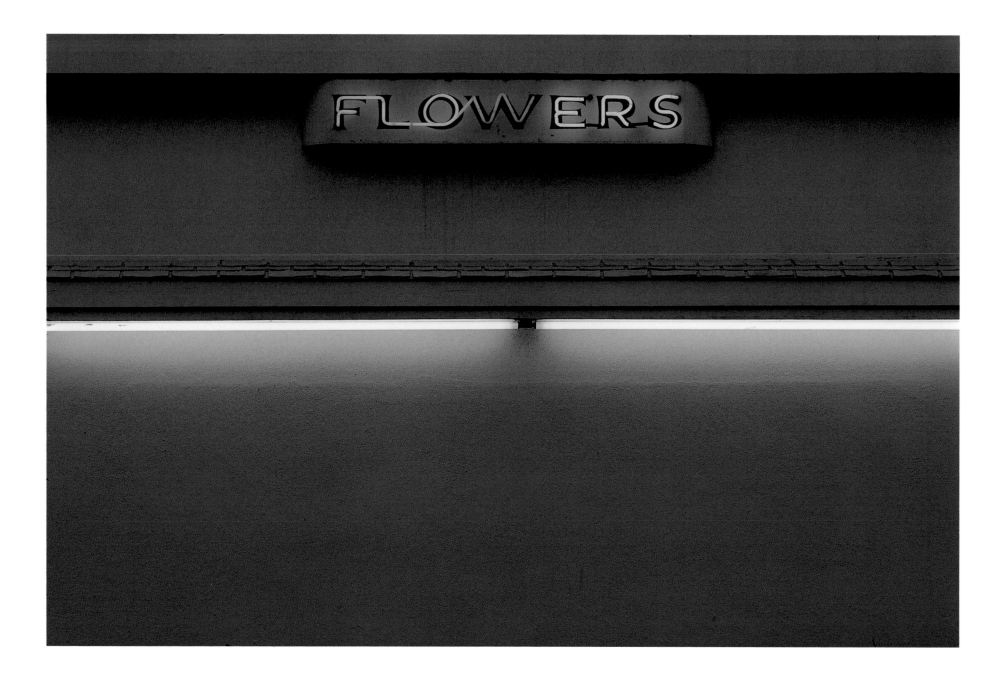

SUDBURY, ONTARIO, CANADA

SEEING GARDENS

ONE MARCH I DROVE NORTH from Toronto through gritty suburbs, dark forests full of old snow, and towns that were tired of winter, until Sudbury, the nickel-mining capital of the world, came into sight. Decades of mining and smelting had exhausted the landscape. Even the snow was dirty.

Late one evening I came around a corner and saw a broken neon sign almost spelling out the word FLOWERS. That glowing word looked like a garden to me. In it was the promise of another season, another possibility.

Other possibilities are often on the traveler's mind. The busy road, the anonymous room, the waiting—all emblems of the distance from home—combine to close out poetic possibility.

Then, unexpectedly, the image of a garden presents itself. It can be anywhere. Often the images are modest ones: floral fabric on a wall or worn by Russian women in the rain; a simple bouquet in a restaurant or in the hands of a man on a bus; a bird and some flowers going to the compost pile; a small shrine on a radiator; a man in a window painting a flowering tree.

These were gardens of the passing moment. But seeing them made me stop and take their picture. Photography, to me, is an act of appreciation. By taking my time I extended to these small gardens my thoughts.

Often we are far from the garden of our dreams, but nearby may be a reminder of it, waiting to be seen.

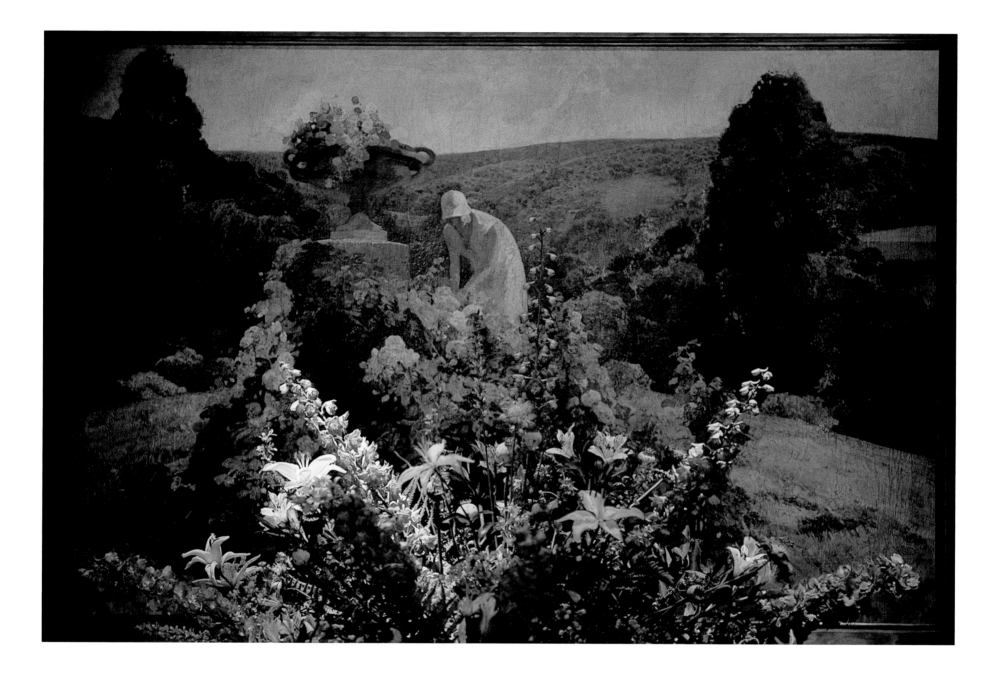

LITTLE THACKHAM, SUSSEX, ENGLAND

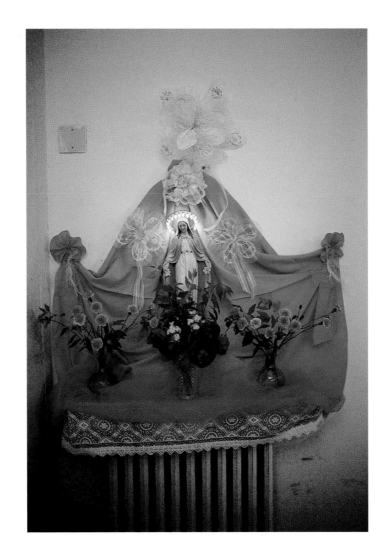

VENICE, ITALY

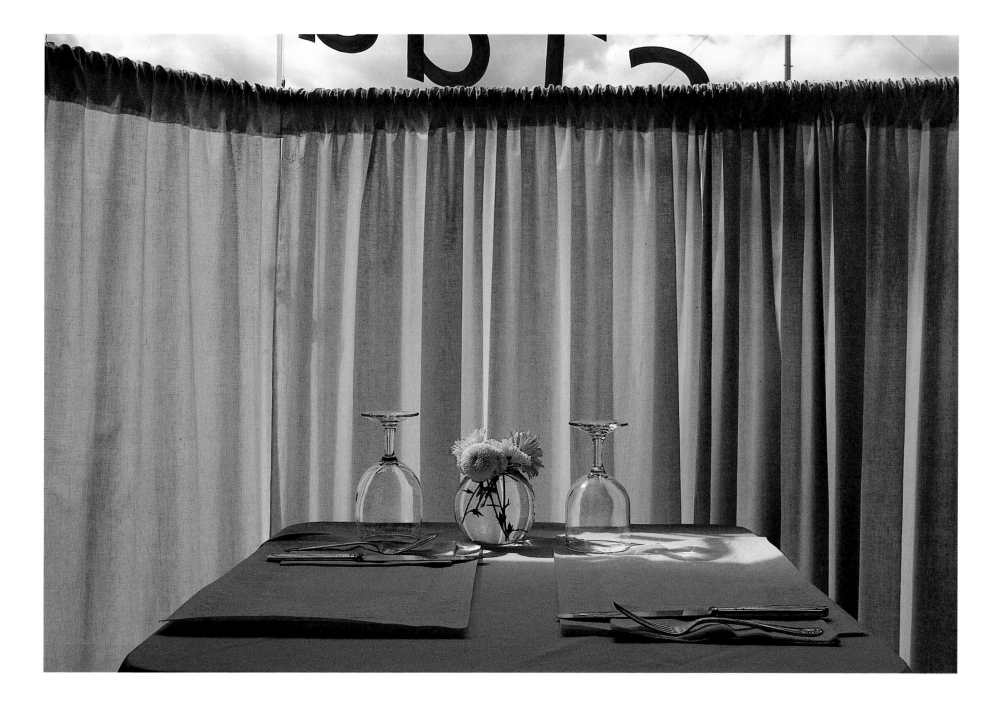

CHARLOTTESVILLE, VIRGINIA

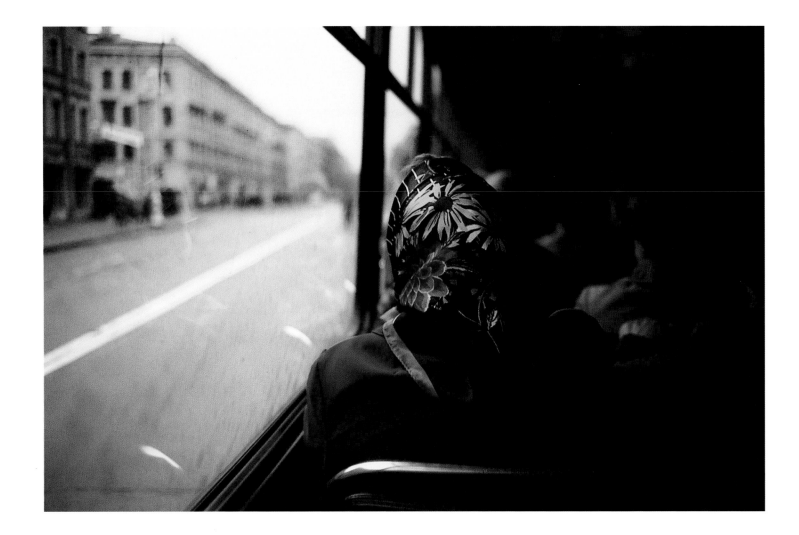

MOSCOW, RUSSIA

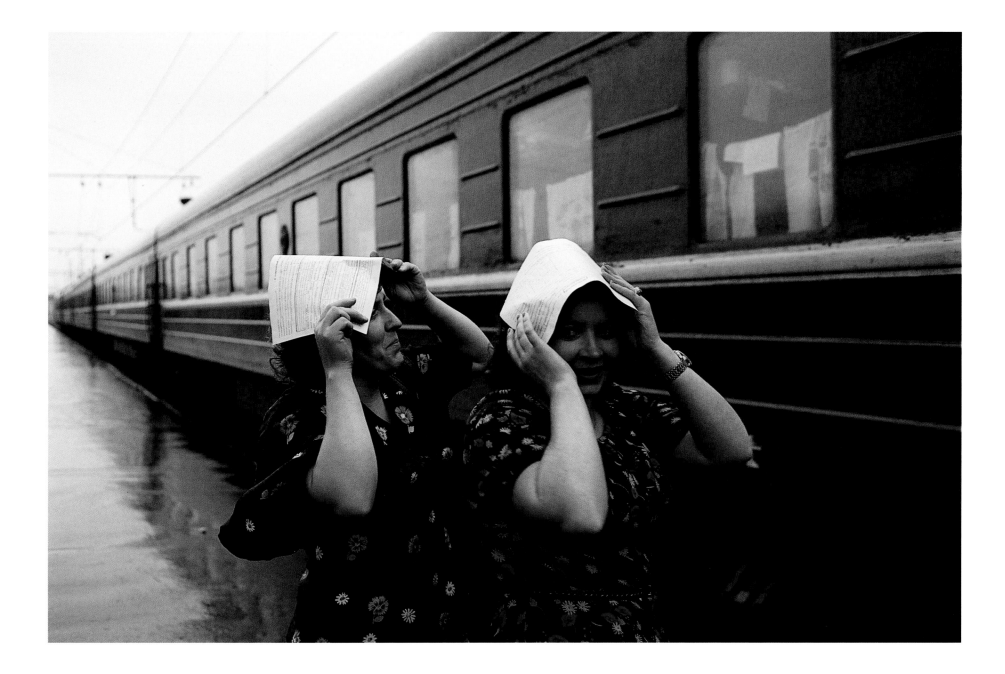

TULA, RUSSIA

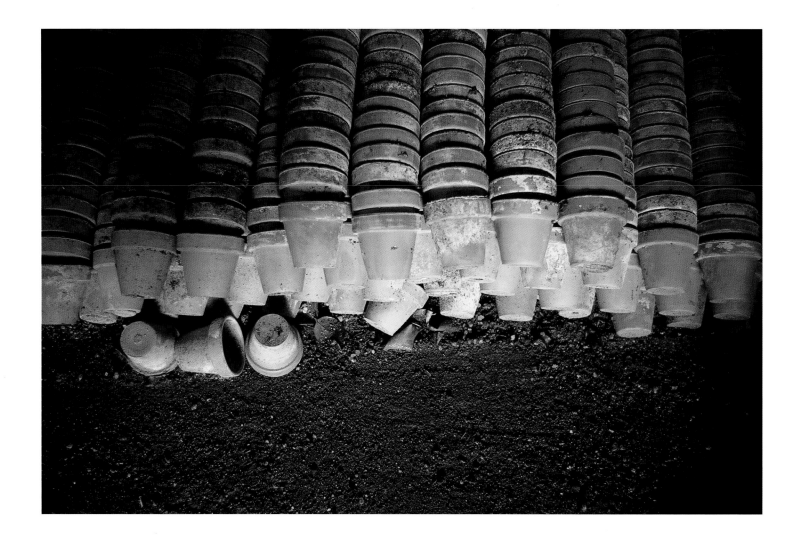

KENT, ENGLAND

CHARLOTTESVILLE, VIRGINIA

NORTHERN IRELAND

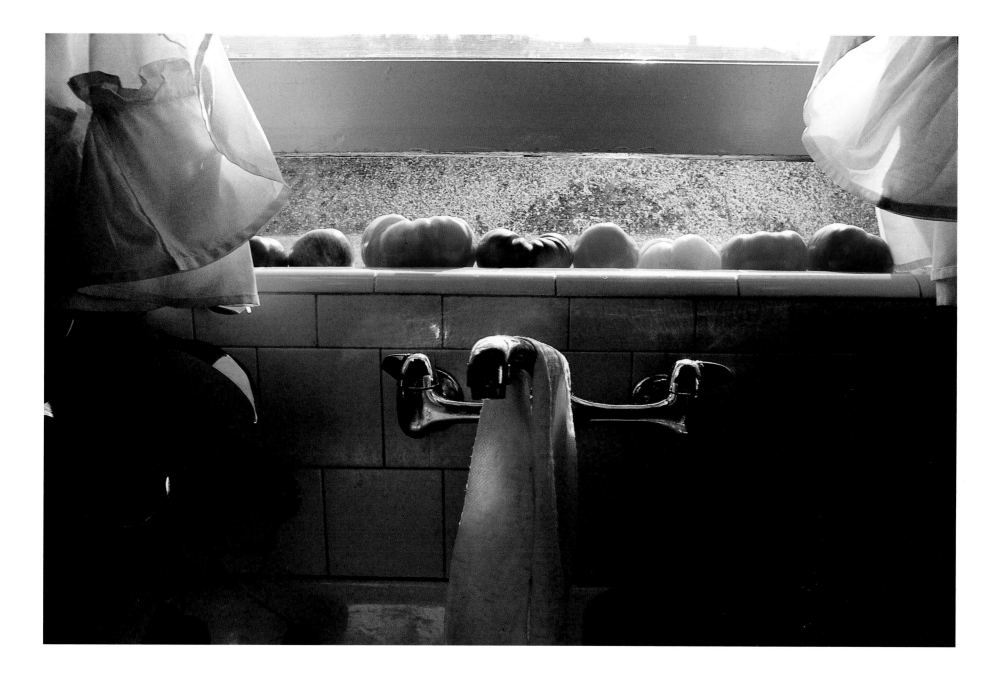

SAN DIEGO, CALIFORNIA

MILLINGTON, VIRGINIA

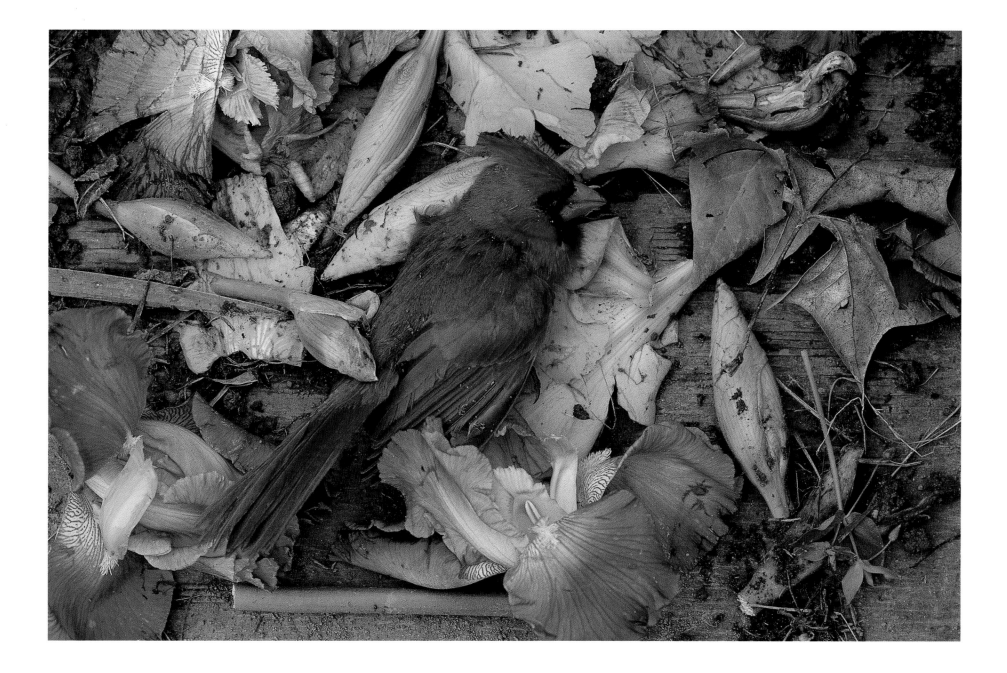

MILLINGTON, VIRGINIA

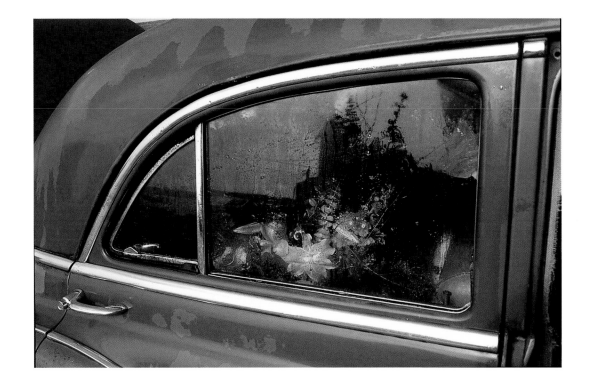

PORT TOWNSEND, WASHINGTON

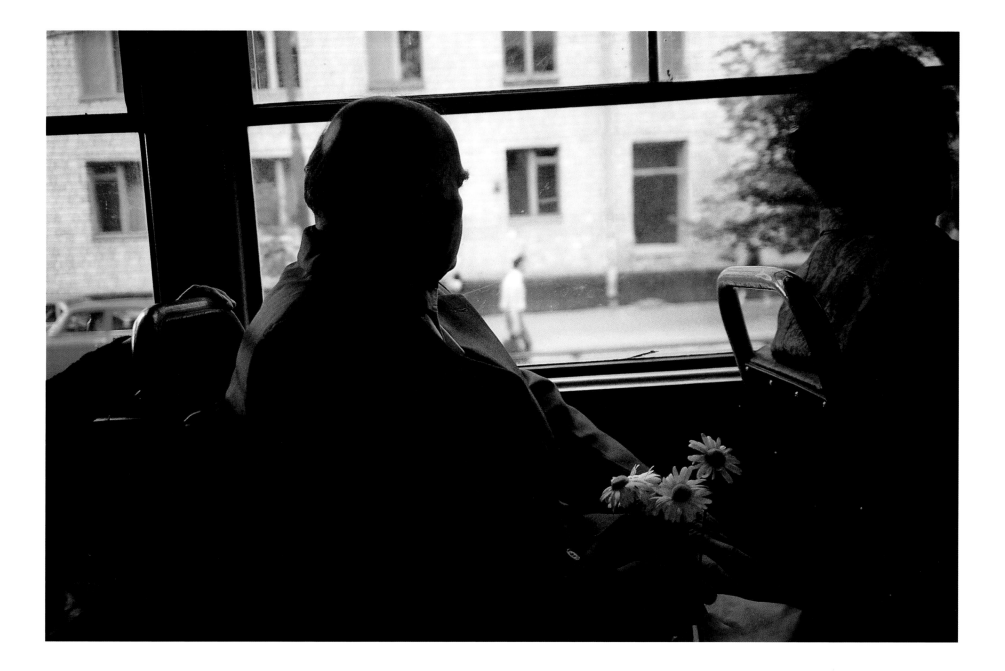

MOSCOW, RUSSIA

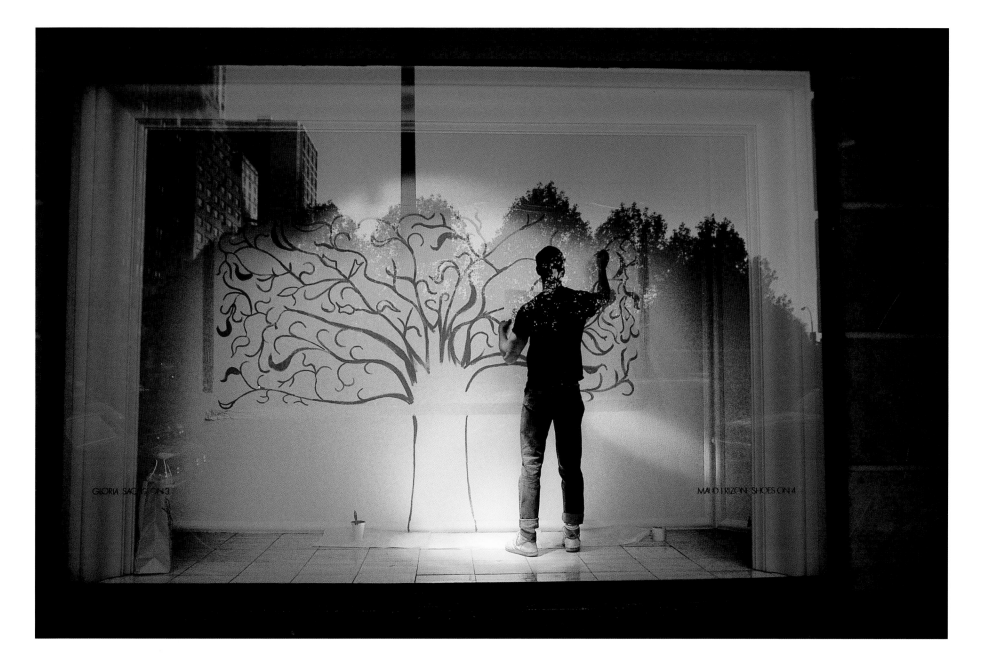

NEW YORK CITY

Author's Note

A BOOK IS A GARDEN TO ME and the photographs within this one represent the work of thirty years.

The editor of my work, both words and pictures, is Leah Bendavid-Val. We have worked together closely for ten years and from the beginning she has seen the garden in my photographs.

Marilyn Appleby designed the book. It is our fourth collaboration because her spare, careful design adds distinction to both words and photographs. The designer Carol Dean also made an important contribution by stepping in in time of need and going beyond the call of duty.

My friend Will Gray, Director of National Geographic's Book Division, and Nina Hoffman, Executive Vice President of the National Geographic Society supported the book by being open to a different way of seeing gardens. Kevin Mulory, Director of Trade Books, and the design and manufacturing team of the Book Division all gave this project their expertise and enthusiasm.

This book is, among other things, a memoir of travel made meaningful by the companionship of my wife Denise. For twenty five years we have traveled together. Now we live, and garden, in Albemarle County, Virginia.

Published by the National Geographic Society
1145 17th Street N.W.
Washington, D.C. 20036

First printing, October 2000